Along Artistic Lines
two centuries of railway art

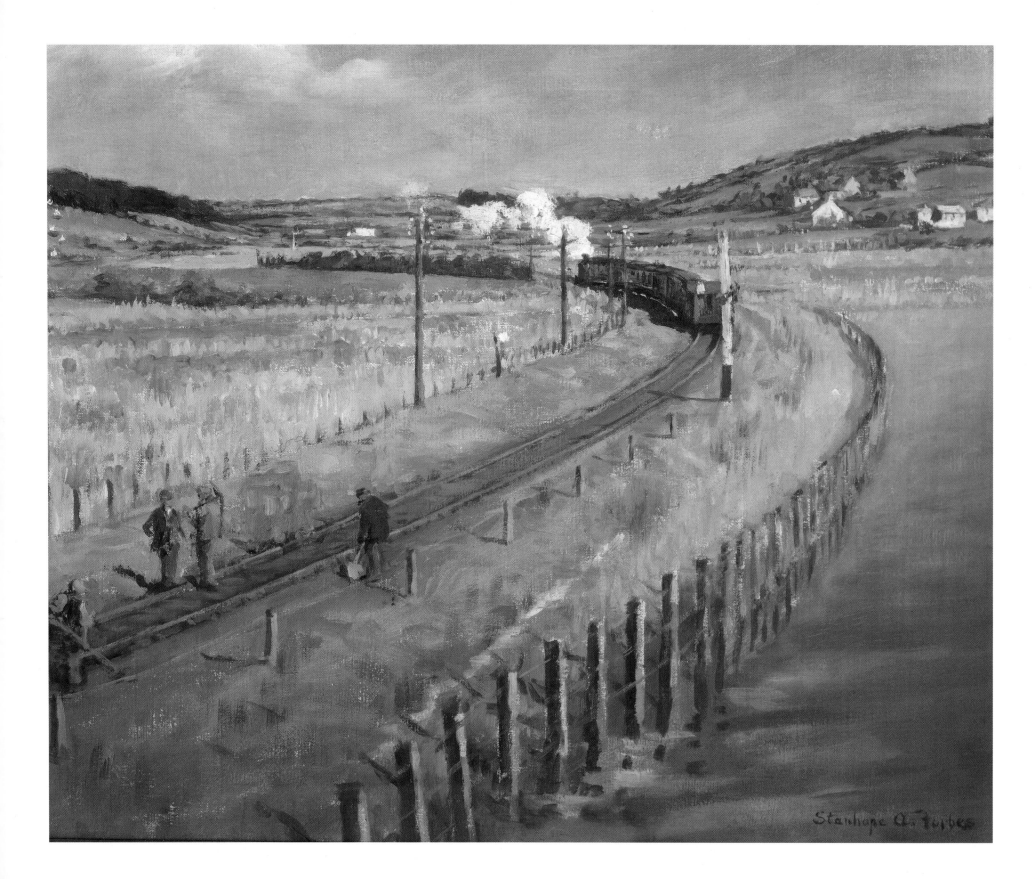

Stanhope A. Forbes

Along Artistic Lines
two centuries of railway art

BEVERLEY COLE AND THE GUILD OF RAILWAY ARTISTS

in association with the National Railway Museum

Atlantic Publishers
Trevithick House,
West End, Penryn,
Cornwall, TR10 8HE

ISBN: 1 902827 10 4

Text by Beverley Cole and Andrew Scott,
© Board of Trustees of the Science
Museum 2003

© Guild of Railway Artists 2003
The copyright of the original works of art
remains with the contributing members
of the Guild of Railway Artists.

Paintings reproduced on pages 2, 12 to
33 inclusive and 67 are courtesy of
National Railway Museum/Science &
Society Picture Library. Painting on
page 8 courtesy of the National Museums
& Galleries of Wales.

Design and layout: Roy Wilson

Printed by The Amadeus Press Ltd,
Bradford

British Cataloguing in Publication Data
A catalogue for this book is available
from the British Library

PAGE 1
Piston and Slidebar
PHILIP D HAWKINS
11 x 13 CM, PENCIL

PAGE 2
Through the Marshes
STANHOPE ALEXANDER FORBES
76 x 65 CM, OIL, 1927 (1987-9226)

PAGE 5
*Bournemouth Fast; Speeding
'Hall'; Rebuilt Bulleid*
PHILIP D HAWKINS
11 x 13 CM, PENCIL

Contents

ACKNOWLEDGEMENT

The original idea for *Along Artistic Lines* – a joint venture between the Guild of Railway Artists and the National Railway Museum – came from Roy Wilson, without whose dedication this volume would not have been published.

Once the green light was given to proceed with the project by the GRA Council, Roy went into action, working as Co-ordinator. Name it, he did it, designing the book and the layout, yet finding time to create six paintings – all of which are reproduced in the book.

Another tireless worker on the project was Beverley Cole of the National Railway Museum. She like Roy had an unwavering enthusiasm resulting in the writing of an excellent text.

Thank you Roy and Beverley.

Laurence Roche
Past President,
Guild of Railway Artists

Foreword

BY ANDREW SCOTT

HEAD OF THE NATIONAL RAILWAY MUSEUM

Once Richard Trevithick demonstrated the capabilities of his locomotive at Penydarren in 1804, the way was set for a new technology that would change the world. Although it would be several more years before the locomotive had advanced to the stage that it became a useful tool for industry, the way was set for the evolution of the steam railway into the crucial lubricant of the industrial revolution. When the railway became able to move materials, products and people speedily and cheaply from place to place, it became clear that the impact of the industrial revolution was going to be all pervasive – changing the world and the lives of everyone.

It is not clear whether all who gathered to witness events in South Wales in 1804 realised the full impact of what would follow. But one aspect of the steam locomotive became apparent straight away. All those who reported on the day commented on the impact that the steam locomotive had on all their senses.

And so it was to remain. As the steam locomotive spread across the country – and the world – it quickly became something that fascinated viewers by both its immediate impact and the visual impression of power that it represented. It soon became an icon for progress, for speed, for power and for the mystery of what lay beyond the horizon. It was inevitable that artists would want to record their impressions of the train and the impact it would make.

Two paintings by Turner, the *Fighting Temeraire* and *Rain, Steam and Speed*, encapsulate the force of change that steam brought with it in the first half of the nineteenth century. The first portrays the end of the days of sail, as a now redundant battleship is hauled off – by a steam tug – to the breaker's yard. The latter captures, perhaps for the first time in the work of a major painter, the power of steam – the urgency of the express train and the way in which the steam express would shrink the world regardless of what (in this case a hare!) might get in the way.

As the railway matured and became a routine part of everyday life it became a backdrop against which artists could record the eternal story of human life. The National Railway Museum has collected examples of the work of those who recorded the railway over the last 150 years. This book highlights some of their work and that of more recent artists who have used their brushes to recall the way in which the railway impacted on our senses. The integration of the railway into the fabric of society is perhaps best illustrated in George Earl's two paintings *Going North* and *Coming South*. These date from nearly fifty years after Turner. Whilst they portray what was clearly a major event for the participants – their annual shooting holiday in the Highlands of Scotland – it is in a sense the very ordinariness of the scenes which comes across. By 1893 it can be taken for granted that a short visit can be made to a part of the country some 500 miles from home, taking as much luggage as one thinks fit. The passengers are just another day's work for the lamplighter and the porter whom we see peopling the scenes.

In the twentieth century, the coming of the railway advertising poster created a new need for commissioned artworks which would encourage travel or pro-

ANDREW SCOTT

mote the services of the railway company. The need for advertising turned the railways into prodigious sponsors of art, some mawkish and shallow but much of which was at the leading edge of graphic art. The NRM's collections are rich with the work of some of the UK's leading graphic artists of the twentieth century and the best of their work will be found here too.

The train continues to inspire artists and the Guild of Railway Artists brings together a wide group of those who seek to record the impact of the train on the world around us. Much of this work is retrospective. But it too serves to communicate how the railway impacted on the world around it. It is a great pleasure for the National Railway Museum to be working in partnership with the Guild of Railway Artists to produce in this volume a record of the railway through the eye of the artist, two hundred years after Trevithick's locomotive made its first faltering journey.

Andrew Scott.

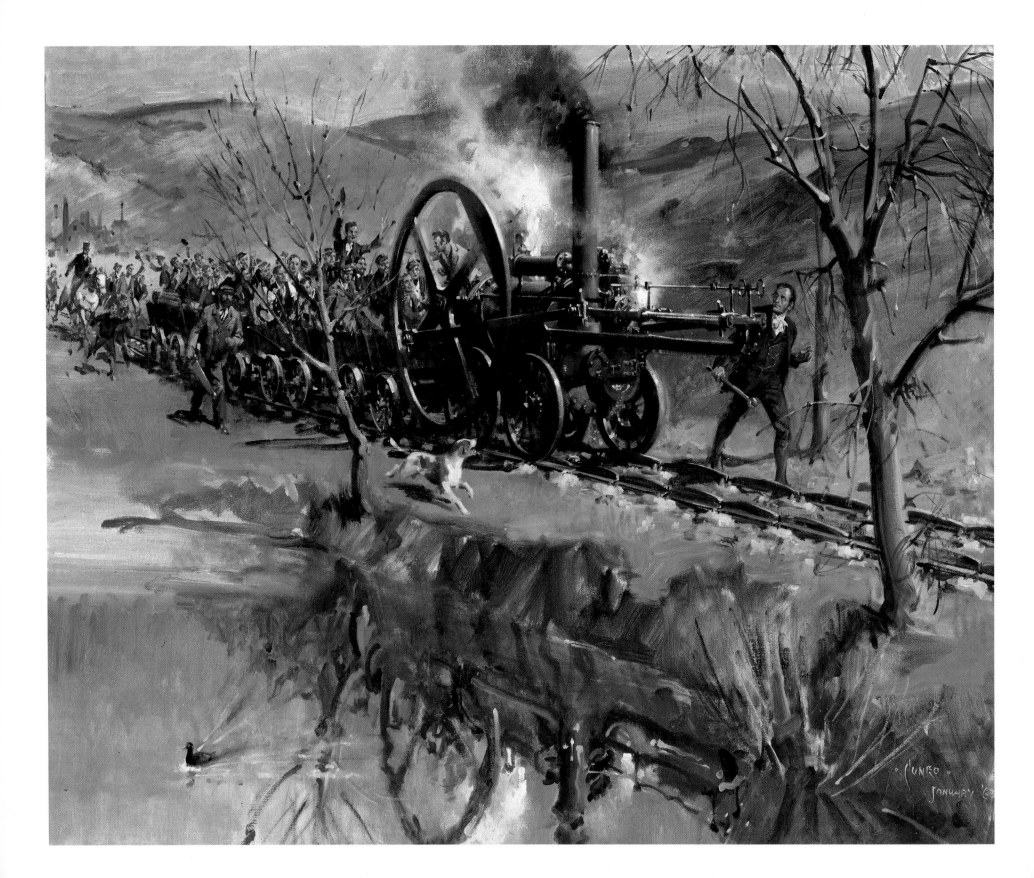

The First Railway Locomotive

RICHARD TREVITHICK AND 'PENYDARREN'

The reason this book came about goes back to 1804 when Richard Trevithick built *Penydarren*, the first steam locomotive known to have successfully run on rails. The National Railway Museum and the Guild of Railway Artist's were keen to celebrate the 200th anniversary of this event and decided to stage a joint exhibition in 2004. Such was the enthusiasm for the project that they also decided to publish a celebratory book based on two centuries of railway art".

Richard Trevithick was born at Illogan on 13th April 1771 to a mining family. He was the fifth child with four older sisters, his father being mine captain to four mines. School reports were not altogether favourable, but it is said that he had a prodigious capacity for mental arithmetic. An imposing figure of a man he stood six foot two, very tall for the age, strong, and was an accomplished Cornish wrestler. He picked up his engineering knowledge by wandering around the mines where his father worked and by the age of nineteen he was employed as a consulting engineer.

In the years before James Watt's steam-engine patents expired in 1800, Trevithick became involved in the search for a way to bypass the separate condenser patent which was costing Cornish mine owners a lot of money in royalties. It was in 1797 – the year his father died and the year he married – that Trevithick made his first models of high-pressure engines. In these the steam from the cylinders was expelled to the atmosphere, doing away with the need for a condenser, circumventing Watt's patent and producing much more power. He called them 'puffers' because of the noise they made.

Trevithick built his first road steam locomotive at Camborne in 1801, and it had a short but interesting life before burning out while Trevithick and his colleagues were in a local tavern. Another road machine followed in 1803, which ran several times in London streets before Trevithick turned his attention to railways.

Penydarren made its debut on the normally horse-drawn Penydarren tramway in South Wales and on 22nd February 1804 pulled ten tons of iron and seventy men. Unfortunately for Trevithick, he was a little ahead of his time. The cast-iron rails of the tramways of those days were just not strong enough to support the weight of his newfangled machine and it was to be several years before the idea became commercially viable.

However, an engine similar to the Penydarren version was built to Trevithick's specifications at Gateshead the following year, and it seems highly likely George Stephenson saw this machine. Stephenson and Trevithick certainly met at this time. New ideas poured from Trevithick's fertile mind in the following years.

In 1808, Trevithick constructed at his own cost not only a locomotive but a circular railway track on the parcel of land now forming the southern half of Euston Square in London. The engine, called *Catch-me-who-can*, weighed ten tons and attained a speed of 12mph.

Trevithick was a prolific inventor. His inventions included a steam dredger, steam propulsion for ships, iron floating docks, the screw propeller, agricultural steam engines, pumping engines, hot-air heaters and a method of making ice. He even had ideas for a scheme for draining the Dutch polders and plans for the erection of a monument a thousand feet high to commemorate the passing the Reform Bill.

From 1817 to 1822 Richard was in Peru supervising the installation and

OPPOSITE PAGE
The Penydarren Tramroad Locomotive
TERENCE CUNEO
89 X 75 CM, OIL, 1963
(Copyright Cuneo Estate)

BELOW
The Mining Journal, Railway and Commercial Gazette of 2nd October 1858 throws interesting light on Richard Trevithick's *Penydarren* locomotive.

Life of Richard Trevithick, written by his eldest son Francis in 1872. (collection Lawrence Roy Wilson)

from the public; but should this be all, I shall be satisfied by the great secret pleasure and laudable pride that I feel in my own breast from having been the instrument of bringing forward and maturing new principles and new arrangements of boundless value to my country. However much I may be strait-ened in pecuniary circumstances, the great honour of being a useful subject can never be taken from me, which to me far exceeds riches.

Richard Trevithick's genius is now wide-ly acknowledged. It is with great pleasure that we celebrate his contribution to the industrial revolution and the invention of the first railway locomotive two hundred years ago with *Along Artistic Lines – Two Centuries of Railway Art*

Who built the first railway locomotive?

There was much controversy in the mid-nineteenth century when strenuous efforts were made to prove that the engine built to Trevithick's specifications at Gateshead pre-dated *Penydarren* and thus was the first railway locomotive. These claims were eventually discounted but not before some fascinating com-ments and recollections had been pub-lished in *The Mining Journal, Railway and Commercial Gazette* of 2nd October 1858.

The locomotive in question was des-tined for Wylam Colliery and was con-structed by John Steele at the Pipewellgate foundry of John Whinfield. *The Mining Journal* takes up the story:

The death of Mr John Whinfield, who was concerned in the manufacture of some of the earlier locomotives, has revived the question as to who was the first to apply the power of steam to loco-motive purposes; and it has, we think,

working of pumping engines at the gold and silver mines. The Peruvian Civil War of 1822 led to the complete destruction of Trevithick's machinery. He then moved onto the copper mines of Costa Rica. In one of his letters home he reported being 'half drowned, half hanged, and the rest devoured by alligators'. Trevithick returned to England safe but penniless.

John Hall, the founder of Messrs J & E Hall Ltd, invited him to Dartford to carry out some experiments associated with 'the engine of a vessel lately built'. It is generally supposed that Trevithick was engaged with the development of a reac-tion turbine. He was probably based at Hall's Dartford Engineering Works for about a year.

Despite having many revolutionary ideas he had neither business acumen nor a sponsor and did not receive money

or recognition whilst he lived. He died on 22nd April 1833 in the Bill Hotel in Dartford aged 62. He would have been buried in a pauper's grave but the mechanics he worked for acted as bearers at the funeral and paid the burial fees. They also paid for watchmen to remain by the grave to prevent body snatching which was prevalent at the time.

Shortly before his death Richard Trevithick wrote to his old friend Davies Gilbert:

I have been branded with folly and mad-ness for attempting what the world calls impossibilities, and even from the great engineer, the late Mr. James Watt, who said to an eminent scientific character still living, that I deserved hanging for bringing into use the high-pressure engine. This so far has been my reward

been well established that the honour is due to Mr Richard Trevithick, of Camborne, who, more than 50 years since, ran a locomotive through the high street of his native town, and employed a locomotive to draw a load of bar-iron from the Penydarren Iron-works to the basin.

The article goes on to refer to Trevithick's original drawing for the locomotive and those involved in its operation:

Rees Jones, who aided in fitting the engine, and William Richards, its driver, are still alive; the former, who is in his 83rd year, upon being shown the plan, instantly recognised it; and the latter, now 85 years of age, has worked no other than Trevithick's high-pressure engine. To this day portions of the old engine exist in the one he now works at Penydarren, and during a period extending far beyond half a century he has never had an accident with his boiler.

Before the run from the works to the basin, Trevithick made a bet with Richard Crawshay that he would take a load, by steam power, from the works to the Navigation House, a distance of nine miles. Trevithick won the wager; but, owing to heavy gradients, sharp curves, and the frangible nature of the cast-iron tramway operating against the success of the machine, the experiments were discontinued.

A sworn statement by Rees Jones is then quoted:

I came to Penydarren on April 1, 1794. I was then 18 years of age. I have been in the employ of Penydarren Iron Company ever since. I am still able to do a little. I am in the works every day. About the year 1800 Mr Trevithick came to Penydarren to erect a forge engine for the company. I was at this time over-looking the engines at Penydarren. I

assisted Mr Trevithick in the construction of the forge engine.

When this engine was finished, Mr Trevithick commenced the construction of a locomotive. Most, if not all, the work of this locomotive was made at Penydarren. Richard Brown made the boiler and the smith work: I did most of the fitting, and put the engine together. When the engine was finished she was used for bringing down metal from the furnaces to the Old Forge. She worked very well, but frequently, from her weight, broke the tram-plates, and also the hooks between the trams.

After working for some time in this way, she took a journey down the Basin-road, upon which road she was intended to work. On the journey she broke a great many of the tram-plates; and before reaching the Basin she ran off the road, and was brought back to Penydarren by horses. The engine was never used as a locomotive after this. She was used as a stationary engine, and worked in this way several years. I understood the reason for discontinuing using her as a locomotive was the weakness of the road.

The sworn statement was forwarded to the *Journal* by William Menelaus, who commented that Rees Jones had traced his early connection with the works clearly year by year and that he had no doubts over the correctness of his dates. Menelaus concluded:

It seems clear – first, that as early as 1800 Trevithick had a locomotive actually working in Cornwall on the turnpike road – and, secondly, that in 1803 he had constructed and put to work a further engine, at Penydarren.

None of this entirely satisfied the *Gateshead Observer*, which the following week somewhat grudgingly conceded that Whinfield and Steele at the Pipewellgate foundry did not have 'priori-

ty over Trevithick, whose laurels are undisturbed'. Perhaps understandably it then went on to praise with characteristic Victorian verbosity the achievements of John Steele, the local lad made good:

Trevithick's is of prior date to Steele's, but Steele was no mere copyist. The school boy of Colliery Dykes – 'the extraordinary clever lad', whose master 'could never set him fast' – who had 'a turn for machinery' in his boyhood, and who took his playfellows home 'to see his imitations of pit engines' – 'Jack Steele', who prophesied to George Bold 'that the day would come when the locomotive engine would be fairly tried, and would then be found to answer' – was possessed of an original genius, and we claim for him the honour of being a co-labourer with Trevithick, the constructor of the first locomotive engine.

Steele moved on to make marine engines in France and was killed when one of his boilers exploded. *The Gateshead Observer* has the last word:

Such was the end of poor Steele – whose memory we would rescue from oblivion, and whose claims in connection with the locomotive engine we would establish, without injustice to Trevithick or offence to his friends.

Statue of Richard Trevithick. Drawing by Julie West.

(Extracts from the archive of the *Mining Journal* provided by Lawrence Williams, BSc, Eng, CEng.)

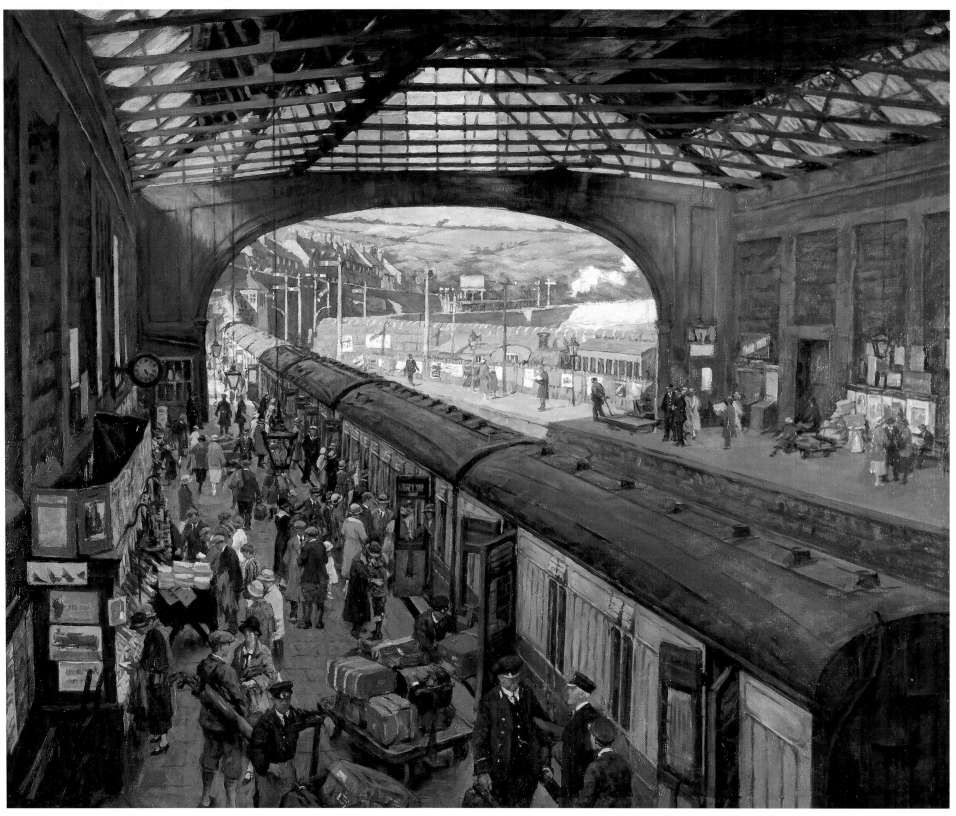

Two Centuries of Railway Art

AN INTRODUCTION BY BEVERLEY COLE

CURATOR OF PICTORIAL COLLECTIONS, NATIONAL RAILWAY MUSEUM

Art and early railways

From the beginning of railway history, contemporary artists understood the need to document the building, development and operation of the railways in Britain. Before the railways no one could travel any further or faster on land then the horse would allow. In 1758 the Middleton Railway in Leeds became the first to be authorised by an Act of Parliament and, although the term 'railway' was not universally used, it was the beginning of the railway as we know it. These early railways linked mines and quarries and carried minerals to furnaces and waterways as part of the Industrial Revolution. 1804 saw another step forward with the invention of the first steam railway locomotive. This was designed and built by Richard Trevithick and used at Penydarren in South Wales. Trevithick was also responsible for the first railway attraction in 1808 when he set up a circular track in Bloomsbury, London, which took passengers on a continuous circular tour. It was a very fashionable event and did much to publicise the new railways. Trevithick's locomotive was called *Catch me who Can* but nicknamed 'Captain Trevithick's Dragon.'

In 1812 Matthew Murray and John Blenkinsop introduced rudimentary rack and pinion locomotives to and from coal mines and in 1813, in the Tyne Valley, William Hedley's *Puffing Billy* and *Wylam Dilly* set the standard for the embryonic steam locomotive. George Stephenson appeared on the scene in 1814 with his first locomotive, *Blucher*, at Killingworth. He was the first proponent of wrought iron rather than cast iron railways, wrought iron being less likely to crack under pressure. In 1821 the Act was passed for the Stockton & Darlington Railway, which linked the two major industrial towns and was to carry passengers as well as goods and minerals. The line was also built by George Stephenson and his son Robert, with the financial backing of the Darlington entrepreneur Edward Pease. It opened on 27 September 1825 and the first train was hauled by *Locomotion No 1*. This railway was significant because it attracted the attention of other engineers and industrialists and, most importantly, made a profit for its shareholders.

Following the success of the Stockton & Darlington Railway, George Stephenson was contracted to build the Liverpool & Manchester Railway. The directors were reluctant to use the current steam locomotives which were slow, used too much coal and were incredibly unreliable. Realising that a more efficient locomotive was needed, the directors of the newly constructed Liverpool & Manchester Railway threw out a challenge to all locomotive builders. This was to design and build a locomotive that could pull three times its own weight along a mile and two-thirds of track forty times – representing in total the actual distance from Liverpool to Manchester and back.

In 1829 George Stephenson won this competition known as the Rainhill Trials with the locomotive *Rocket*; this was to strike a spark that would start a revolution. The *Rocket* completed the course of seventy miles at an average speed of 13mph. An industry was born. Following the success of the Liverpool & Manchester, railways spread all over Britain with engineers such as the Stephensons, Locke, Vignoles and Brunel collaborating with entrepreneurs like George Hudson, who was nicknamed 'the Railway King'. The term applied to this period was the 'railway mania': by 1850 there were 6,000 miles of track in Britain.

During this period the power and nov-

OPPOSITE

The Terminus: Penzance station
STANHOPE ALEXANDER FORBES
102 x 87 CM, oil, 1925 (1976-9301)

BELOW

Beverley Cole, Curator of the Pictorial Collections, examines a poster acquisition

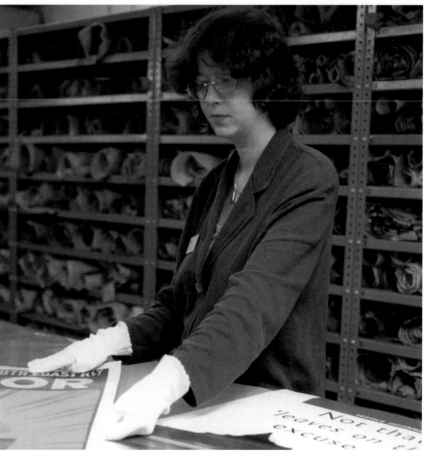

ticular realised, with great foresight, how important it was to document these changes. He used vision and draughtsmanship to illustrate the new industrial world and its 'dragons'.

JOHN COOKE BOURNE

Bourne (1814 -1896) was born to a hatter of Hatton Garden. His family also included the artist and engraver George Cooke (1781 - 1834), who became Bourne's godfather. Bourne began his artist career as a pupil of the landscape engraver John Pye (1782 - 1874). Under Pye's guidance, he showed himself to be a highly competent draughtsman from an early age, with a remarkable understanding of line and form. Bourne probably used the camera obscura to calculate angles and perspective.

In 1836, less than a mile from Bourne's home in Lamb's Conduit Street in London, the engineer Robert Stephenson was beginning to build the London & Birmingham Railway. It started at Euston and ran through the streets of Camden Town, on towards the Midlands. At the age of 22, Bourne began a series of sketches and watercolour drawings of Stephenson's construction work. As production of these increased, so did interest in his work. Bourne sent several examples of the sketches to John Britton (1771 - 1857), a writer and patron of the arts, who was greatly impressed and subsequently became his sponsor.

It was John Britton who first persuaded the London & Birmingham Railway Company to publish a set of tinted lithographic prints by Bourne. Britton had two reasons for this request. Firstly, he felt that there was enough genuine interest in the subject matter to ensure their success and, secondly, he hoped they would counter the prevailing anti-railway culture. The decision to produce the work was probably taken in the early part of 1837. Bourne was sent northwards to sketch the nearly completed Watford Tunnel and views of the construction work at Boxmoor, Berkhampstead, Tring and Wolverton. By 8 July 1837, Bourne had reached the Kilsby Tunnel, where

ABOVE
Work on the Kilsby Tunnel
JOHN COOKE BOURNE
19.5 x 20.5 CM, WASH DRAWING, 1837
(1990-7238)

RIGHT
The building of Euston Arch
JOHN COOKE BOURNE
34 x 23.5 CM, WASH DRAWING, 1837
(1990-7189)

elty of the railway and the locomotive caught the imagination of everyone from the young actress Fanny Kemble to Queen Victoria. Whilst some artists were attracted to the new stations, viaducts and bridges, many were dumbfounded by the aesthetic problems that the locomotive posed and its inhumanity. John Martin (1789 - 1854) depicted a train in his 'Last Judgement' painting. It symbolised part of man's depravity, the damned being carried to hell in 3rd class carriages. Some people complained of the noise, smoke and the dangers of suffocation to which passengers were exposed as they travelled at high speed – yet even this was to contribute to the art of the time. Cartoonists from *Punch* and *Vanity Fair* satirised this new invention.

As with all change there was rejection and reaction but one railway artist in par-

some of his most memorable sketches were produced.

It is Bourne's detailed recording of the progress of construction, the accurate delineation of the tools and the laborious work by the men, which makes his art so historically important. Although his work has strong artistic value, it is this accurate recording of the construction work that has given future generations an insight into the development of the railway network in Britain.

Another significant aspect of Bourne's work is the realistic depiction of 'navvies', the men who actually built the railways, during the construction of the network, which he considered essential to the whole record. At that time, most of his fellow artists were concentrating on topographical, pastoral pictures of an idyllic England inhabited by innocent peasants pursuing rural tasks. Bourne realised that it was essential to depict an accurate record of the creation of these 'iron roads' as their development would revolutionise the world.

Bourne spent the winter and spring of 1837-38 preparing the lithographs. Thirty-six of the initial drawings were selected for inclusion in *A Series of Lithographed Drawings of the London & Birmingham Railway*, first published in four parts by the publisher Ackerman in 1838. John Britton produced the text. The publication sets the railway in a global historic context and enthuses about steam power and its many applications. The text is crammed with statistics and the tone is energetic and optimistic. Britton realised that he was living in a time of great change.

After the success of the London & Birmingham Railway drawings, the architect, printer and publisher Charles Cheffins (1777 – 1844) commissioned Bourne to draw a series of wash drawings of the Great Western Railway (GWR). These were printed in *The History and Description of the Great Western Railway* published by David Bogue in 1846. This

time it was the stations, bridges and scenery he depicted rather than the construction.

The book opens with a picture of the locomotive *Archeron* travelling through a tunnel with a bridge above it, engraved 'The Great Western Railway by J C Bourne'. The inspiration for this book was the achievements of the railway as a heroic enterprise. The preface explained the purpose behind the book and showed the engineering and architectural structures produced for the railway, which usually go unnoticed because of their remote siting or the speed of travel. The writer also added geographical notes and information on ecclesiastical architecture. The book is a guide to the history and architecture surrounding the GWR as well as a showcase of its engineering feats.

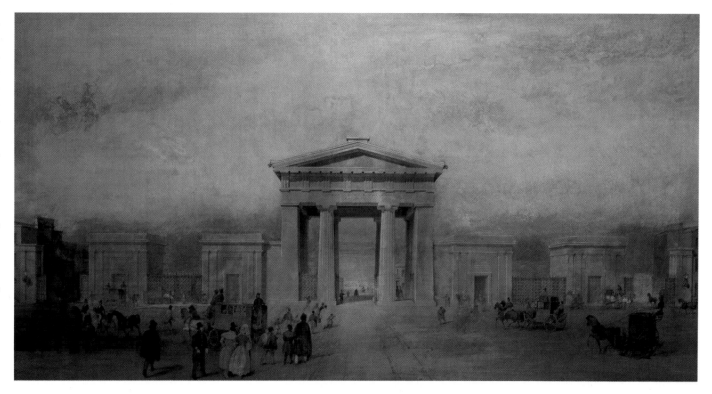

Euston Station
JOHN COOKE BOURNE
155 x 110 CM, WATERCOLOUR, 1837
(1989-7158)

Railway Art in the Victorian Era

Once the railway network in Britain was established the Victorian artists seized the opportunity to paint the architecture that the railways inspired and the people who used them. The railway station was a product of the industrial revolution and, for the artist, was a microcosm of industrial society. It was a public place where all social classes could mix – ironically the station architects were usually resolutely attached to classical design whilst the stations themselves symbolised progress and modernity. Many nineteenth century authors described stations as 'Cathedrals of the modern age'. However, to the Victorian narrative artist, the stations as well as carriage settings were ideal backdrops for the stories that so appealed to the Victorians. A pair of paintings often told these stories. One would introduce the story and set the

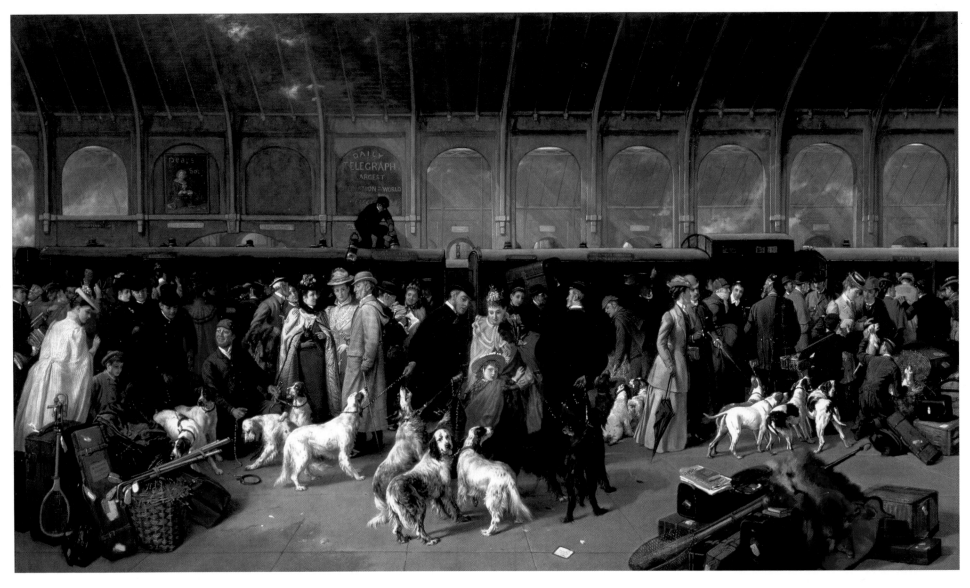

scene and the second would conclude the story, leaving the viewer to use his imagination to fill in the gaps. The National Railway Museum collection has two of these narrative pairs of paintings in its collection.

'GOING NORTH' AND 'COMING SOUTH'

One pair of narrative paintings in the NRM are 'Going North, King's Cross Station', 1893, and 'Coming South, Perth Station', 1895. Whilst these do not have the same moral message as the other pair (pages 18-20) they are important for their

detail of the Victorian station.

Apart from William Firth (1822 - 1898) in 'The Railway Station' (1862), no artist has exposed the station interior, its architecture, social classes and the romance of train travel in such detail. George Earl (1824 - 1908) was well known for his animal and sporting paintings and exhibited at the Royal Academy from 1856 to 1883. The portrayal of the passengers is very complimentary because these sorts of people would be Earl's patrons. The paintings celebrate prosperity and privilege.

In the first painting, 'Going North', it is August and the beginning of the shooting season. A party of friends has gathered at King's Cross station ready to board the East Coast Joint Stock carriages to travel to Scotland for a sporting holiday. The scene is set in the East Hall of King's Cross, which was designed by Lewis Cubitt and opened in 1852. Two carriages are destined for Aberdeen via the Forth and Tay bridges and the other marked for Perth. In August 1883 a train left King's Cross at 10am. They all have their luggage, equipment and dogs with them and

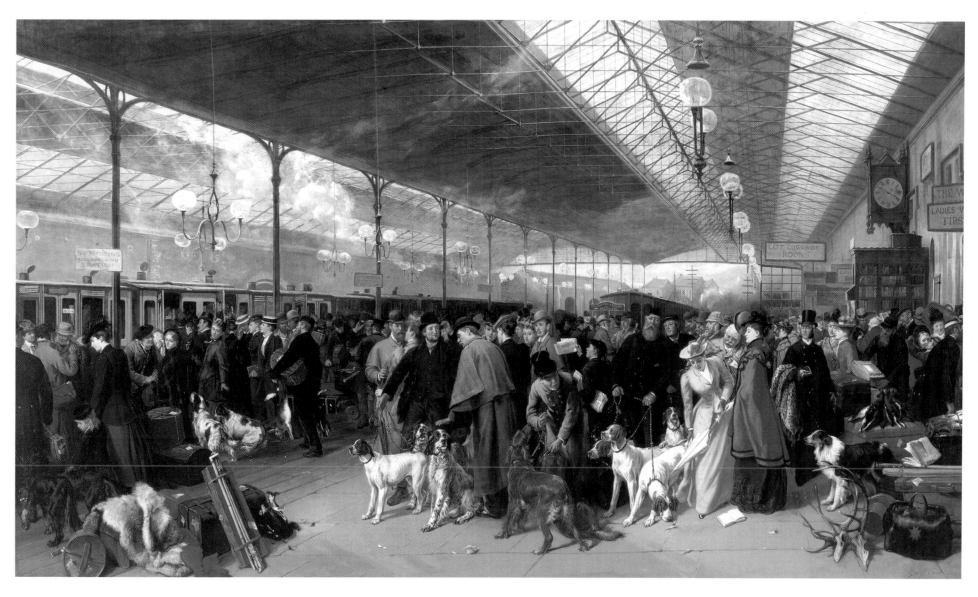

are all ready for the 'glorious twelfth'. The gun case on the left has a label 'From Bombay to Southampton', which would indicate that its owner had been game hunting in India. Next to this we see a set of seven golf clubs, three woods and four irons on top of a wicker basket. There is also a tennis racket, an umbrella, a walking stick and a shooting stick. On the other side of the painting we can see fishing tackle, a fur, the *Graphic Magazine* and a *Bradshaw's Railway Guide*. The platform is littered with food, paper and a cigar end.

The dogs are particularly numerous. The middle carriage is strewn with straw and pointer puppies, English Setters, Lennox Gordon Setters, Springer Spaniels and an English Toy Terrier or 'black and tan'. Apart from the dogs some of the travellers are worth a second glance. Note the ghillie or gamekeeper with his rugged face and the Indian Ayah dealing with the small girl in the centre of the painting. Ayahs or nannies were very popular at this time. The artist, George Earl, can be seen accompanied by advertisements for the *Daily Telegraph*, Van

Houten's Cocoa and Russell's Watches.

In the second painting 'Coming South', it is now September. The party has had a successful expedition. The seasonal trek to the North is over and they are assembled at Perth station ready to board the train, which will take them back to London by the West Coast route. Perth station was designed by Sir William Tile in 1848 and was enlarged in 1885-87 but Earl shows it in its original state.

Among the luggage we see stags' antlers, grouse, blackcock and rabbits for skins. The guard carries a hare and a

Coming South, Perth Station
GEORGE EARL
214 x 123 CM, OIL, 1895 (1990-671)

Second Class: The Departure
ABRAHAM SOLOMON
112 X 86 CM, OIL, 1855 (1975-8509)

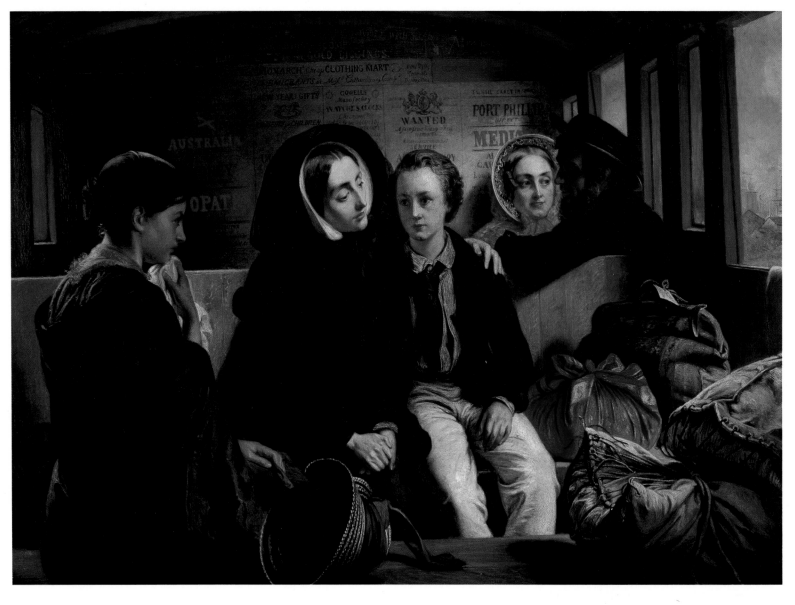

wicker basket, which no doubt contains salmon. A boy walks along the station selling *The Scotsman* newspaper whilst the grooms and footmen control the dogs. Not only has the artist depicted all the same dogs as were at King's Cross but has also managed to include a Border Collie which we presume is with the gentleman in the top hat to the bottom right of the painting.

There are several characters that appear prominently in both paintings. These are the ghillie, the lady in the red cloak and the artist. Again the platform is littered, but this time with feathers, food and an open book. The station signs are more obvious in this painting. A notice at the end of the Highland Railway bays points to the Caledonian Railway for through trains to Aberdeen. There is also a 'no smoking' sign but such signs were soon withdrawn.

The clock shows 3.50pm. The train would depart at 4.04 and would arrive in London Euston about twelve hours later at 3.50 in the morning. Today the overnight sleeper departs at 2320 and arrives at London Euston at 0745 some 8½ hours later.

'THE DEPARTURE' AND 'THE RETURN'

The other pair of paintings at the NRM are known as 'The Departure' and 'The Return'. They were transferred from the Transport Museum in Clapham to the NRM in 1975. They were in heavy, unsuitable, unwieldy frames and the ravages of time had taken their toll. Generally, oil

paintings on canvas are fairly robust. They do not fade rapidly when exposed to light, unlike watercolours or posters, and any dirt accumulated over time can usually be cleaned off, so there was hope. However, after a conservator was contacted for a report, the prognosis was discovered to be poor.

A detailed examination revealed a deposit of surface dirt covering a layer of yellowed varnish. There were large areas of stress cracking and shrinkage and several scratches on the surface of the paint-ing. The canvas was also slack. The frame itself was totally unsuitable being a weak box-frame which flexed each time the painting was handled and transferred this tension onto the canvas which was causing more cracking. In all over a hundred hours of conservation work was spent on restoring the paintings.

In order to understand why this work was undertaken it is necessary to understand why these two paintings are an important part of the NRM collection. Although the paintings are, artistically, good examples of Victorian narrative art and would be an asset to any art museum's collection, they are also equally important to the NRM collection historically because the setting is a railway carriage. This was a novel setting in 1855. The artist has used the railway carriage as a medium through which to tell the story.

In the first painting 'The Departure', we see a basic second class carriage. The central figures are a widow and her young son. She is wearing black to

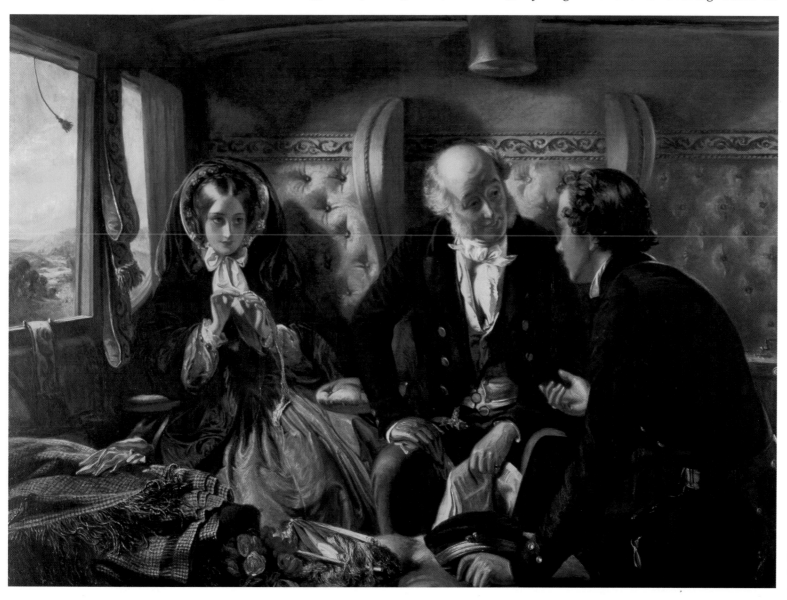

First Class: The Return
ABRAHAM SOLOMON
112 x 86 CM, OIL, 1855 (1975-8534)

denote her recent widow status and he is wearing white trousers to symbolise his innocence. His sister is sitting on the left and crying into a handkerchief. They are in a railway carriage because the mother is taking her son away to a port where he will go to sea. Being without a husband she can no longer afford to keep him. Looking through the carriage window we see a storm, which adds to the sense of upheaval and the unnatural path of events. The weather is in sympathy with the occasion. The gentleman at the back of the painting is an older sailor going back to sea looking nostalgically down on the young man and remembering his own youth.

In the second painting 'The Return' we see the same young man a few years later. He is now a successful, affluent gentleman most probably on his way home to visit his mother, again by train. However, because he has worked hard he is now in a first class carriage. The sun is shining outside the window and the general atmosphere is lively. The bright red velvet curtains and padded seats are also significant. His life is now comfortable. We can safely assume that he will marry the young lady and live happily ever after as another reward for his hard work.

The paintings are of social historical importance to the NRM because the artist Abraham Solomon (1823 - 1862) has chosen railway carriages as a medium to tell a moral story. This is that, although the young man had an unfortunate start in life, he was successful because he worked hard. These paintings tell us much about how the Victorian society saw itself and are as important for their social history content as their artistic merit. They tell a story about Victorian life and morals. The story is revealed in clues provided by the objects, costumes and facial expressions. To the educated Victorian this was easy but to us it is slightly more difficult. Every detail is contrived to give a meaning or clue and both paintings are very detailed. Abraham

Solomon lived in Gower Street in London and most probably visited the London & North Western Railway station in Euston to study and sketch the detail of the railway carriages. It is no coincidence that William Frith's painting titled 'The Railway Station' was executed at the same time.

The paintings also tell us a lot about Victorian morality. Although they seemingly give a realistic impression of contemporary society with detailed references and illusions they are infused with moral attitudes. The facts are tailored to suit Victorian morality. This was usual in this type of narrative painting. The unpleasant facets of society such as poverty, death and adultery were ignored. Although poverty is seen in 'The Departure' it is treated with sentimentality and eventually overcome. The only reason it features is because it was conquered. The Protestant work ethic was strongly promoted at the time and work, self-help, discipline and thrift were encouraged. This was how a young man became successful and famous. The actual process the youth went through, however, is left to the imagination because it would have been unpleasant and not considered to be a subject fit to paint.

Even more enlightening is the fact that 'The Return' was Abraham Solomon's second 'respectable' version of this image. In its first rendering it was called 'First Class – the meeting' and was exhibited in 1854. It depicted the young man flirting with the girl whilst her father is asleep. This was criticised and frowned upon. The art journal at the time wrote: 'It is to be regretted that so much facility should be lavished on so bald – or vulgar – a subject.' So Abraham Solomon awoke the father and placed him between the young man and the girl, thus separating them. The girl was now allowed to look at the young man! This shows how Victorian morality influenced art. However, the first image is much more

lively, believable and realistic, whilst 'The Return' seems sentimental from our modern viewpoint.

The railway carriages also reflect the attitudes of what is expected of and for different classes. The rich travelled in a secure, comfortable and friendly atmosphere, whereas the second class traveller in is an insecure, draughty and uncomfortable carriage. Interestingly, shortly after this, the railway companies abolished second class status for travellers and replaced it with first and third class, which was considered less derogatory.

Railway Stations

PENZANCE

One artist to use the railway station as a theatrical setting was Stanhope Alexander Forbes (1857 - 1947) in his 1925 study of Penzance (page 12). He not only uses the station arch as a border, but lights the whole set with the translucent Cornish light which has drawn artists to the area over the years. Forbes founded the Newlyn School of Art in Cornwall where he lived. The detail in the rolling-stock livery, railway workers and equipment and the bookshop turn this painting into a social document as well as a work of art. It was displayed in the Royal Academy in 1925.

Sir William Forbes, the artist's brother, was the general manager of the London, Brighton & South Coast Railway for several years and his uncle, James Statts Forbes, was the chairman and general manager of the South Eastern Railway.

LETCHWORTH

Another important work in the NRM collection is Letchworth Station (1912) by

Spencer Frederick Gore (1878 - 1914). This painting was bought for the collection in 1983 from a London gallery with grants from the National Arts Collection Fund, the National Heritage Memorial Fund and the Friends of the National Railway Museum.

An Australian collector had set his heart on this picture but it was not granted an export licence because it was considered to be of national importance and should be retained by a public collection in Britain. The painting was said to be 'so connected with our history and national life that its departure would be a misfortune', 'of outstanding aesthetic importance' and 'of outstanding significance for the study of a particular branch of art and history'.

This was partly because Letchworth was the first Garden City – an idea initially proposed by Ebenezer Howard in his book *Garden Cities of Tomorrow*. He was a social reformer and town-planning pioneer who combined his idealism with practical planning for the community. Letchworth was founded in 1903. It was the beginning of the implementation of the principles advocated by Howard. Letchworth was to become an example of what was a remarkable piece of social engineering and planned development. As such it provided the blueprint for the first generation of 'new towns' developed after the 1939-45 war.

Part of this vision of the self-contained town set in the countryside was the railway station and system serving as the new town's vital artery with the capital. The people were to live in an environment that offered them the happy union of town and country giving them 'new life, new hope and new civilisation'. From the beginning the Garden Cities attracted colonies of railway staff who enjoyed concessionary travel to work and could therefore afford to live in them and commute to their occupations. They also attracted many artists keen to live in such an enviroment

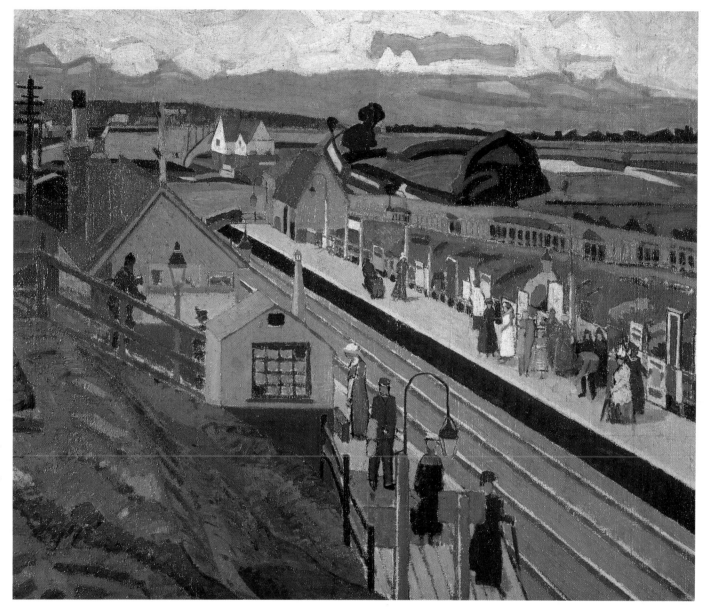

Spencer Frederick Gore was born at Epsom in Surrey. After a distinguished early career he met and formed a close friendship with Walter Sickert during the summer of 1904 and spent much of the following year at Sickert's house at Neuville, France. This gave him a deep sympathy with and understanding of the work of the French Impressionists. On his return to England he became a leading member of the Camden Town Group. This Group was one of the most important movements in painting in Britain in the years before the First World War. It was noted for its innovations in style and colour and its concern with the subjects of everyday life. Gore produced his major work during a short period of only eight years from 1906 until his early death in 1914. Much of his time was spent on theatrical scenes but his later works, and particularly his Letchworth paintings, cover a wider field of subjects in the Post-Impressionist style.

Letchworth Station
SPENCER FREDERICK GORE
96 x 83 CM, OIL, 1912 (1983-8607)

York Station
'F. Moore'
33.5 x 22cm, painted photograph, c 1910 (1994-8520)

and white photographs and F Moore did not really exist. Whilst evidence of how these prolific works were actually produced is inconclusive, it is believed that there was a studio of photograph printers based in London who over-painted photographic prints and signed each one 'F Moore'. They are important to the National Railway Museum because we know that, as photographs, they are accurate representations of the railway at the time. They are contemporary reproductions of the working railway. However, the particular painting of York station reproduced here is also beautifully composed and aesthetically pleasing. The only problem with these works, of which the National Railway Museum has 141 examples, is one of conservation. The chemical reaction between the photographic process and oil paint means that the picture slowly destroys itself, although this is minimised by low temperature and darkness.

Railway poster art

The National Railway Museum has over 8,000 railway posters in its collection and these are regularly seen in publications, web pages and exhibitions. A lesser-known fact is that the NRM also holds a major collection of original artwork for the posters. Generally, the artists were given pretty much a free hand to design the posters. These were usually full size, either 635 x 1016mm (25 x 40in) or 1016 x 1270mm (40 x 50in) in poster paint, oil or watercolour. Whilst they were produced very quickly and not intended to be seen as works of art but merely a means to an end, some of them are artistically interesting.

TOM PURVIS

One of the most famous poster artists

Gore stayed in Letchworth with friends in 1912 and produced several paintings of the area including 'Harold Gilman's house' (H G was another Camden Town artist), 'At 100 Wilbury Road, Letchworth', 'The Road, Letchworth' (looking east down Wilbury Road) and 'The Beanfield, Letchworth'. The Museum's painting, which is perhaps the most striking, shows Letchworth station from a high viewpoint beside the pedestrian bridge over the railway. The bright colours in Cubist style symbolise the optimism of the new Garden City, which is also depicted in the staunchly upright citizens. The importance of the railway to this new town is emphasised by it being the central attraction. The eye

is drawn to the line, which is symbolically seen as its central artery.

An interesting fact about this painting is that it was lost for many years and was only re-discovered by chance in Portobello Road, unstretched and lying on the pavement with the price chalked across the canvas.

THE ANONYMOUS 'F MOORE'

An introduction to the National Railway Museum Pictorial Collection would not be complete without mentioning the works of the anonymous artist 'F Moore'. They do not fit into any school or historic category because they are not really paintings at all. They are painted black

was Tom Purvis (1888 - 1957). At the time of writing, the National Railway Museum has 87 of his posters in its collections and two original designs. One of these was produced for the London & North Eastern Railway in 1931. Titled 'East Coast Joys – No 3 Safe Sands', it is one of a series of six posters that form a continual coastline showing six of the pleasures that can be enjoyed at the seaside. The others are walking, sun bathing, sea bathing, sea fishing and sea sports.

Tom Purvis was the first commercial British poster designer. He had a definite attitude to commercial art. His ideas shunned those of traditional fine artists, and the fashionable art world rejected his work. He worked for the LNER under contract from 1927, firstly with advertising manager William Teasdale and later under Cecil Dandrige.

The LNER employed five of the leading poster designers of the day, known to them as 'The Big Five', the others being Fred Taylor, Frank Newbould, Frank H Mason and Austin Cooper. They agreed to confine their railway poster work to the LNER with the exception of the London Underground. In Purvis's case he was free to continue to do line work for LMS press advertisements. A LNER totem designed by Purvis was adopted for use on posters in 1927. His contract for the years 1927 to 1929 guaranteed him commissions to the value of £450 per annum.

In all his work Purvis was insistent on the closest co-operation with the client before a drawing was started. He would talk over the client's wishes with extreme care and thoroughness and then patiently search for the best method of illustrating the 'personality of the product' and the purpose of the campaign. He never allowed technique or pictorial mannerism to get between the product and the public.

His fashion designs for Aquascutum were used extensively in advertisements, booklets, catalogues and sales leaflets and were extremely successful. There

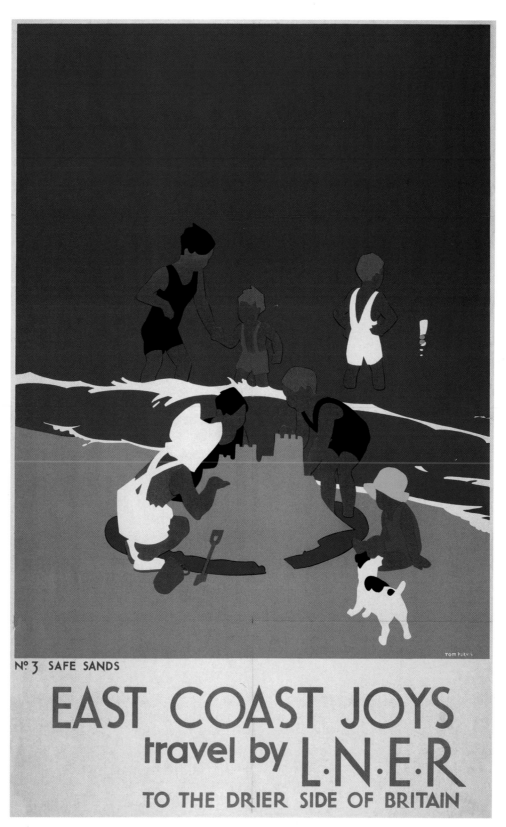

East Coast Joys: No 3, Safe Sands
TOM PURVIS
63.5 x 101.5 CM, POSTER PRINT, 1931
(1978-1416)

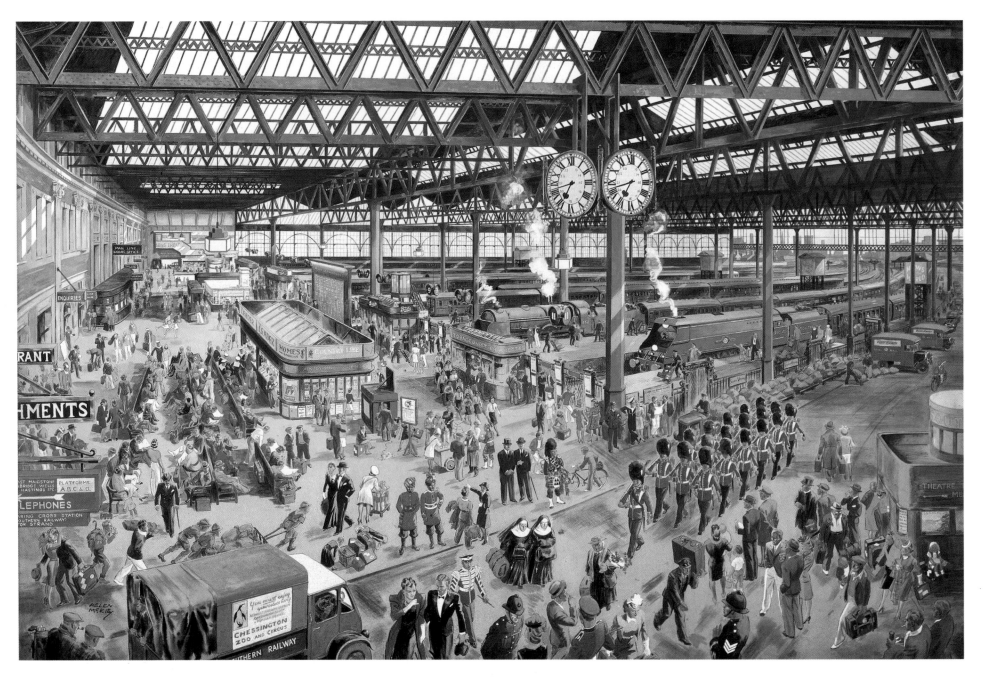

Waterloo Station: Peace
HELEN MCKIE
127 x 101.5 CM, WATERCOLOUR, 1948
(2002-7770)

was a rapid increase in postal enquiries after he was commissioned to illustrate their sales literature and these advertisements were frequently cut out and sent in with the enquiry from both home and overseas.

Tom Purvis brought respectability to commercial art. He said: 'I loathe the word artist. Personally I am proud of being called a Master Craftsman.' In 1930 he was among a group who banded together to form the Society of Industrial Artists, which brought economic pressure on industry to improve standards for training and to win better scope for employment for commercial artists. He became one of the first eleven Royal Designers for

Industry in 1936 and in 1939 was elected Master of the RDI Faculty.

HELEN MCKIE

The other poster designer who cannot be left out is Helen McKie (d 1957). In 1947 she produced two posters of Waterloo station to celebrate its 1948 centenary.

The original watercolours for these posters are part of the National Railway Museum's collection as are the initial pencil sketches and worked-up colour sketches of individual studies.

The artist, Helen Madeleine McKie, carried out a wide range of work for the Southern Railway. In addition to both writing and illustrating booklets and other publicity material, she designed uniforms and was initially employed because the male artists were occupied with war work. (In fact, had it not been for the war, these posters and the accompanying sketches would probably not have been produced.)

An unusual characteristic of this artist's work is her meticulous attention to detail, and there is no doubt that she must have spent a considerable length of time at Waterloo station studying the characters and uniforms. Other watercolour studies of Waterloo include a female pick-and-shovel gang (c1940), porters (1942), an air raid porter (c1940), the milk bar (1940), a roof spotter (1940), a look-out man during an air raid (1940),

Waterloo Station: War
HELEN McKIE
127 x 101.5 CM, WATERCOLOUR, 1948
(1975 - 8528)

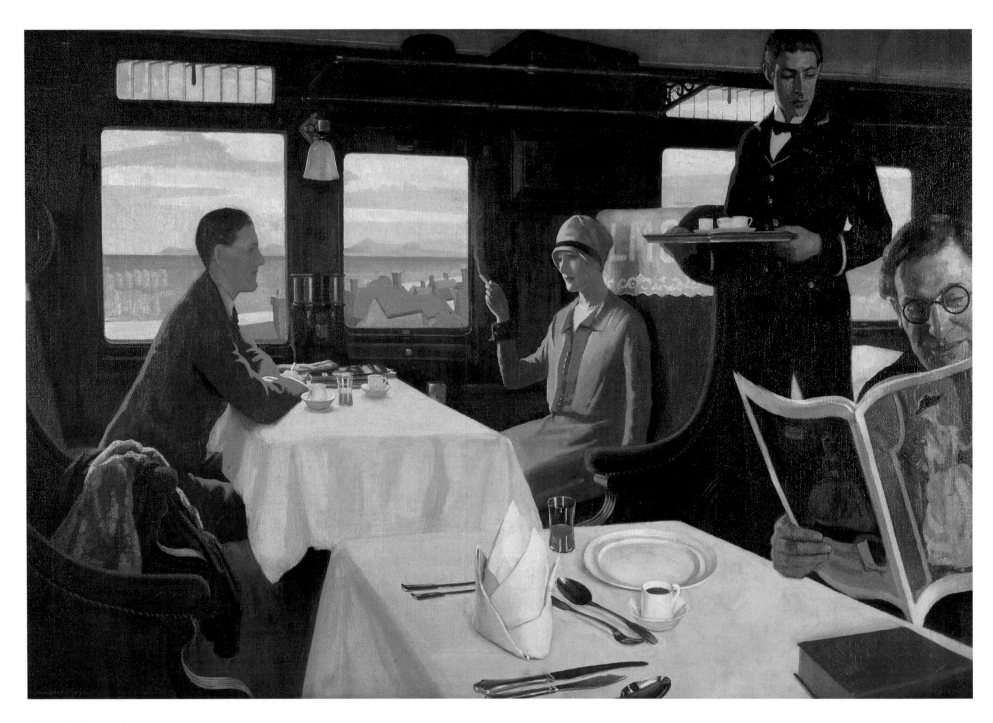

The Refreshment Car
LEONARD CAMPBELL TAYLOR
102 x 78 CM, GOUACHE, C1935
(1976-9309)

a shoe black and the Belgian nuns in the blackout (1940). All these have been incorporated into the final posters.

Note the use of camouflage in the wartime version. The roof is blacked out and most of the soldiers' uniforms are in khaki. The van, which was advertising the delights of Chessington zoo and circus, is covered and even the locomotives are in disguise. The war seems to make life dreary both psychologically and literally. Notice the mail vans in the middle right-hand side of the paintings. In peace time they urge people to 'post early' but in wartime the message is 'Be Brief'.

There are also some delightful touches. The war has not stopped the romance between the couple at the bottom left-hand side of the painting or the badly behaved poodle near the centre kiosk. The golfers in the bottom left corner have put away their clubs and exchanged them for kit bags. Also, in the wartime poster, notice the lights shining on the clock face (because they would otherwise not be seen in the blackout) and the sign to the passenger ARP shelter at the bottom of the clock column.

These posters give a wonderful insight into the social effects of wartime on everyday life and in the running of the railways. As they were commissioned in 1948, they are also a celebration of the pleasantries of life that could and did resume after the war. They also illustrate how the railways carried on despite the war and how they contributed to war effort.

LEONARD CAMPBELL TAYLOR

After studying at the Royal Academy, Leonard Campbell Taylor (1874 - 1969) illustrated popular magazines and designed for the London, Midland and Scottish Railway. Influenced by John Everett Millais he illustrated contemporary middle-class life. In the poster opposite we see a couple dining in the restaurant car whilst admiring the coastal scenery.

Modern railway paintings

TERENCE CUNEO

The National Railway Museum also collects modern railway paintings that add to the understanding of other objects in the collection or tell us more about contemporary railway history. Particularly of note are two historic paintings by Terence Cuneo (1907 - 1996). One of these is 'The opening of the Stockton & Darlington Railway', painted in 1949, which is influenced by the ink sketch of the actual event, drawn in 1825 by the artist John Dobbin. The other is 'The First Day of Steam', which shows Richard Trevithick's *Penydarren* locomotive with Francis Trevithick's locomotive, *Cornwall*, painted in 1954.

Terence Tennyson Cuneo is probably the most well-known railway artist and a

The opening of the Stockton & Darlington Railway
TERENCE CUNEO
610 x 305 CM, OIL, 1949 (1975-8500)

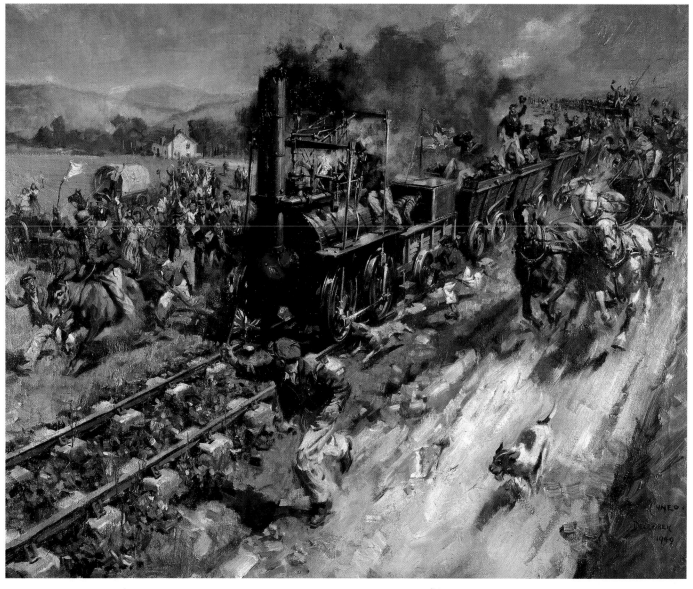

Fellow of the Guild of Railway Artists. He was born on 1 November 1907 in an Edwardian house in Shepherds Bush, London, the only child of Cyrus Cincinnati Cuneo (1879 - 1916), painter and magazine illustrator, and his wife, Nell, who was also an artist.

His father was an Italian born in the United States who was related to Garibaldi and died of blood poisoning when Terence Cuneo was only nine years old. His mother was related to the poet Alfred Tennyson. Known as Terry, he went to school at St Michael's College in Dawlish and the Sutton Valence Public School in Kent. At the age of seventeen he spent two years at Chelsea Polytechnic and then followed in his father's footsteps as a commercial illustrator working on magazines like *The Boy's Own Paper*, *The Magnet* and

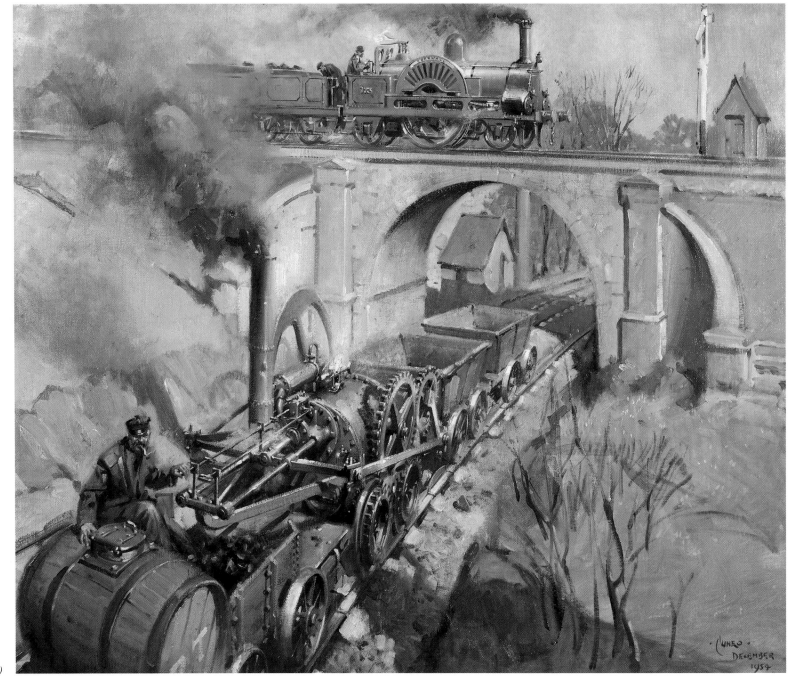

 THE DAY BEGINS

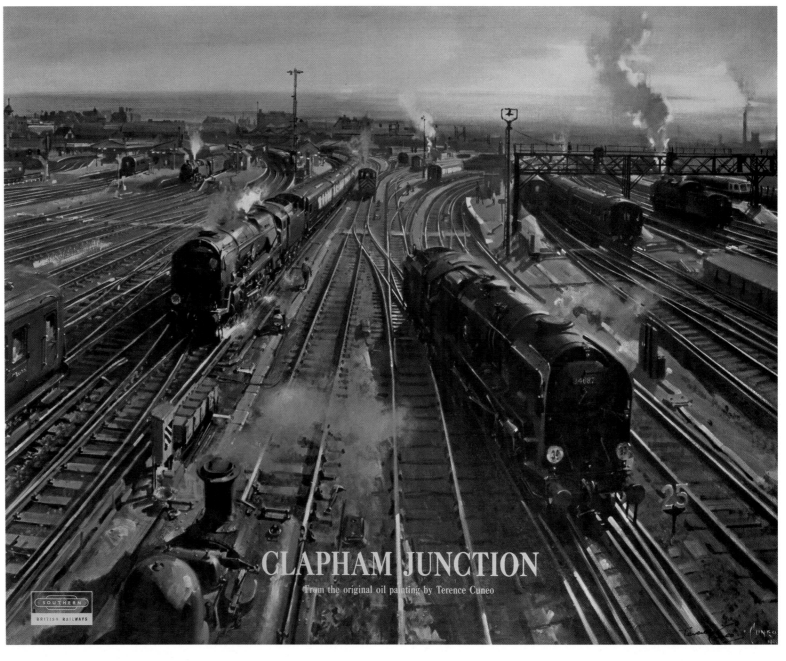

CLAPHAM JUNCTION

From the original oil painting by Terence Cuneo

Christian Herald. In 1931 he joined the London Sketch Club and met his wife-to-be Catherine Munro, whom he married in 1934. In 1940 he became the *Illustrated London News* war artist and illustrated the book *How to Draw Tanks*.

After the war the publicity manager of the London & North Eastern Railway commissioned Cuneo's first poster design 'Giants Refreshed' showing locomotives in Doncaster Railway Works. This was the beginning of his railway poster career which was to last for the next fifty years.

As an official war artist, Cuneo did many drawings and paintings for the Ministry of Information. He was also a renowned portrait painter. Among those he painted are King Hussein of Jordan, Field Marshal Montgomery, former Prime Minister Edward Heath and Queen Elizabeth. Cuneo was official artist at the Coronation in 1953 and painted several other pictures of the royal family. He was the first president of the Society of Equestrian Artists and did many other industrial and military paintings. His

largest painting (20ft x 10ft) was of the concourse of Waterloo station and was commissioned by the Science Museum in 1967.

Cuneo is popularly known for putting a mouse in his paintings. The first appeared in 1953 and subsequently in most of his work. His autobiography was entitled *The Mouse and his Master*. He was an insatiable traveller and had a mischievous sense of humour. He was awarded both the OBE (1987) and the CVO (1994). He died in Esher, Surrey, on 3 January 1996. A retrospective exhibition of his railway art was held at the National Railway Museum in January 1997. He painted up to his death and his last, unfinished painting, left in his studio, was of the Channel Tunnel.

Among other works of Cuneo's in the National Railway Museum collection are his first original poster design for the London, Midland & Scottish Railway 'The Day Begins' (1946), and the British Railways (Southern Region) poster design 'Clapham Junction' (1961).

CUTHBERT HAMILTON ELLIS

Also in the collection are the original oil paintings for the historical carriage print series produced in 1951 by Cuthbert Hamilton Ellis (1909 - 1987). All the prints are titled 'Travel in….' and cover the period from 1835 to 1920. There are twenty-four in all and they were commissioned by the publicity officer of British Railways (London Midland Region) George Dow. Although they are stiff and dated in style, they are probably the best known of all carriage prints.

OIL PAINTINGS BY OTHER ARTISTS

Leslie Carr, who painted an oil of the Leader Class locomotive No. 36001, was a prolific poster designer who worked for several railway companies. The locomotive was designed for the Southern Railway by O.V.S. Bulleid in 1949. The

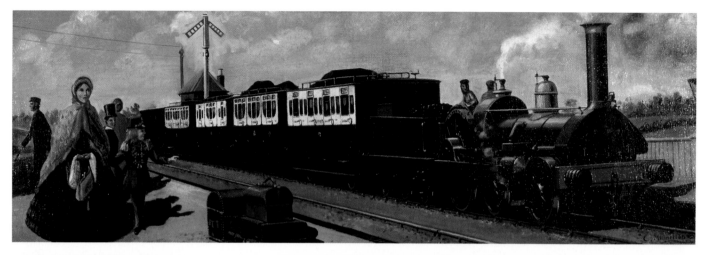

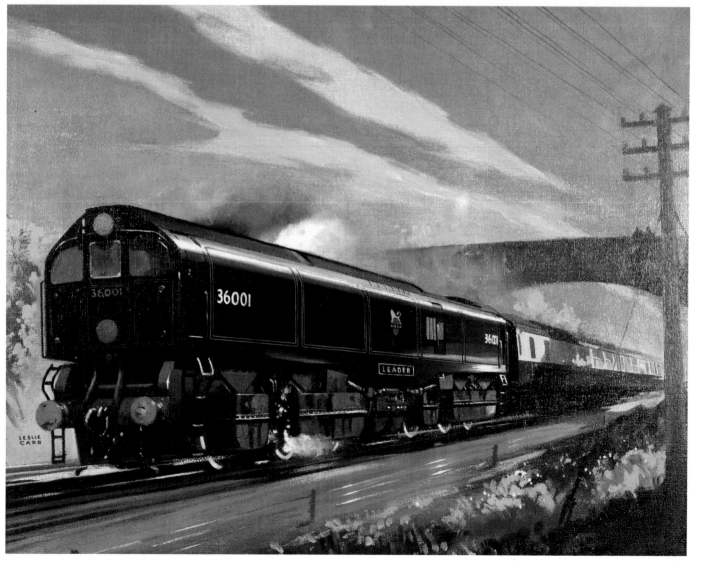

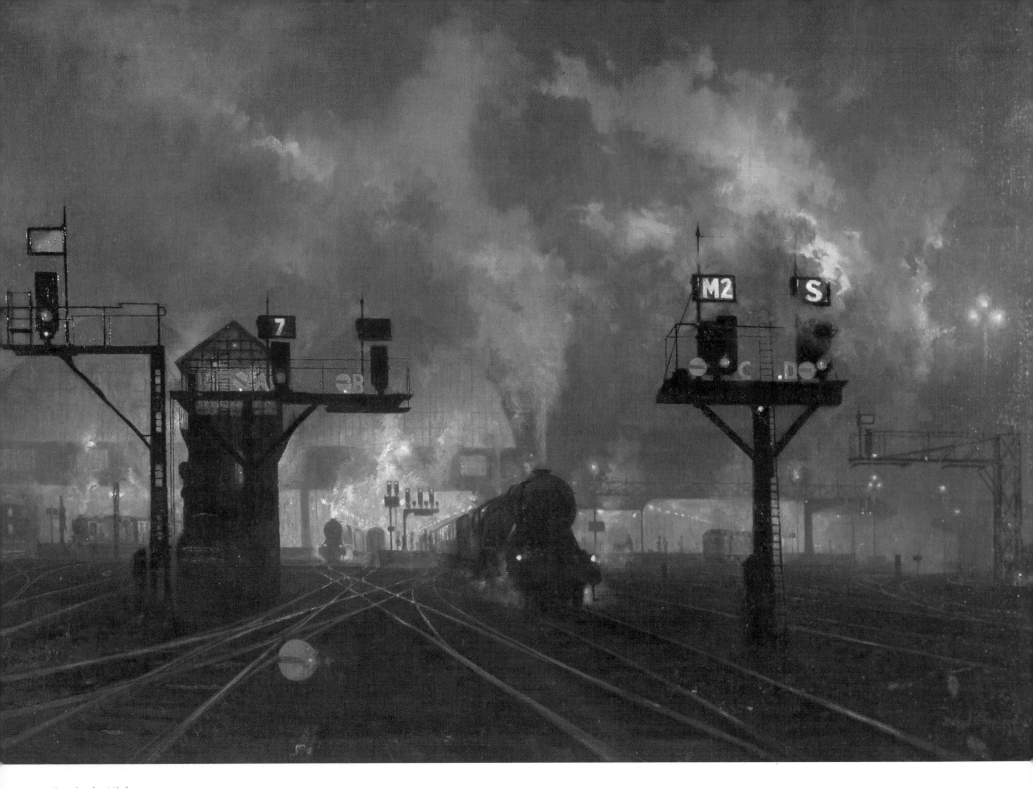

Service by Night
DAVID SHEPHERD
99 x 68 CM, OIL, 1955 (1979-7988)

design was a culmination of a lifetime of ideas, which changed the conventional layout of the locomotive to accommodate the advantages of diesel and electric engines. However, it was not a success. Leslie Carr was most likely commissioned shortly after it was finished.

David Shepherd (b 1931), who is better known for his widely reproduced pictures of wild animals, is a railway enthusiast. His artwork for the British Railways poster 'Service by Night' (1955) showing King's Cross station is in the National Railway Museum's collection. The painting was not commissioned. The artist took it, with some others, around various regional offices of BR hoping they would buy. It was bought by the Eastern Region for £60. The actual sketches were made by torchlight at King's Cross just outside the tunnel where all the tracks come into the station. Shepherd was so proud to see his work in print that he drove to several railway stations hoping to see the poster.

The final painting by Roy Wilson shows the ceremony to launch the Bullet train or Shinkansen, which was given to the National Railway Museum in June 2001 by Japan Railways West. The painting is called 'Welcome to Japan's Shinkansen' and shows the traditional Japanese drummers or Taiko in the NRM's Great Hall with *Mallard* in the distance and the Eurostar to the right. This modern painting captures the essence of the NRM and its aims (which are to care for the collections, inspire the public, stimulate research and enhance the visitor experience). The pictorial collection is a small but vital part of this work; the collection will hopefully continue to grow for the next 200 years.

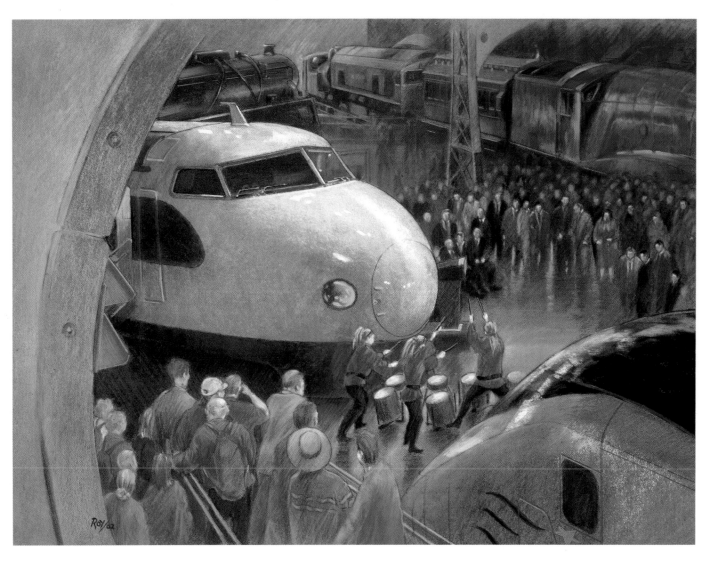

Welcome to Japan's Shinkansen
Roy Wilson
45 x 35 cm, pastel, 2001
(Collection of Mrs Janice Senior)

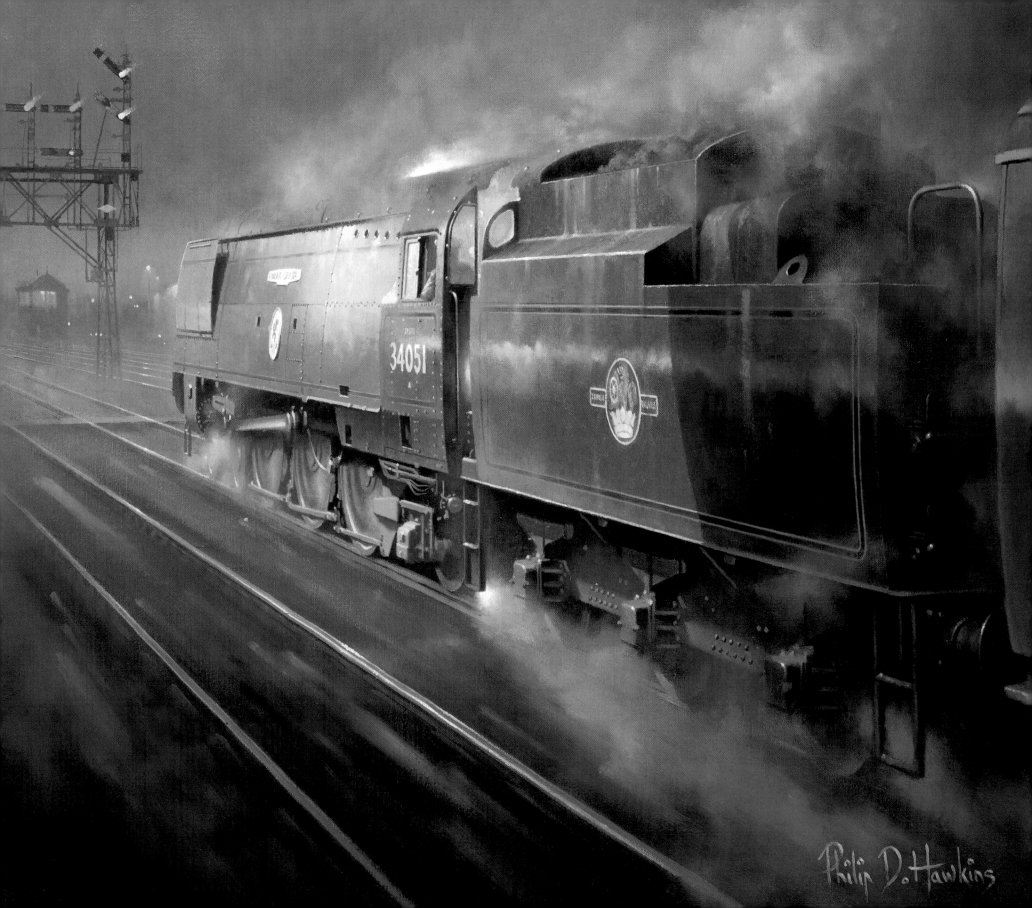

34051

Philip D. Hawkins

Along Artistic Lines
PAINTINGS BY THE GUILD OF RAILWAY ARTISTS

OPPOSITE PAGE
Into the Night
PHILIP D HAWKINS
51 x 41 CM, OIL, 2003

Bulleid Pacific No. 34051
Winston Churchill is shown
thundering through
Basingstoke with a West of
England to Waterloo express
during the early 1960s
No. 34051 (as 21C151) was
built at Brighton Works and
delivered into traffic during
December 1946. Its claim to
fame was that it hauled
Winston Churchill's funeral
train in 1965. Withdrawal from
service came in 1965 and the
locomotive is now preserved as
part of the National Collection.

THIS PAGE
*Peppercorn Pacific; Castle on
the Table; Lanky Flyer*
PHILIP D HAWKINS
11 x 13 CM, PENCIL

Formed in 1979 with some thirty member artists, the Guild set out to forge for the first time a corporate link and identity for artists depicting the railway. Its members have followed the path of artists beforehand in the portrayal of railway by depicting the past, the present and even sometimes the future.

The membership of the Guild includes both the full-time artists and those who undertake their depictions in their leisure time. The mediums used cover a wide range. Oils, watercolour and acrylics tend to dominate but other mediums such and pen and ink, pencil, crayon and pastel are also used. The Guild is also now seeing, from some members, work being carried out using the new media of this new century – the computer – and examples of this are contained within these pages. The Guild membership spreads the length and breadth of the United Kingdom, together with some members residing beyond these shores in South Africa and the American continent.

The Guild normally mounts two exhibitions a year in spring and in autumn for its members to exhibit their work. Its spring exhibitions have been mounted in many locations around the United Kingdom and its autumn exhibition 'Railart' has more latterly been located either at the Kidderminster Railway Museum, 'Steam' at Swindon or the National Railway Museum at York.

*Frank Hodges, Chief Executive
Officer, Guild of Railway Artists*

Museum Pilot
JULIE WEST
61 x 66 CM, OIL, 2002

This is a British Railways
Drewry 0-6-0 diesel mechani-
cal shunter in the National
Railway Museum car park. It is
used to shunt many of the
more famous locomotives
around the Museum. It was
built at Doncaster in 1960 and
preserved in 1976.

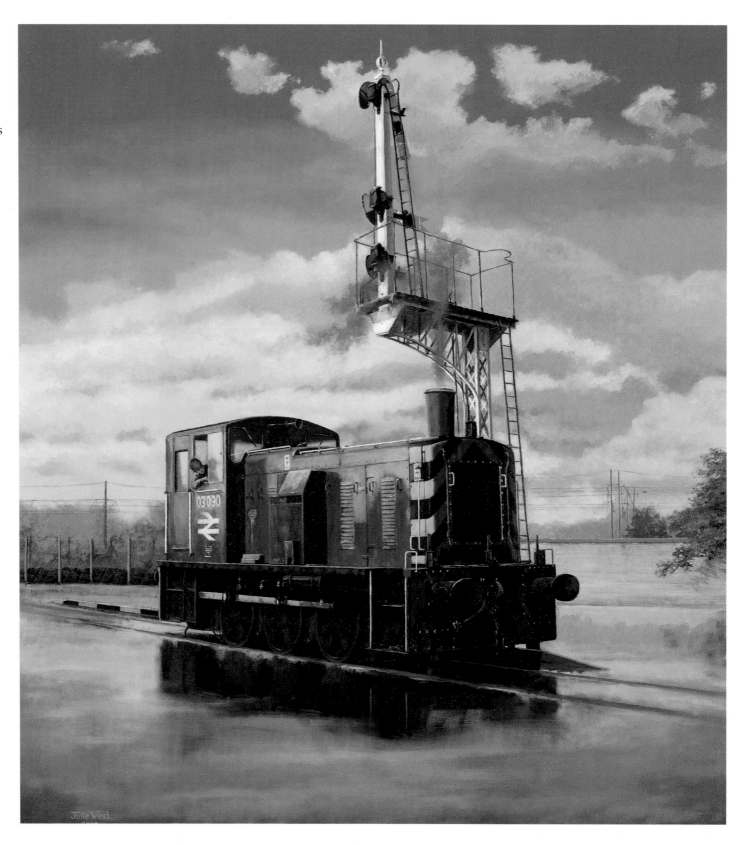

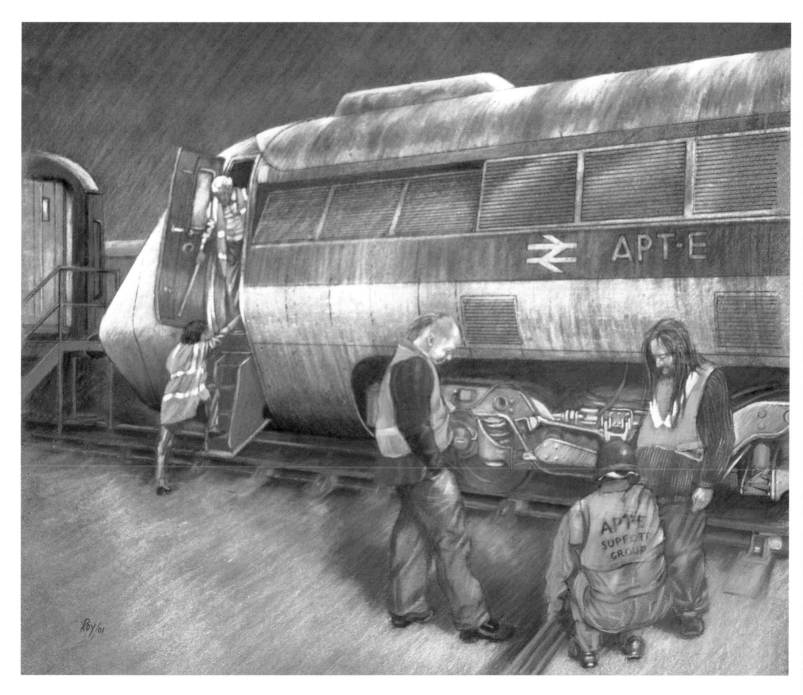

National Railway Museum,
York. APT-E Restoration Survey
– Britain's Pioneering Advanced
Experimental Passenger Train
ROY WILSON
37 x 34 CM, PASTEL, 2001

The National Railway Museum is currently restoring the APT-E to its former glory. Whilst this project is managed by the NRM, it relies heavily on volunteers to do the actual work. The support group meets every fourth Saturday and hopes to finish the cosmetic restoration, both inside and out, for the opening of the Shildon Village Railway Centre in 2004. This painting was produced in the very early stages of restoration and verdigris can be seen on the carriage roof. The preliminary figure sketches are also shown.

The artist can be seen in the cab and the author climbing into it, along with three of the volunteers.

Four preliminary studies for
APT-E painting
ROY WILSON
14 x 21 CM, MIXED MEDIIUMS, 2001

GWR – Marking-out Table
JOHN WIGSTON
55 X 38 CM, WATERCOLOUR, 2002

This marking-out table was built at Swindon in 1878 and used at the works for technical precision work on locomotive parts. Made from cast iron, it was heated from below to give a standard temperature of 68 degrees Fahrenheit. It is now used by the National Railway Museum workshop for restoration work. Here we see parts from the Super 'D' motion. The Super 'D' is currently being restored to working order in the NRM workshops.

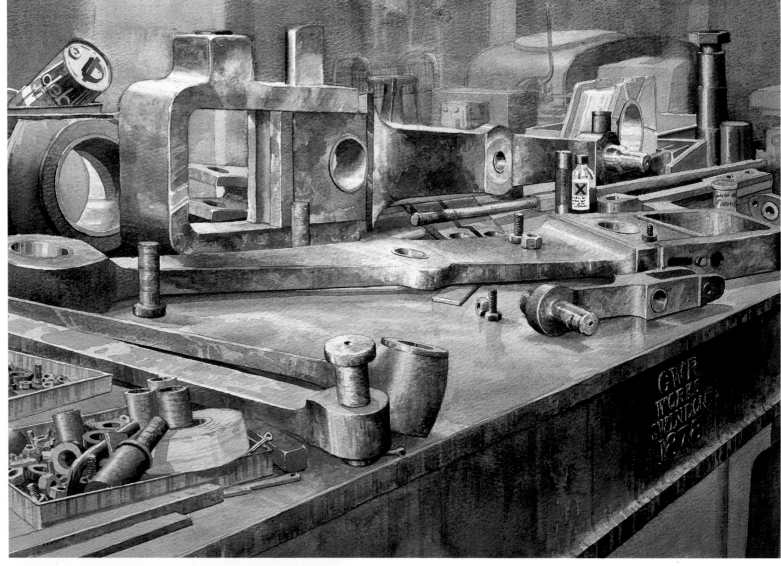

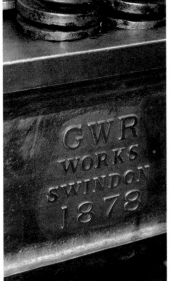

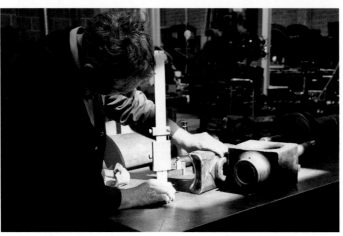

Rodney Lytton, one of the National Railway Museum's engineers, uses a Vernier height gauge to mark out an axlebox brass bearing for the tender of *City of Truro* during a restoration project.

The table, built in 1878 at Swindon Works, has a surface area of 71.36 square feet and is at a working height of 38 inches. The table weighs seven tons. It has heavy skirting on all four sides and diagonal webbing to ensure rigidity and accurate marking out. It also has a network of pipes underneath the surface that was connected to a steam heating system to maintain a consistent temperature, again to ensure accuracy.

Every day at 11.30am and 3.30pm the turntable is operated in the Great Hall of the National Railway Museum by one of the museum's team of Explainers. It gathers crowds and is a spectacular event. In this painting Tracey Parkinson, one of the Explainers, turns the table, which bears the *City of Truro* locomotive.

The artist was on the top of a gantry whilst taking preparatory photographs and making preliminary sketches for this painting (hence the angle). Also, there is another member of the Guild of Railway Artists in the bottom right-hand corner. This is John Austin, who happened to be visiting the Museum on the same day as the artist was making the sketches. The lady with the red coat and grey hair in the centre of the painting is Dorothy, the artist's wife.

National Railway Museum, York. Great Hall – The Daily Turntable Demonstration
ROY WILSON
50 x 29 cm, pastel, 2000
(NATIONAL COLLECTION)

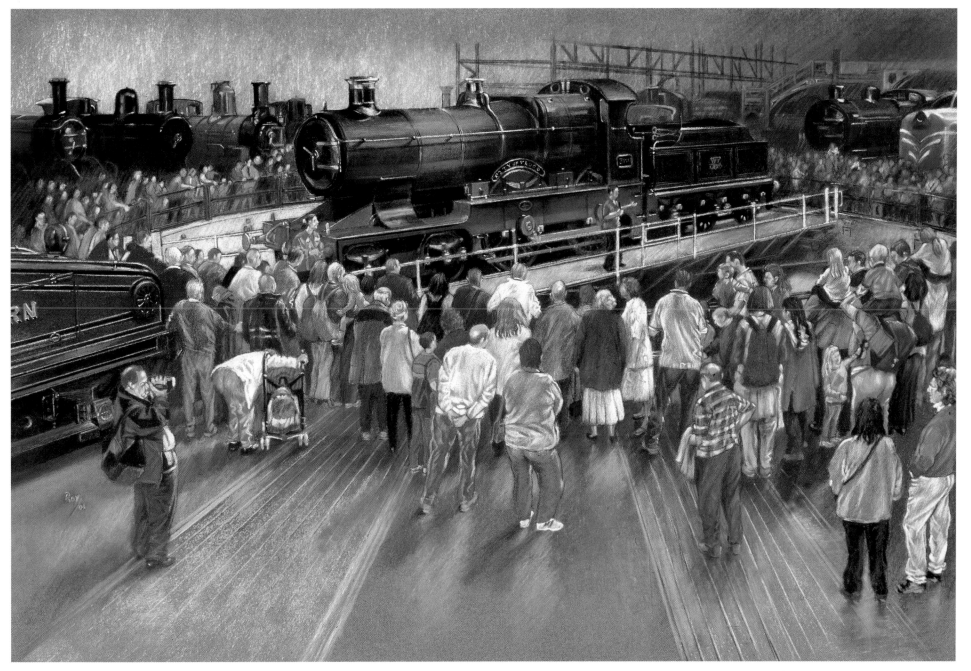

Wheels within Wheels
MIKE BOOTH
36 X 45 CM, OIL ON CANVAS, 2002

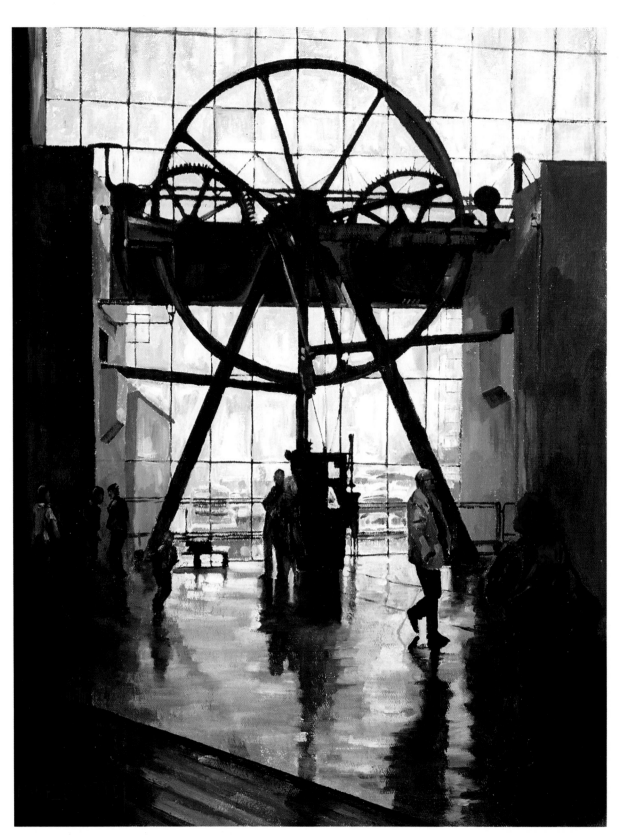

This is the Stanhope & Tyne Railway stationary winding engine in the National Railway Museum's Great Hall. This engine drove a winding drum carrying a long rope used to haul wagons of limestone up the steep Weatherhill incline to the blast furnaces at Consett and elsewhere. It was built in 1833 and used until 1919.

The East Coast main line runs alongside the National Railway Museum, and two contemporary power units can be seen passing the Museum, so the present meets the past. With his usual feel for texture, the artist draws the viewer to the reflection on the floor of the Museum and contrasts it with the wooden running boards. The light shining through the windows at the back of the wheel inspired him, bouncing off the floor and silhouetting the people and the engine.

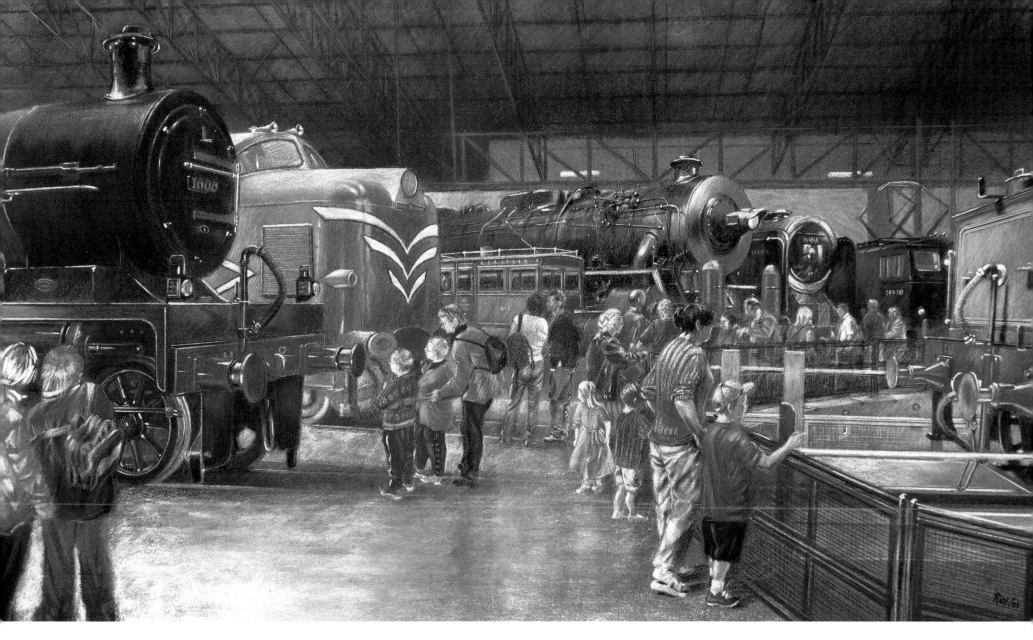

This captures the essence of a typical day at the National Railway Museum. Families wander around the locomotives in the Great Hall with excitement and reverence. Here we see the Midland Compound, Deltic and Chinese locomotives on the left, with the tender of *City of Truro* on the turntable. The artist, now retired, spends much of his time at the National Railway Museum, which results in acutely accurate paintings of the locomotives and charming observations of visitors. The lady on the left of centre is the artist's niece.

National Railway Museum, York. The Turntable
ROY WILSON
59 x 31 CM, PASTEL, 2001

RIGHT
Roy Wilson working on the military locomotive, the Robinson 04 class, which was used extensively in the 1914–18 war. He is using pastels.

BELOW
National Railway Museum, York. The New Workshop – First Week of Operation
ROY WILSON
62 X 40 CM, PASTEL, 1999

The National Railway Museum has a behind-the-scenes team of highly skilled workshop technicians who do everything from hanging exhibitions to restoring locomotives. The new open-plan workshop offers visitors a rare opportunity to watch the Museum's craftsmen conserve the historic railway vehicles in their care. Here we see the *Duchess of Hamilton*, *City of Truro* and the London & North Western Railway 'Super D' locomotives being overhauled.

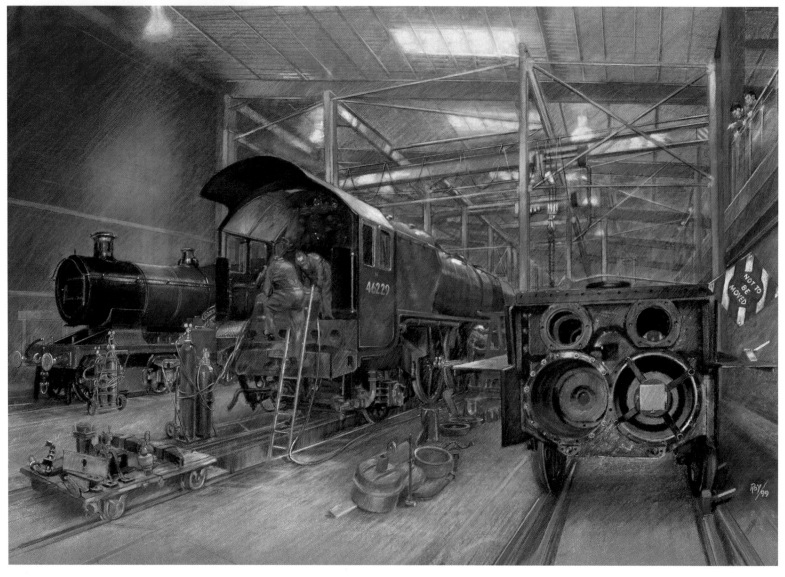

'Brief Encounter' is the name of the National Railway Museum's restaurant, after the film of the same title. The late Keeper of the NRM, Dr John Coiley, chose the name.

The film is a classic romantic drama set in 1945, before the end of the war, in and around the fictional Milford railway station. A married woman, Laura (Celia Johnson), meets Alec, a doctor (Trevor Howard), in the station's waiting room. Alec kindly removes a piece of grit from her eye, then leaves to catch his train. During her following shopping trips to Milford, Laura meets Alec again and a friendship begins to develop. Soon the meetings become a fixed arrangement. As their relationship grows, both Alec and Laura find themselves falling in love. They begin to visit the cinema and the surrounding area during their short spells of time together – then finally they exchange kisses at the railway station to confirm their feelings. After much hesitation,

Laura gives in to Alec's pleas and joins him at his friend Stephen's apartment, thus embarking on a passionate extramarital affair. However, Stephen returns unexpectedly to his flat and a guilt-ridden Laura runs away. Alec later catches up with her and breaks the news that he is soon to leave the country after receiving a job offer from his brother in South Africa – he asks that she meet him the next week for a final rendezvous. They meet the following Thursday and enjoy a day in the country, a romantic final visit to the tea room – before Laura finally says a last goodbye to Alec as his train departs from the railway station.

Here the artist captures the atmosphere of the National Railway Museum's South Hall. It has the feel of an Edwardian station, and the visitors can dine alongside the exhibits. The lighting, people, atmosphere and warmth inspired him.

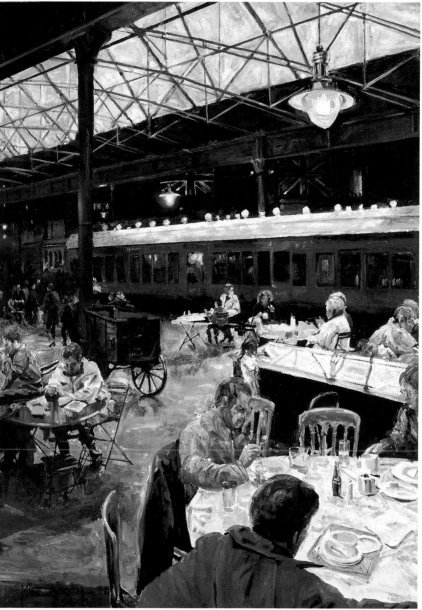

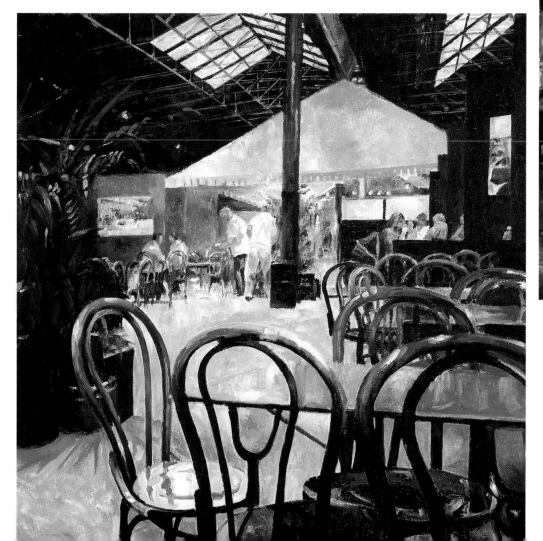

Brief Encounter
MIKE BOOTH
50 x 71 CM AND 37 x 39 CM, OIL ON CANVAS BOARD, 2002

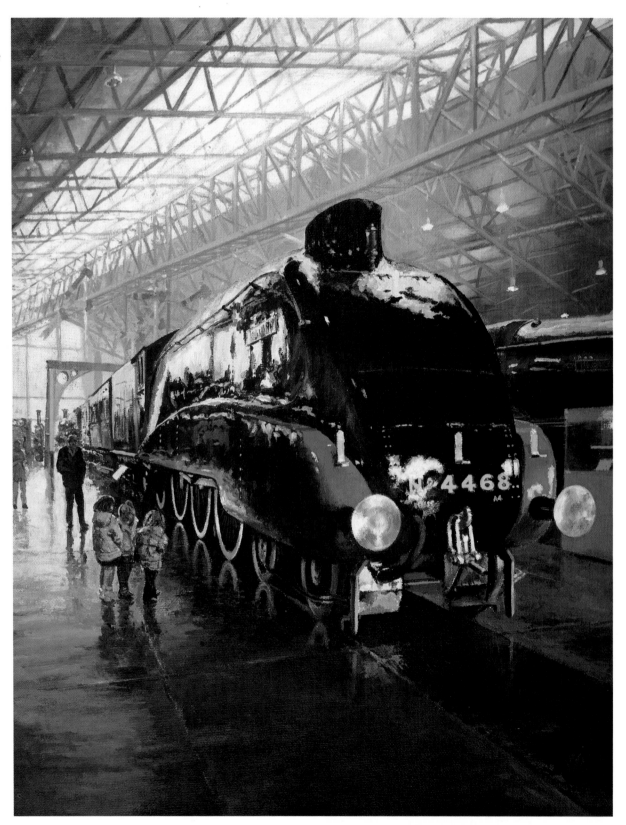

Sir Nigel's Vision
STEPHEN WARNES
41 x 51 cm, acrylic, 2002

Mallard is the National Railway Museum's most popular locomotive. This impressionistic painting reflects its iconic status. The use of light and reflection highlights its magnificence and power.

Mallard is well known because it was the fastest steam locomotive. Its record run on 3 July 1938 was made with a six-car streamline set plus a dynamometer car. Mallard was chosen because it was one of the four engines with Kylchap exhaust at that time. These engines had better running qualities and higher speed than standard A4. The run started from Barkston triangle, running southbound. *Mallard* pulled the train over Stoke Summit at 75 mph, then accelerated downgrade at a gradient of 1:178 to 1:200 over six miles to attain a speed of 114 mph. It eventually reached a speed of 125 mph, with a peak at 126 mph for a few seconds.

Mallard was withdrawn from service in 1963. To celebrate the fiftieth anniversary of its speed record in 1988, the locomotive was restored to working condition and worked on special trains on British Railways mainline routes between 1986 and 1989.

Coppernob
Ian Cryer
50 x 56 cm, oil on canvas, 2001

This is the oldest locomotive with inside cylinders in the National Railway Museum. 0-4-0 No. 3 was built for the Furness Railway in 1846 to haul iron ore and slate from local mines and quarries to the sea at Barrow-in-Furness. It was designed by Edward Bury with a copper dome over the firebox and the end of the boiler; as a result it was nicknamed 'Coppernob'. It was withdrawn in 1898. The Furness Railway company was formed on 23 May 1844 and became part of the London, Midland & Scottish Railway on 1 January 1923. Note the play on light and reflective surfaces.

In Line for Preservation
IAN CRYER
50 x 40 cm, oil on canvas, 2002

This old freight rolling stock has become a work of art in itself. Nature has taken over. These are housed at the back of the National Railway Museum warehouse and are soon to go to the new railway village at Shildon.

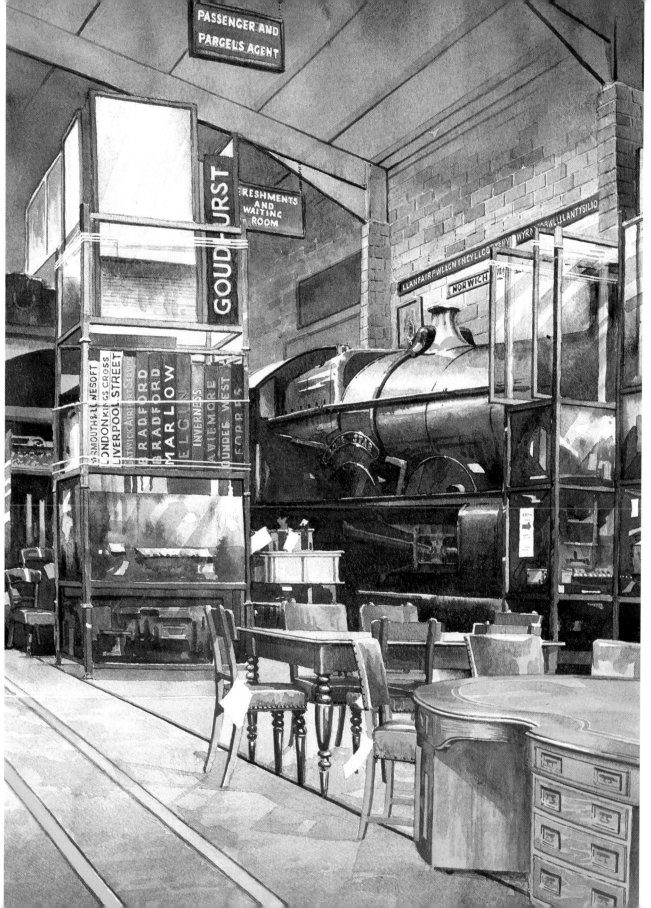

The Warehouse – a Star in the Collection
JOHN WIGSTON
34 x 52 CM, WATERCOLOUR, 2002

The warehouse is a new concept of open storage devised by the collections' curator, David Wright. It was mainly responsible for the National Railway Museum winning the prestigious award, European Museum of the Year 2001, and is very popular with visitors. It is an Aladdin's cave packed to the rafters with over 5000 objects – national treasures which have never before been on open display. Each one has its inventory number attached so that visitors can look up more information in the ledgers available. Here the artist has captured the essence of open storage. We see desks, chairs, destination boards, signs, models and a full-size locomotive.

OPPOSITE

Stanier 'Black 5' 4-6-0 No. 45000 crossing Croal Viaduct in Lancashire
JOHN AUSTIN
100 x 76 CM, OIL, 2002

The 'Black 5' (or Class 5, mixed-traffic) loco-motive was designed by William Stanier when he was the Chief Mechanical Engineer of the LMS. The locomotives were versatile and reli-able, which made them very suitable for mixed traffic. Here we see one pulling a heavy freight train going over Croal Road viaduct in Bolton.

ACE o'er Taw
PETER INSOLE
36 x 53 CM, CRAYON, 2003

The Atlantic Coast Express, hauled by a Bulleid Light Pacific, travelling over the Taw viaduct at Barnstaple. This viaduct no longer exists, although traces of the struc-ture can be seen at low water.

An example of this class of locomotive, No. 34051 *Winston Churchill*, can be seen at the National Railway Museum. It is a Southern Railway Battle of Britain class built in 1945 and designed by Oliver Bulleid.

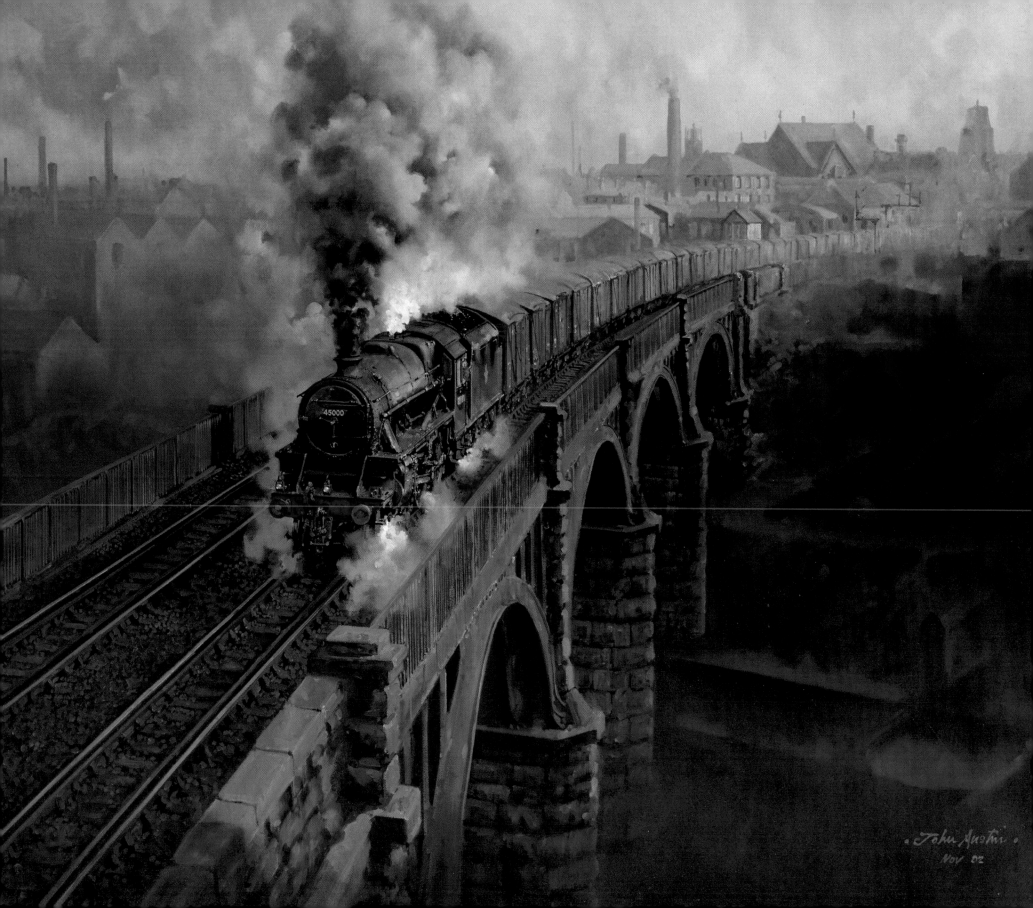

John Austin
Nov 02

Winter on the Settle and Carlisle
CHRIS D HOLLAND
21 x 15 CM, GOUACHE, 2002

A Midland compound in black livery pulls a rake of London, Midland & Scottish Railway coaches across Arten Gill viaduct in Dentdale on the Settle and Carlisle railway in wintertime in the 1930s.

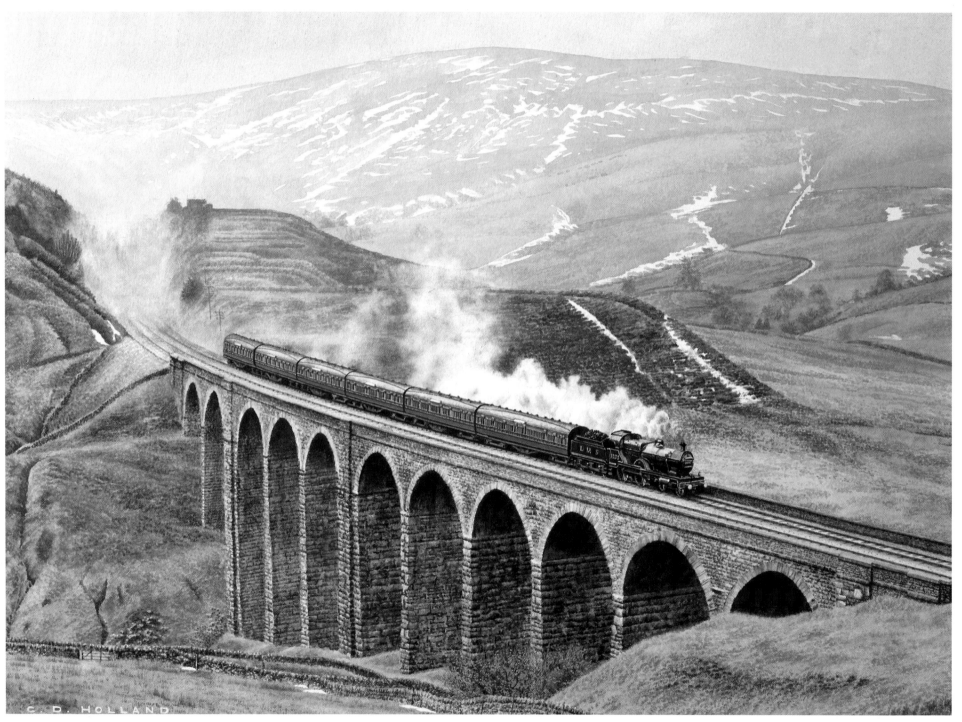

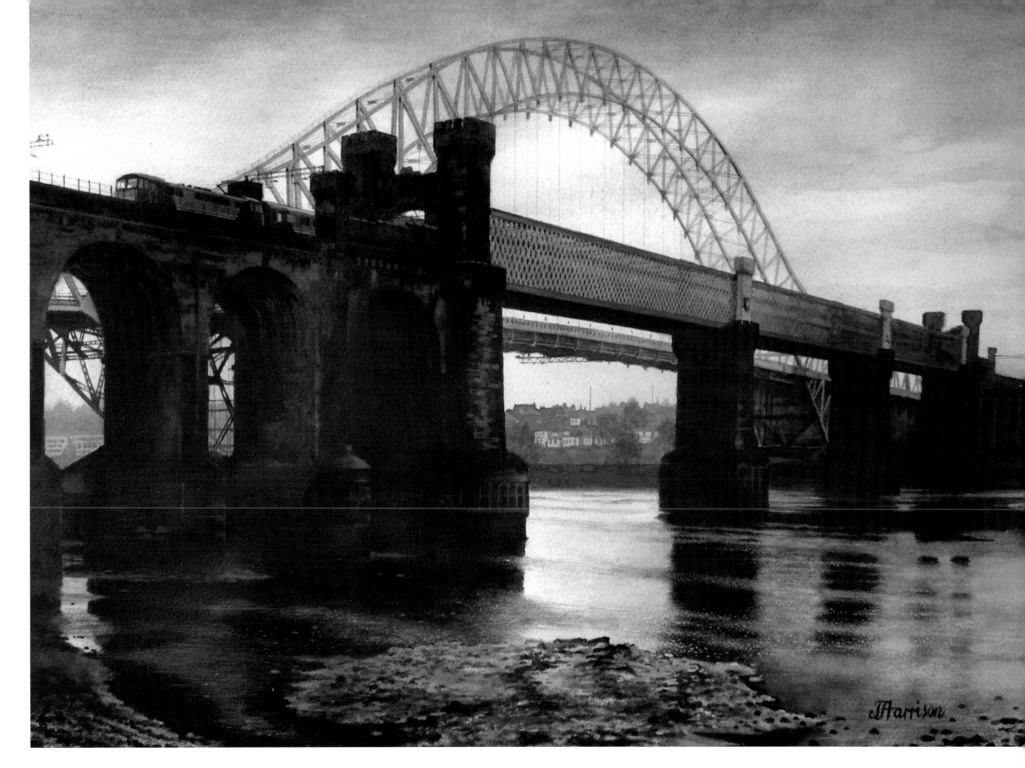

Runcorn Bridge was opened in 1868 after taking five years to build. For the price of one penny, people could walk along the double-tracked bridge. It was officially named 'Aethelfreada' after King Alfred's daughter. It has been crossed by express trains of the London & North Western Railway, the London Midland & Scottish Railway and British Railways. The new Virgin West Coast Pendolinos will soon be crossing this historic bridge that is widely seen as a 'national treasure'.

Crossing the Mersey 2002
JOHN HARRISON
51 x 41 CM, WATERCOLOUR, 2002

'Brit' at Ais Gill
JOHN AUSTIN
61 x 46 CM, OIL, 2001

A Britannia class locomotive travelling over Ais
Gill viaduct on the Settle and Carlisle railway.
The Britannias were the first steam locomotives
produced after rail nationalisation in 1948 and
were mostly used for express passenger trains.
The first batch of 25 was produced in 1951.

Heavy Freight
PHILIP D HAWKINS
11 x 13 CM, PENCIL

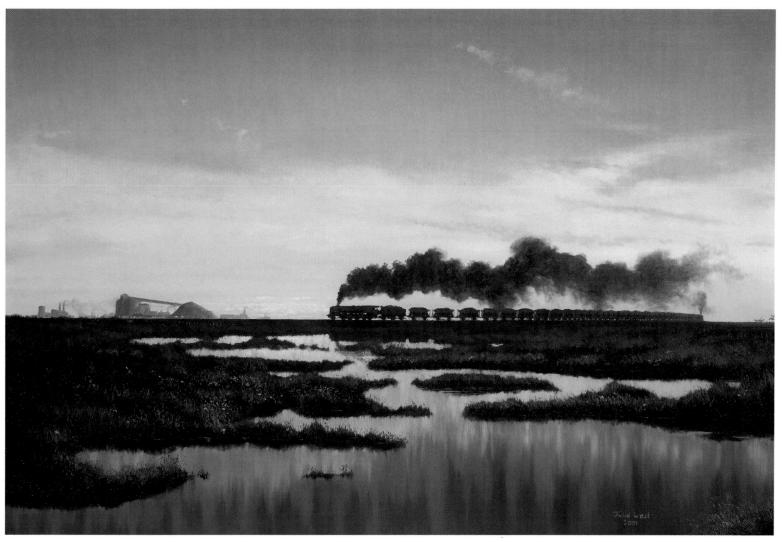

Heavy Freight
JULIE WEST
91 x 61 CM, OIL, 2001

9F 2-10-0 Evening Star is seen in a Welsh industrial scene pulling coal wagons. It was the last locomotive built for British Railways in 1960 and its class represented one of the most significant advances in British steam freight since 1903. The name was chosen by a competition among Western Region staff. The locomotive, earmarked for preservation from the time it was built, was taken out of service after only five years.

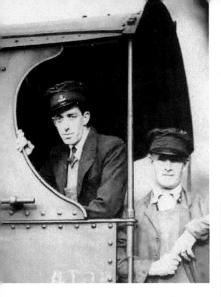

Lone Survivor
ROY WILSON
50 x 36 CM, PASTEL, 2002

This LMS "Super D" class G2 No. 9395 was the prototype of its kind. Originally built in 1921 for the London & North Western Railway, it was rebuilt in 1925 with a Belpaire firebox. It was withdrawn from service in 1959. The artist presented this painting to the locomotive restoration sponsor, Peter Waterman, at the National Railway Museum in 2002. Peter worked as a fireman on it in his BR days.

A dream come true
Suddenly to discover that a distant 'Uncle' was an engine driver seemed too good to be true. No time was lost in taking full advantage of Uncle Syd's invitation to join him on the footplate, suitably attired in overalls and my treasured driver's cap (I am the left-hand figure in this photograph).

I was privileged as a teenager to experience his nightly Wigan Alps coal train run from Widnes sheds, delivering empty wagons and gradually collecting a full load throughout the colliery triangle. Finally, there was my exit on the move as we crawled through the platform of my home station, Earlestown, in the early hours.
Roy Wilson

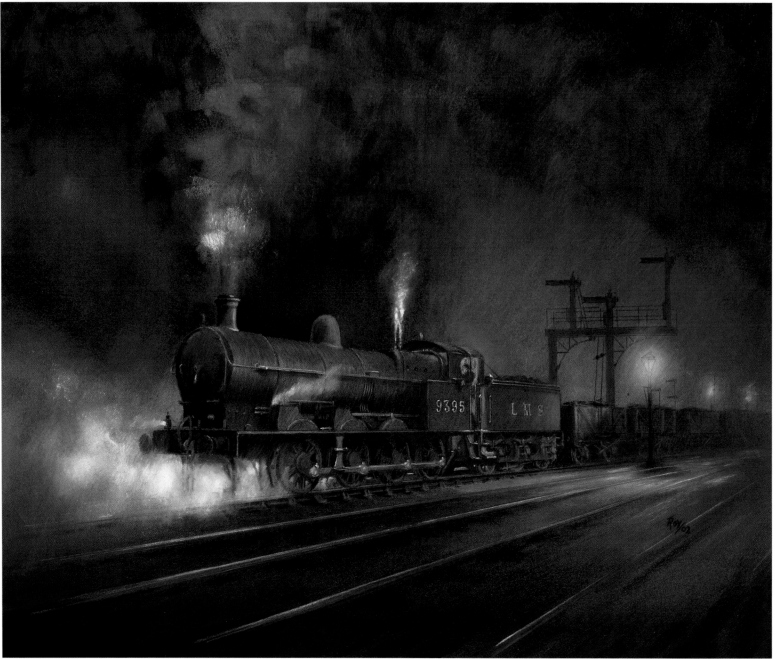

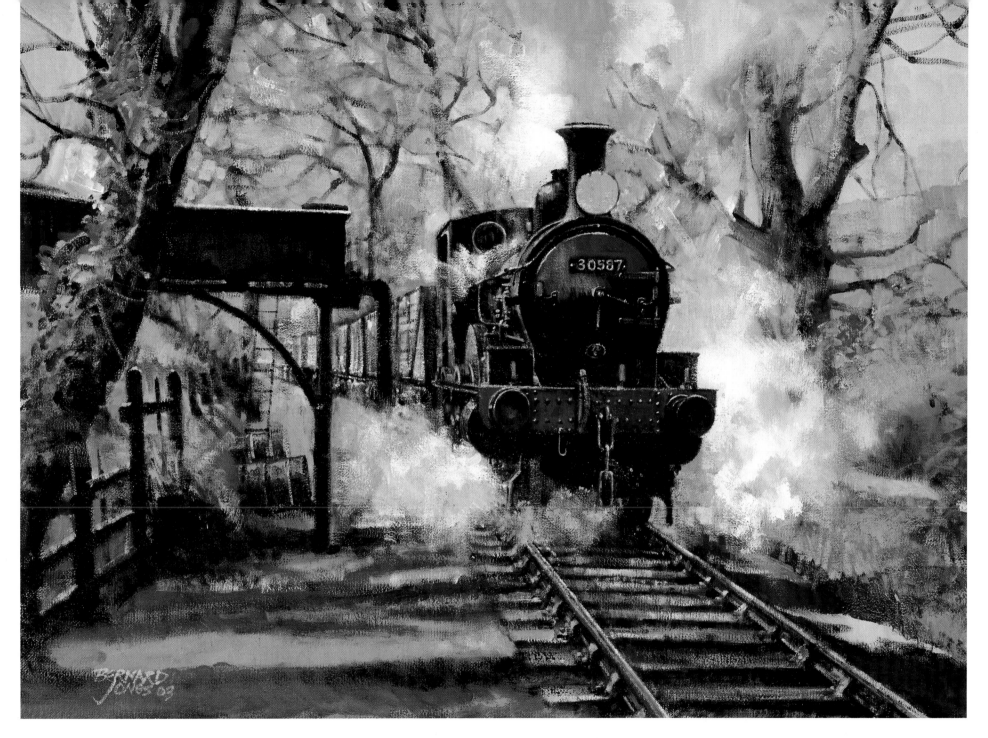

This painting was inspired by a photograph taken by Roger Jones in about 1960. It shows a Beattie well tank on the Wenford Bridge branch in Cornwall. The subject is particularly apt, as these locomotives hauled China clay trains to Wadebridge and the artist was a full-time potter for fifteen years. The locomotives were in service right up to the 1960s because of their suitability for work in Cornwall.

Beattie Well Tank No. 30587
BERNARD JONES
51 X 41 CM, OIL, 2003

Freight Super Power
RICHARD POTTS
60 x 36 CM, OIL ON CANVAS, 2002

These 2-8-0 heavy freight loco-motives were originally designed and built by Churchward in 1903 and were used until the end of steam on the Western Region. No. 2818 was built in 1905 at Swindon and withdrawn in 1963 after running for over a million miles.

Set in about 1955, the painting shows the locomotive leaving the up loop at Oxford North Junction with the 4.15am block coal train from Bordesley to Newton Abbot. The artist himself worked on this engine many times. Both the locomotive and signals are on display at the National Railway Museum.

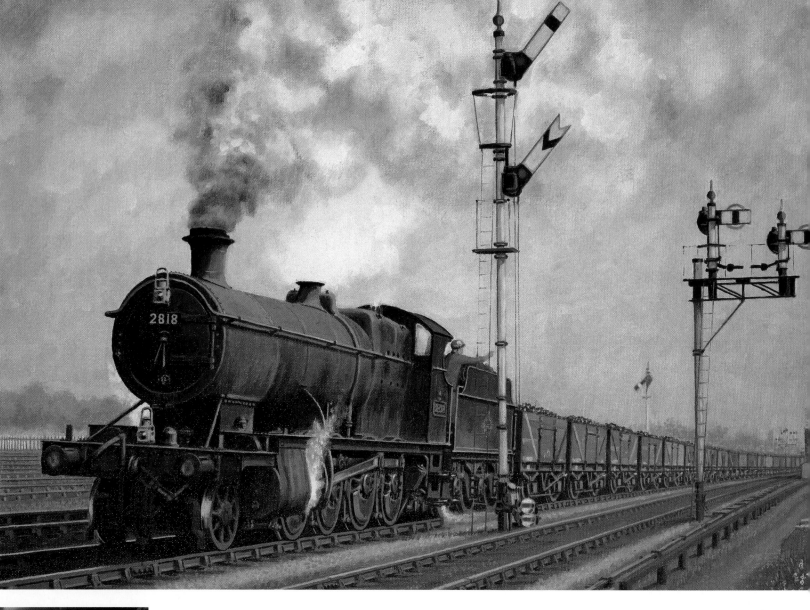

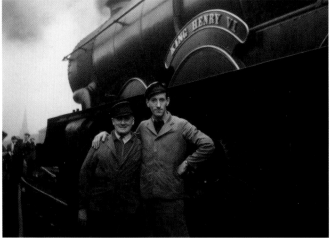

'The Last King'

This photograph taken by my friend Geoff Wood shows my driver Albert Slater (left) and myself standing alongside Great Western Railway No 6018 *King Henry VI* in Swindon Works yard on 28th April 1963. We had worked 'The Last King' special organised by the Stephenson Locomotive Society from Birmingham Snow Hill to Swindon via Greenford and Southall.

The return journey was via Oxford and Banbury, and for the bit between Swindon and Oxford I was allowed to do the driving, this being one of the highlights of my railway career. The sad bit was that a couple of days later *King Henry VI* was taken back to Swindon to be cut up.

Richard Potts

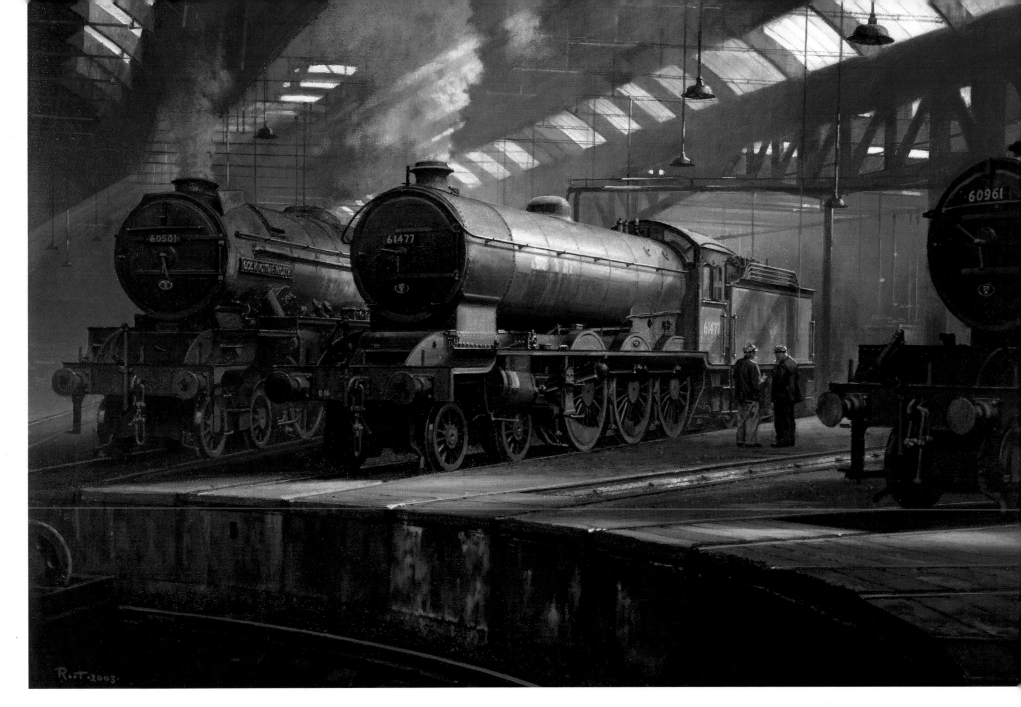

The roundhouse at York is now the Great Hall at the National Railway Museum and, whilst it still houses huge locomotives, the atmosphere today is very different. The artist has attempted to recreate the era when the roundhouse and turntable were being used as a part of the operating railway. The shafts of sunlight and oily, hazy, smoky atmosphere result in the locomotives being seen as ghost-like silhouettes.

This painting is set in the late 1950s and shows a V2, B16 and *A2 Cock o' the North* locomotives round the 70-feet diameter turntable at York. Originally the centrepiece of the North Eastern Railway's No. 4 locomotive shed and subsequently the York North Motive Power Depot, it was powered by an electric motor but could also be operated manually.

York Roundhouse
MALCOLM ROOT
61 x 46 CM, OIL, 2003

Copper Serpents
JOHN WIGSTON
30 x 55 CM, WATERCOLOUR, 2002

An unusual view of *Evening Star* shows the copper injector feed pipes and the injector from the right-hand side. The injector was invented by M Gifford in the 1850s. It takes steam from the boiler to force cold water back into the boiler to be heated up.

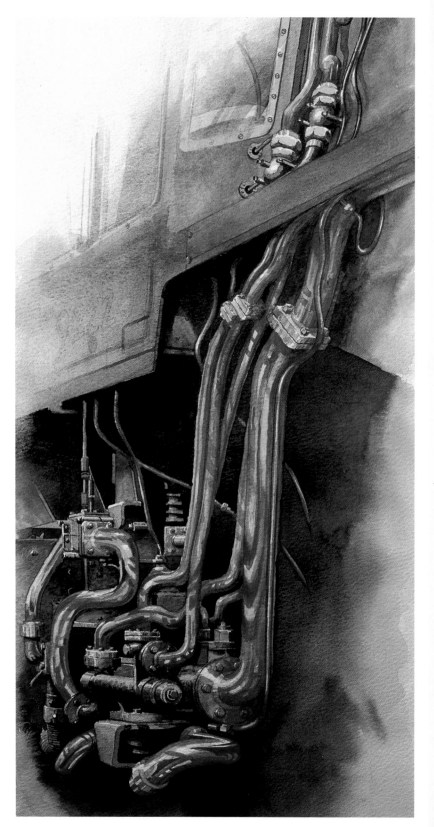

Climbing Aboard
PHILIP D HAWKINS
PENCIL

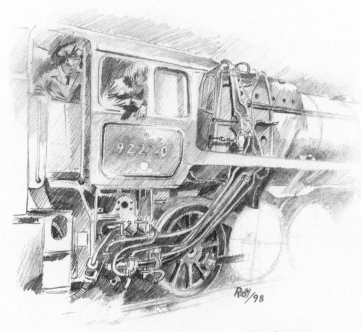

Evening Star
ROY WILSON
PENCIL

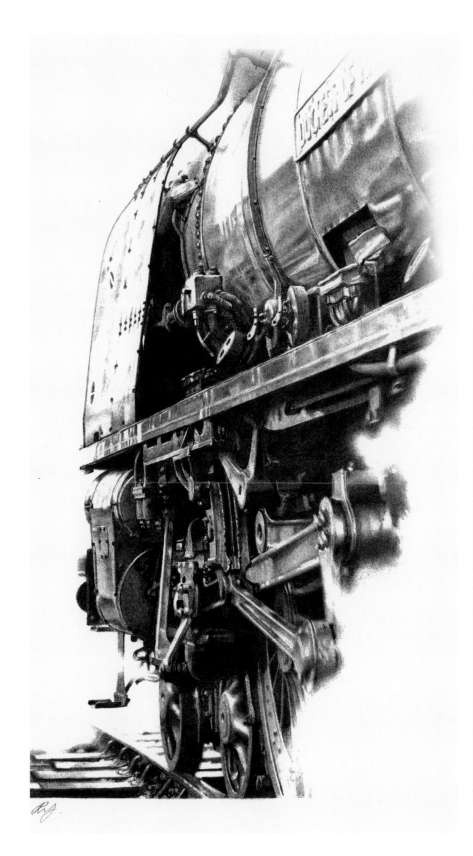

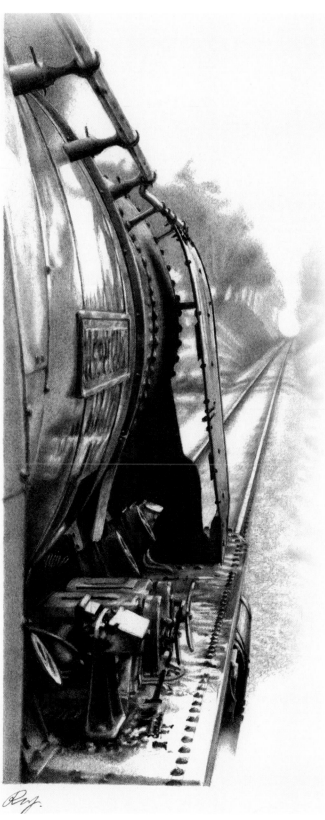

Duchess in Motion and Duchess in Reverse
ROGER WATT
10 x 19 CM AND 8 x 18 CM, PENCIL, 1998 AND 1999

These two drawings were based on photographs taken of No. 46229 *Duchess of Hamilton*, when the artist spent a day learning to drive her in April 1977. This locomotive was withdrawn in 1964 and transferred to the NRM in 1976. It was restored to working order by the Friends of the National Railway Museum and can be seen today in the Great Hall.

The drawings were done with 2H to 9H pencils on hammer board to create atmosphere, movement and texture. They each took three months to complete. To the artist, this locomotive is the ultimate in steam power and this can be sensed from the drawings.

Moving off Shed (detail)
BRIAN LANCASTER
84 x 56 CM, ACRYLIC, 2001

This painting draws attention to the power of the LMS locomotive *Duchess of Hamilton*. Built at Crewe in 1938, she was one of a class introduced in 1937 by William Stanier, Chief Mechanical Engineer of the LMS from 1932 to 1942. They were some of the largest and most powerful express passenger steam locomotives in Britain.

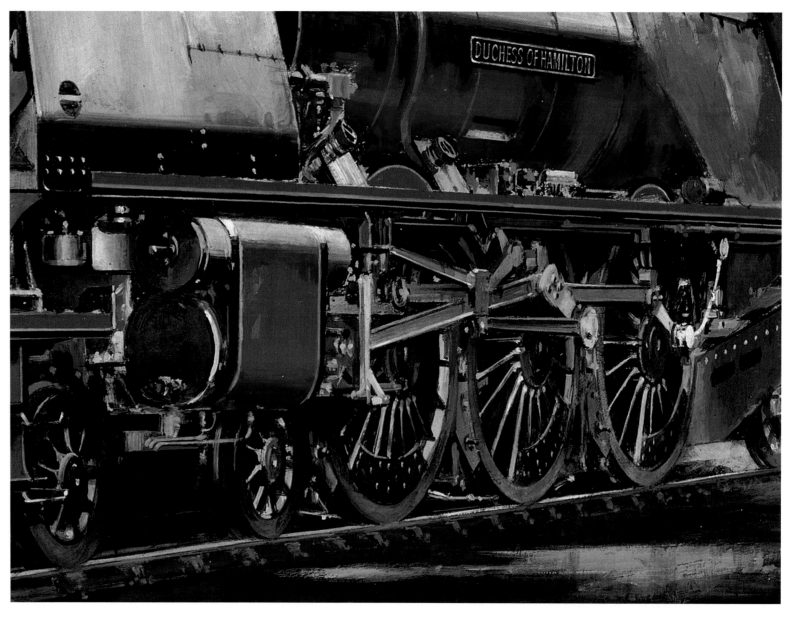

OPPOSITE

Four – Sub – Zero
PETER INSOLE
40 x 30 CM, CRAYON AND GOUACHE, 2003

The Southern Railway programme of electrifying lines in the 1920s and 1930s led to more sets of fixed multiple unit trains. The steel 4 sub units were introduced in 1941 on the Orpington line and consisted of two motor brake second compartments with domed cab fronts. A second generation were introduced in 1946 with flat cab fronts. They were notorious for being problematic in bad weather because the ice on the conductor rails caused arcing. The scene here is at Wimbledon West Yard c.1960 and shows the purple arcing. The last one ran in passenger service on British Rail on 6 September 1983 from East Croydon to Victoria station. The unit, originally built in 1925, can be seen on display at the NRM.

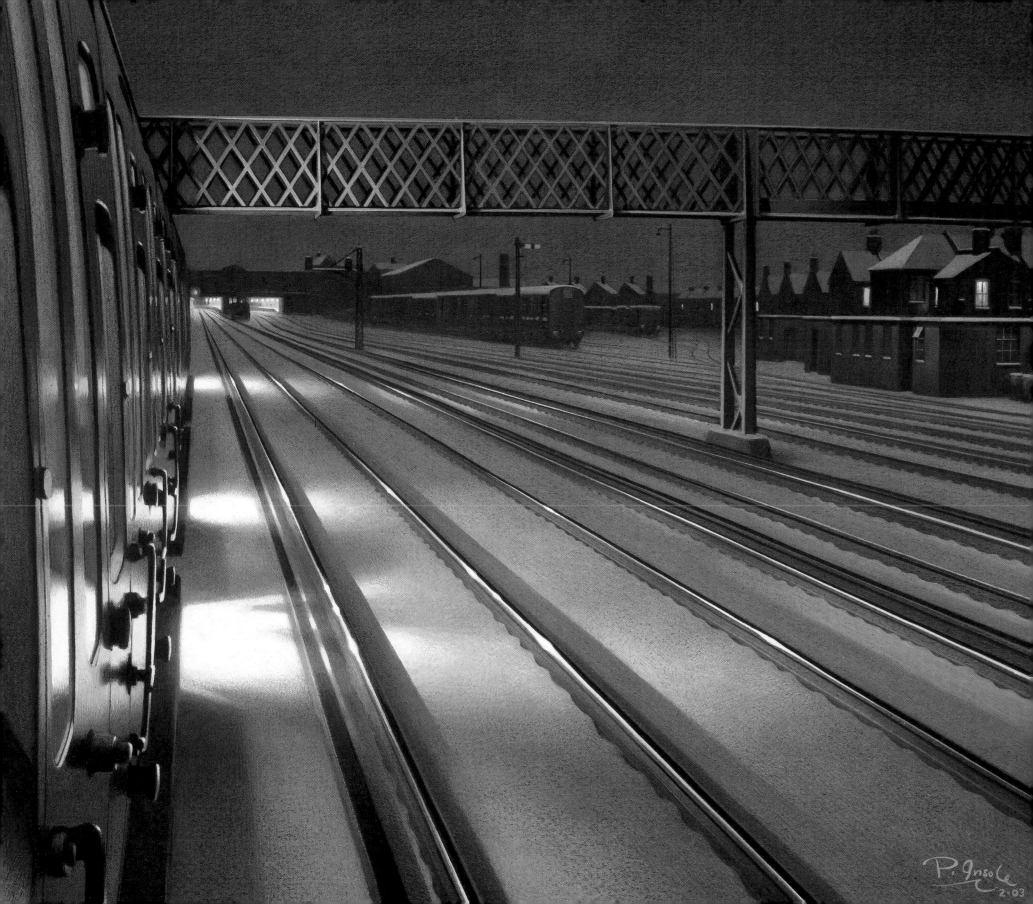

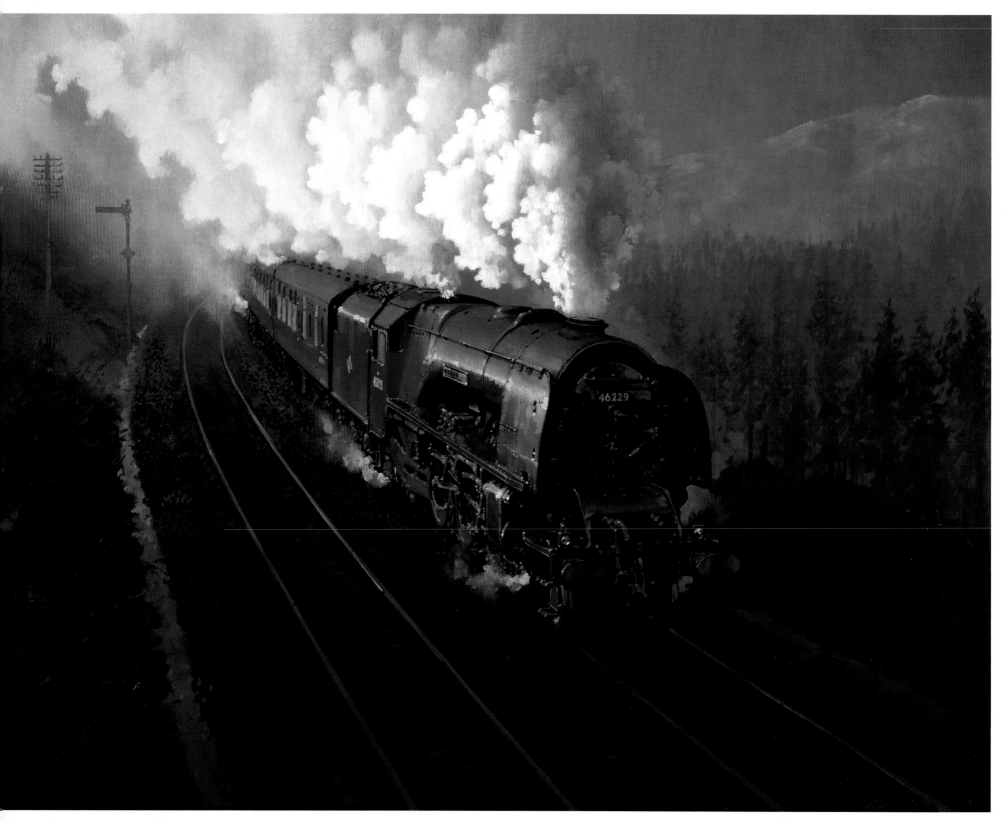

LMS 4-6-2 Pacific 46229
Duchess of Hamilton
JOHN AUSTIN
76 x 61 CM, OIL, 2001

Duchess of Hamilton is here
seen on the West Coast main
line between Carlisle and
Glasgow.

Duchess of Hamilton in Willesden yard about
1962. The artist spent much of his youth at this
yard, in north-west London, originally part of
the LNWR network.

'Lady in Red' was a popular song in the
1980s about a beautiful woman – and railway
enthusiasts refer to locomotives in the female
gender. The title is appropriate for the *Duchess
of Hamilton*.

Lady in Red
JOHN COWLEY
76 x 50 CM, OIL, 2003

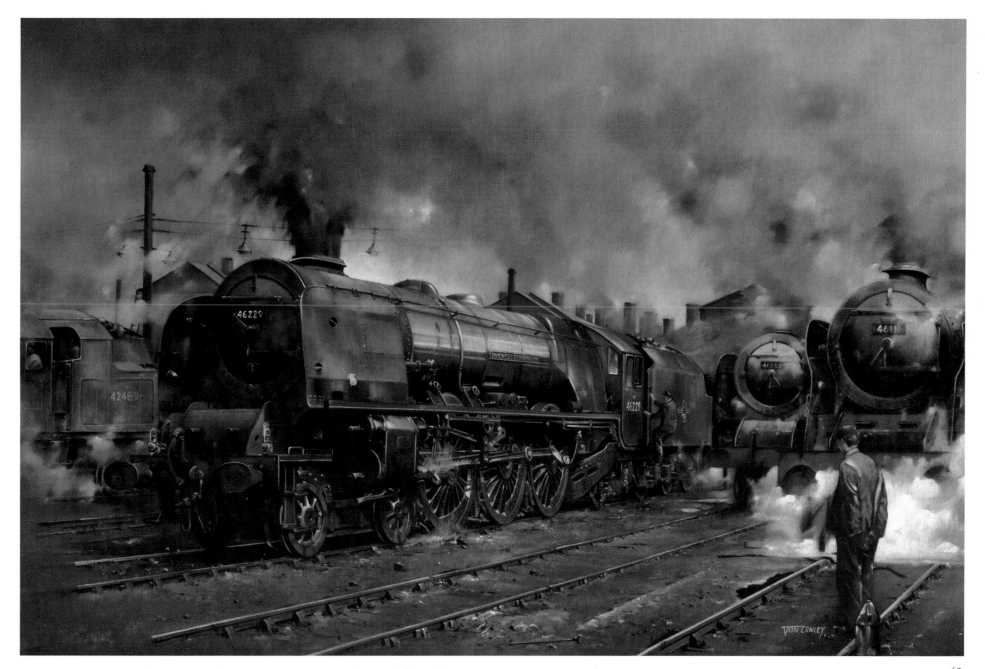

Last Drink Before London
PETER GREEN
50 x 40 CM, OIL, 1990

An LMS original-design Royal Scot class loco-
motive, introduced in 1927 by Fowler, passing
the water trough at Bushey near London. The
scene here is c. 1930. The sun is behind the
locomotive and a rainbow has formed in the
steam. Troughs such as these enabled water to
be picked up at speed and thus avoid delay
while travelling.

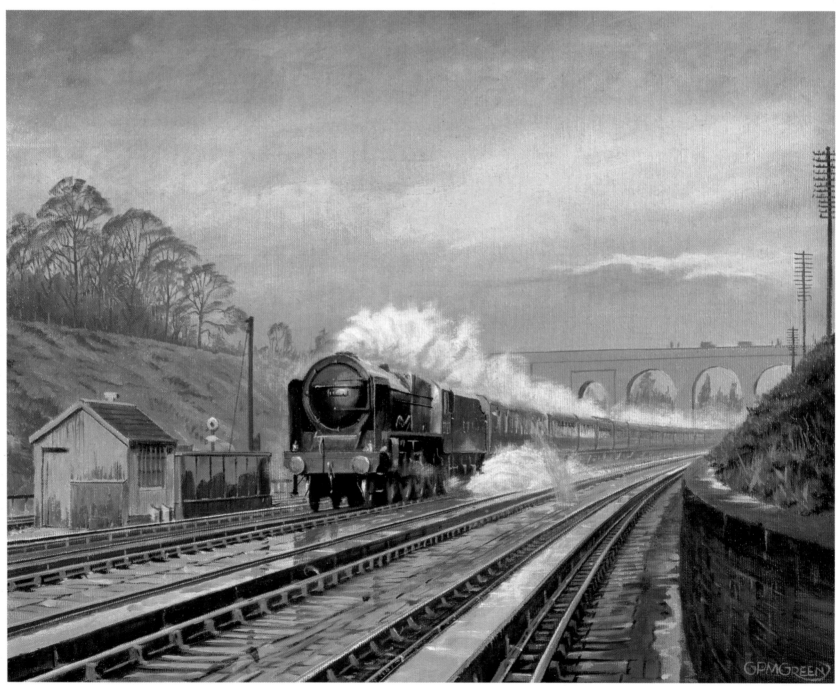

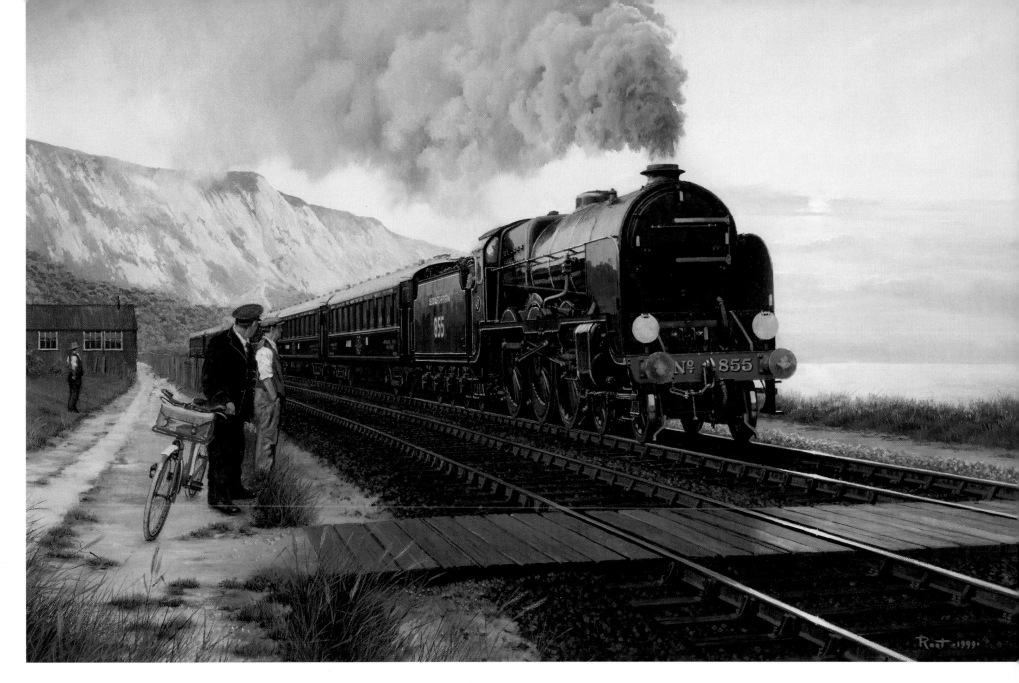

This painting shows the inaugural run of the Night Ferry leaving Dover on its way to Victoria station in London from Paris. It was Britain's first international passenger train and first ran on the morning of 14 October 1936. The Southern Railway in England and the Nord railway in France operated the service. The locomotive is Lord Nelson Class 4-6-0 No. 855 *Robert Blake*.

The Wagons Lits vehicles were overnight sleeping cars, specially built for the Night Ferry service to conform to the Southern Railway's loading gauge. They also had a solid-fuel stove, enabling the carriage to be heated during the ferry stage of its journey.

During the winter of 1942–3 the train was requisitioned by the Germans for use on the Mitropa expresses between Berlin, Vienna, Brest-Litovsk and Prague. The Night Ferry service ended on 31 October 1986. The National Railway Museum has car 3792 in its collection. It was built by ANF Blanc-Misseron and withdrawn in 1974. It was restored by Wagons Lits at Ostend and presented to the NRM in 1980.

The Dawn of the Night Ferry
MALCOLM ROOT
61 x 46 CM, OIL, 2003

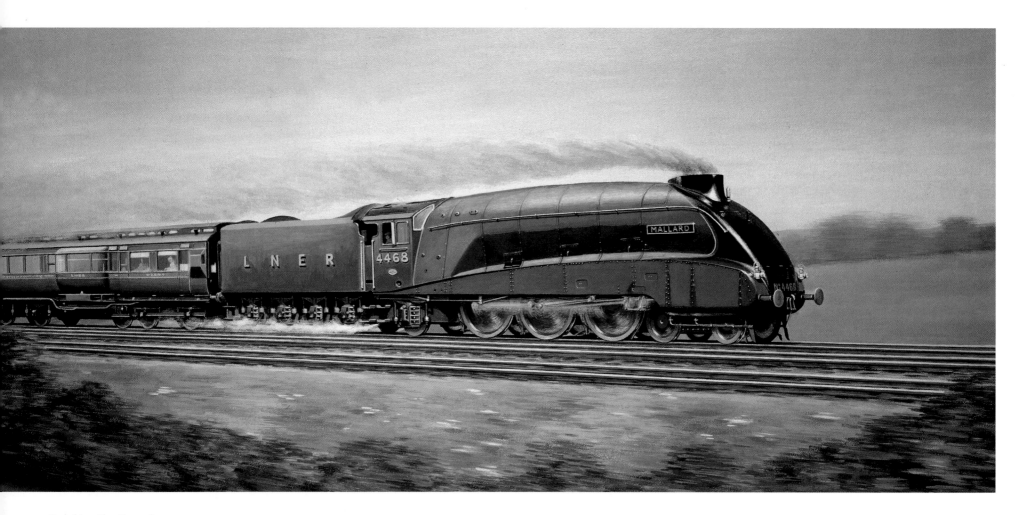

Breaking the Record
PAUL BATE
74 x 39 CM, ACRYLIC, 2002

A dramatic interpretation of A4
No 4468 *Mallard* descending
Stoke Bank on 3 July 1938
when it established a world
record for steam power of
126mph. The dynamometer car
that recorded the details is
next to the locomotive. More
background information
about this unique event is
on page 44.

A painting inspired by the watercolour 'Train at Shakespeare Cliff' by George Childs, 1850 (left; 1987-9230). The locomotive would then have been new to the South Eastern Railway. In 2001 we see one of the new Connex class 375 Kent coast electrics. The George Childs painting was commissioned to reassure the sceptical critics that the railway would not devastate the landscape or change people's lives in an adverse way. Mike Turner has found exactly the same vantage point as the nineteenth-century artist.

The Waterspout (Shakespeare Cliff, Dover)
MIKE TURNER
43 x 38 CM, WATERCOLOUR/ GOUACHE, 2001

Settle Approaches
CHRIS D HOLLAND
21 x 15 CM, GOUACHE, 2000

A 1980s steam special on the Settle and Carlisle is portrayed in wintertime. The restored red liveried Midland Compound 1000, leading Jubilee class *Leander*, pull a rake of British Railways coaches into Settle. Little has changed on this timeless railway line since the scene fifty years earlier depicted in the painting on page 50.

The Settle–Carlisle railway is one of Britain's most spectacular lines. From Settle it runs north through the limestone uplands of Ribblesdale between the gritstone-capped fells of the famous Three Peaks. These are Ingleborough, Whernside and Pen-y-Ghent. At the head of Ribblesdale the line climbs onto open moorland across the famous Ribblehead

viaduct before entering the mile-and-a-half Blea Moor tunnel under Whernside. It then runs into Dentdale and Garsdale before crossing Mallerstang Common and heading down the Eden Valley.

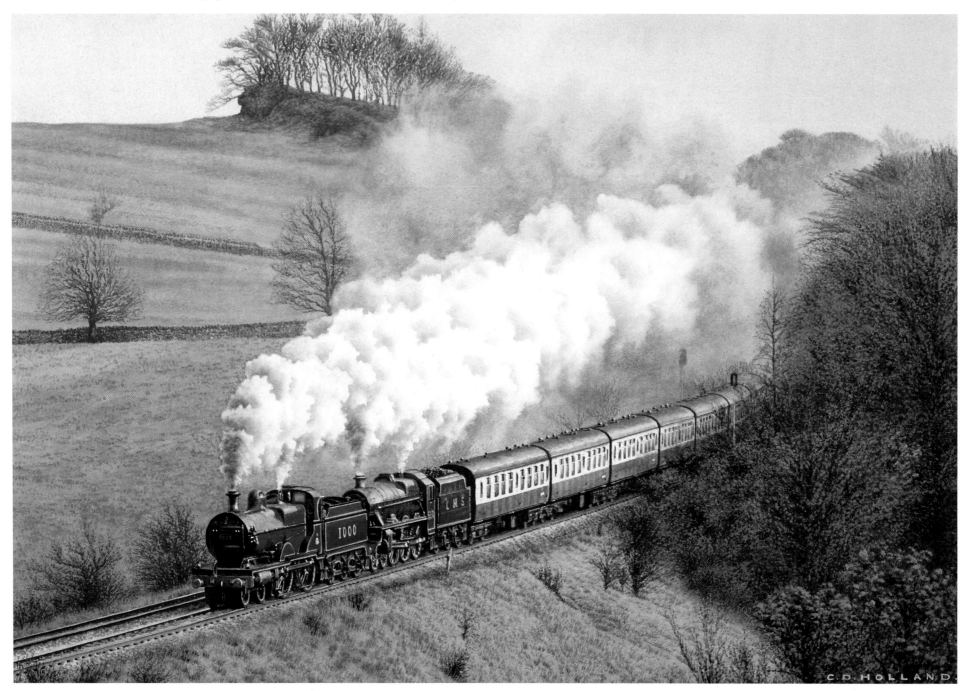

PHILIP D HAWKINS

Stanier's Finest (journal cover)
PHILIP D HAWKINS
76 x 51 CM, OILS, 1979

The cover illustration (right) for the Autumn 1998 *National Railway Museum Review*, showing two Princess Coronation Pacifics in their original streamlined form in two different liveries. No.6221 *Queen Elizabeth*, in red and gold, was the only one to change to that livery from blue and silver.

Painted panels showing alternative liveries for the front end of the Princess Coronation Pacifics' streamlined casing (below). These were originally displayed on the paintshop wall at Crewe works where they were affectionately known as the 'cats' whiskers'.

NATIONAL RAILWAY MUSEUM REVIEW

The Journal of the Friends of the National Railway Museum

No 85 Autumn 1998

FUTURE....

Stanier's Finest: an example of Philip D. Hawkins' early work showing two Princess Coronation pacifics in original liveries.

© *Philip D. Hawkins FGRA.*

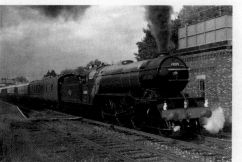

PRESENT....

Green Arrow *taking water from the re-instated water tower at Appleby on 3 October 1998 during its loaded test run.*
Photograph Paul Timperley.

Past and Present at Parkside
JOHN HARRISON
53 x 38CM, WATERCOLOUR, 2002

A First North Western 'Coradia' DMU passes the memorial to William Huskisson MP, killed on the opening day of the Liverpool & Manchester Railway on 15th September 1830. The original marble tablet commemorating the event is now part of the National Collection at the National Railway Museum. Railtrack presented it in 2000 when they restored the monument and installed a replica tablet. The Museum also holds other memorabilia relating to the death of William Huskisson and engravings of the former Parkside station.

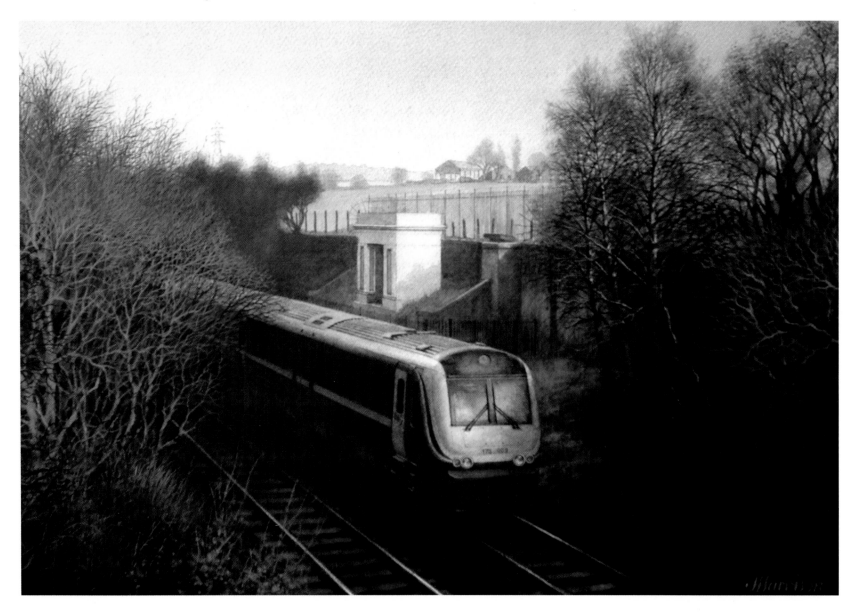

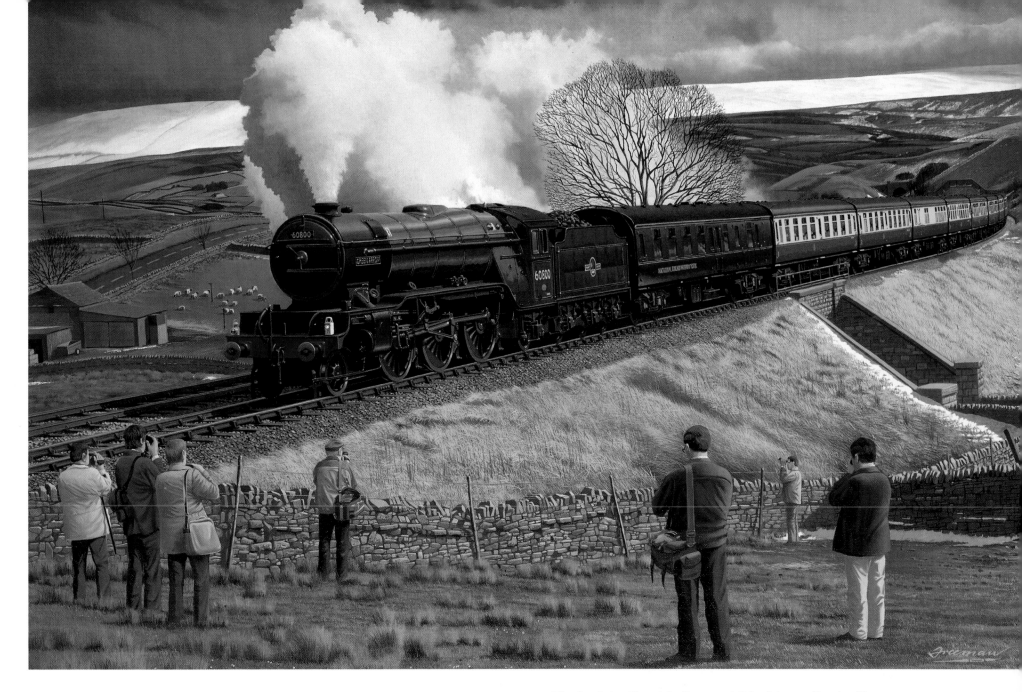

The Cumbrian Mountain Express at Grisedale crossing, near Garsdale, on the Settle and Carlisle railway in December 1999. The restored London & North Eastern Railway V2 2-6-2 *Green Arrow* pulls the train towards Ais Gill summit. The Settle and Carlisle is a major tourist attraction, and steam specials attract hundreds of photographers along the route.

Green Arrow is one of the National Railway Museum's locomotives that has a current boiler certificate and works steam specials all over the country.

Pennine Storms
BARRY FREEMAN
92 X 71 CM, OIL ON LINEN, 2002

Tunnel Vision
PETER INSOLE
24 x 30 CM, CRAYON AND GOUACHE,
1996

Interior of a Southern Railway
coach showing the upholstery,
carriage print and luggage
rack. This Bulleid coach
upholstery was restored to its
original design from samples
held by the National Railway
Museum. Little has been
published about rolling stock
furnishings and textiles, so the
NRM's is a valuable reference
source. The title refers to the
artist's childhood memory of
watching the blue hazy smoke
rush into the coach when
travelling through a tunnel.

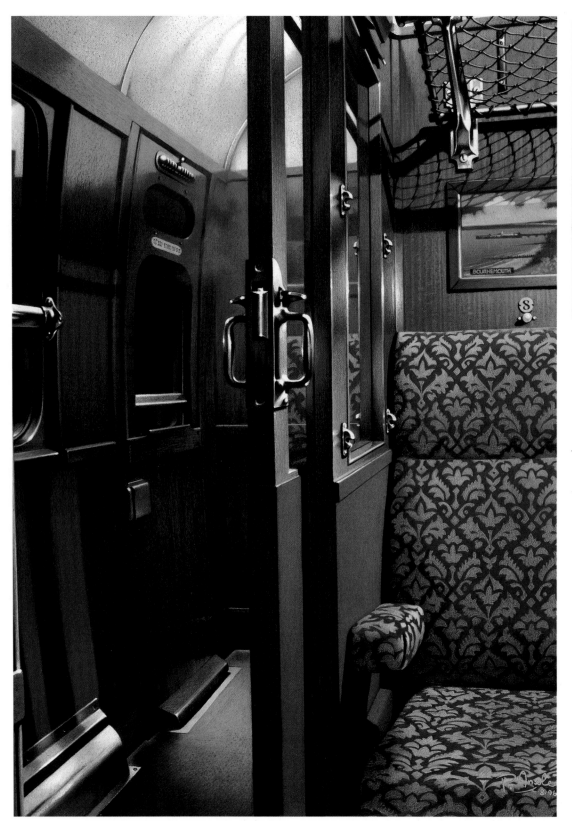

Looking Ahead
PHILIP D HAWKINS
11 x 13CM, PENCIL

OPPOSITE
'The Goathland' at Goathland
JOHN AUSTIN
92 x 66 CM, OIL, 1999

A North Eastern Railway 'Hunt' 4-4-0
No. 62765, *The Goathland*, is seen on
the North Yorkshire Moors Railway on a
snowy day. The station, Goathland, has
featured in both the Harry Potter films
and the *Heartbeat* television series.

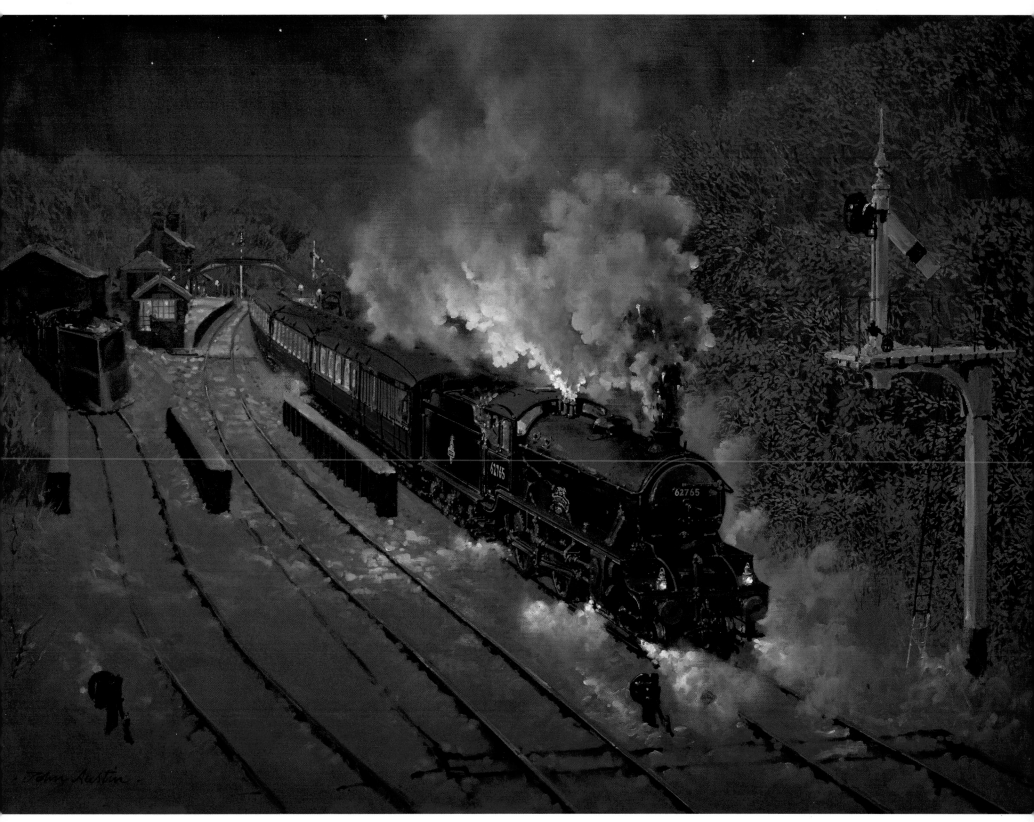

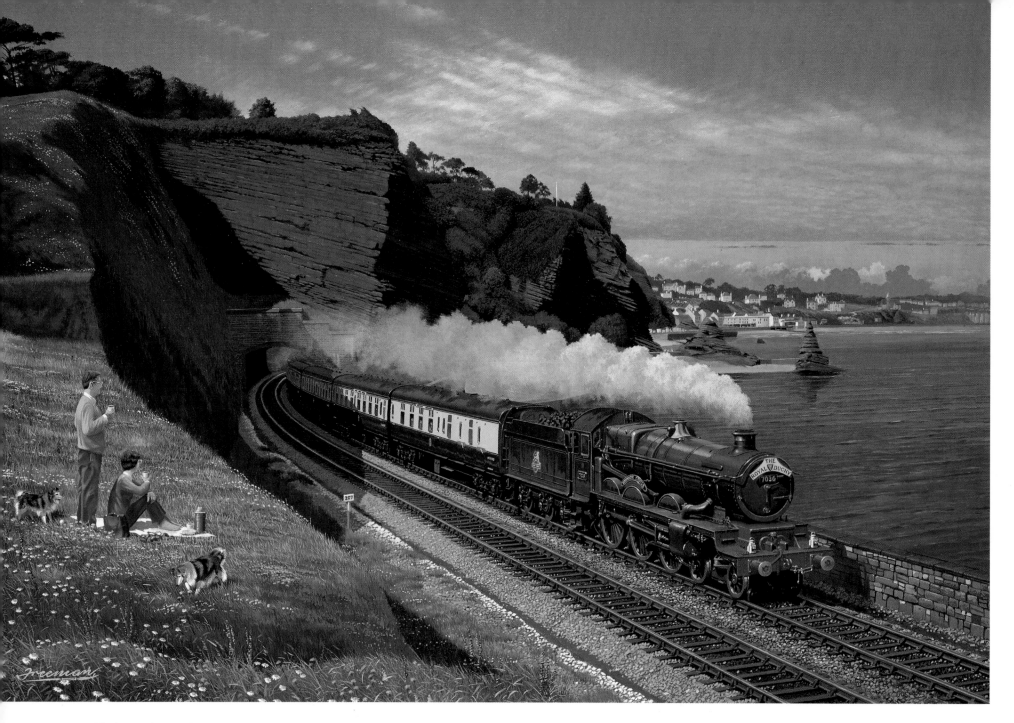

A Date with the Duchy
BARRY FREEMAN
75 x 51 CM, OIL ON LINEN, 2001

The Royal Duchy express first ran in 1957 from Paddington to Penzance. Here it is running alongside the sea wall at Shell Cove, between Dawlish and Teignmouth, headed by Castle class No. 1036 *Taunton Castle* built in 1950. This scene epitomises the post-war English holiday.

The National Railway Museum has the Royal Duchy carriage destination board in its collection.

The simple title belies the enormity and importance of this locomotive. It is in fact a detail from the 4-8-4 KF7 class Chinese National Railways locomotive. It was designed to run on the Canton–Hankow and Nanking–Shanghai lines and had an extra-large firebox to use the low-grade coal in that part of China. It ran in until 1977, when it was presented to the National Railway Museum by the People's Republic of China and has been one of the visitors' favourites ever since. The artist was drawn to this composition because of the contrast between the red and steel and the depth underneath the locomotive.

Mixed-traffic 4-8-4 Tender Locomotive 1935 (detail)
GLENYS BURROWS
38 x 25 CM, WATERCOLOUR, FEBRUARY 2002

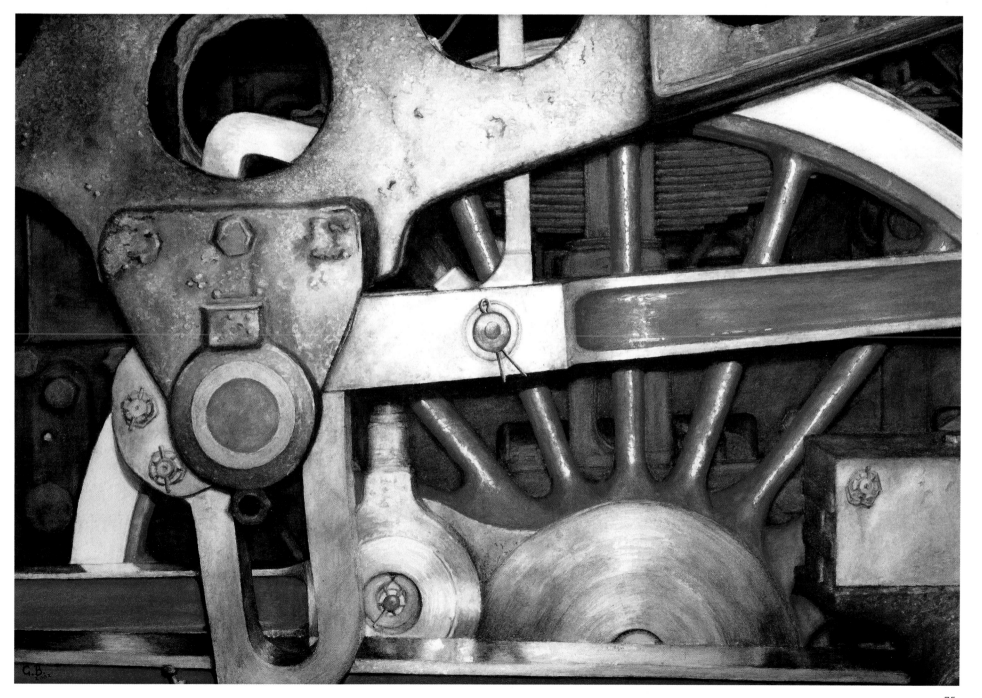

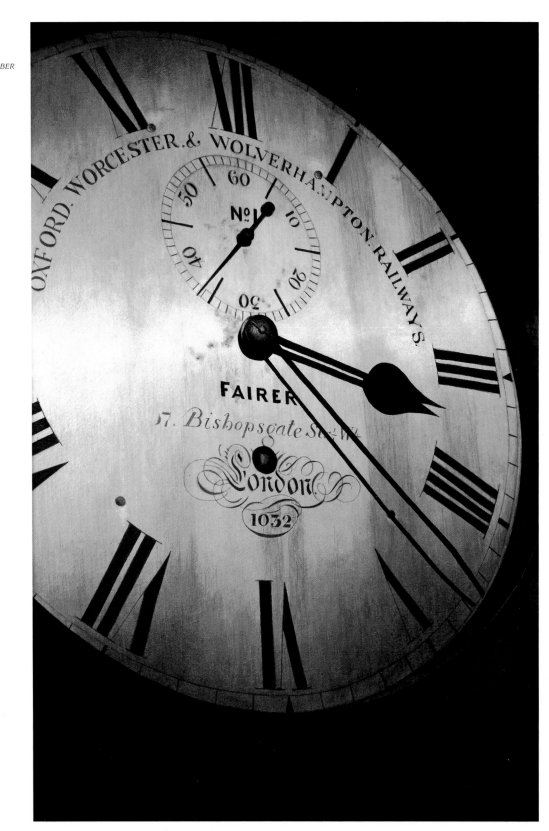

Railway Time
GLENYS BURROWS
27 x 39 cm, watercolour, September 2002

This clock was made for the Oxford, Worcester & Wolverhampton Railway by Fairer of Bishopsgate in London in 1850. It was used as a wall clock at Worcester Shrub Hill Station until 1962 when it was withdrawn. It is now on display at the National Railway Museum.

We take British standard time for granted today, but in the early days of the railways local time varied considerably across the country. As railways spread, they took Greenwich Time with them and, by the early 1850s, when this clock was built, standard time had been adopted. This was referred to as 'railway time'. In 1880 an Act of Parliament established the legal time as 'Greenwich Time'.

This scene is on the East Coast main line in the North London suburbs.

This is the signal gantry from Northolt Junction on the Great Western & Great Central Joint line that is now on display in the National Railway Museum's Great Hall. It provides a good example of splitting distant signals that identified the train's route.

The scene is imaginary but somewhere to the west of London in the British Railways era. The oncoming locomotive is a class 31 mixed-traffic diesel electric built in 1957 by Brush Traction Ltd. This was the first new mainline diesel on British Railways designed for freight and commuter services. The locomotive going away is No. 9400, the last of the Great Western Railway's pannier tanks.

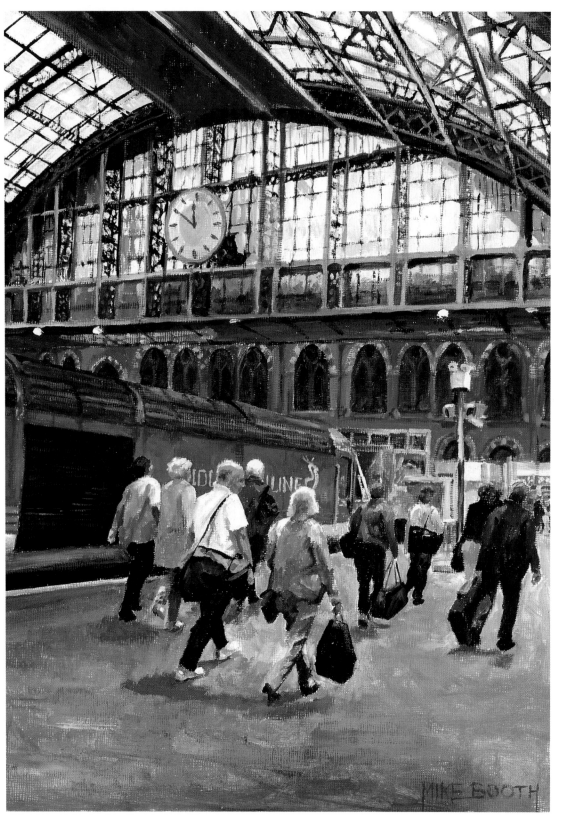

'Arrivals' captures the hustle and bustle of a busy London terminus. Since the beginning of railways, artists have used the railway station as a theatrical backdrop to stage people and meetings. Here we see a Midland mainline locomotive delivering its passengers at St Pancras. There is a busy air of excitement and anticipation that traditionally accompanies railway journeys. The contrast of light coming through the roof, and the concrete floor, are typical of this artist's style.

During this period, c.1954, there were two stations at Leamington Spa. The larger of the two was Leamington Spa General. The painting shows Castle class 4-6-0 No. 7027 *Thornbury Castle* hauling the Cambrian Coast Express.

In the sidings at the rear of the painting an ex LNWR G2a 0-8-0, No. 49395, is shunting goods wagons in Leamington Spa Avenue station. This locomotive is part of the National Railway Museum collection.

Bright Intervals
BARRY FREEMAN
91 x 61 CM, OIL, 1996

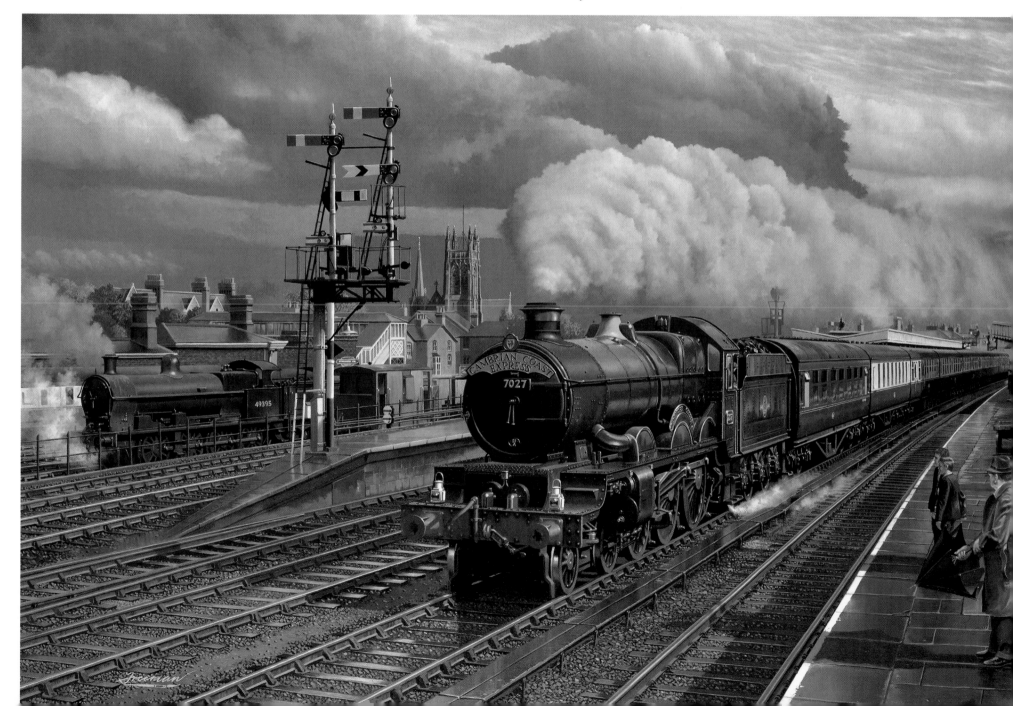

Earlestown – a very special place

Earlestown, originally Newton Junction, dates back to the opening of the Liverpool & Manchester Railway in 1830. It provided shelter for passengers using the pioneering line and was the important junction with the Warrington & Newton Railway. It is now the world's oldest railway junction still in use.

I fondly recall as a youngster the warm and comfortable waiting room, its huge stone fireplace, leaf-carved ceiling beams and the curious stone carvings above the arched entrance. Built from golden sandstone in the Tudor style it was given a Grade II listing by the Railway Heritage Trust but sadly has been allowed to deteriorate.

Special features of this architectural gem are its three sets of different octagonal chimneys and deep mullioned windows. In 1902 the London & North Western Railway rebuilt the station but thoughtfully preserved the old waiting room, although the high pitch of roof was altered to that we know today.

Robert Stephenson & Co in Newcastle on Tyne built the first locomotives used on the Liverpool & Manchester Railway. To get them to the line they were first dismantled, transported across country to Carlisle and thence taken by boat to Liverpool where they were re-erected. This major operation was a factor in Robert Stephenson entering into a partnership in 1832 with Charles Tayleur, a director of the Liverpool & Manchester company, who two years earlier had erected a locomotive manufacturing works a mile south of Newton Junction. Renamed the Vulcan Foundry, it was destined to become one of the world's principal builders and exporters of steam locomotives – a reputation it maintained throughout the modernisation of the industry.

In 1837 the competing Viaduct Foundry was established immediately to the west of Newton Junction overlooking the impressive Sankey Viaduct. It ceased trading fifteen years later but was first leased and then purchased by the London & North Western Railway to become a major centre for manufacturing and repairing wagons.

Around the works grew up the railway community of Earlestown, taking its name from the LNWR director Sir Hardman Earle. Rows of workers' cottages bordered onto Earle Street, at the end of which was Earle Cottage, an impressive residence occupied by the LNWR's resident general manager. I am indeed grateful to have known this grand house, be it only briefly during my courting days, it being the home of my wife's uncle, aunt and cousins.

As for the Viaduct Works, my father, uncles and grandfather all relied upon its regular employment, but now it has gone forever. The Vulcan Foundry also no longer exists, but for me it has fond memories. I consider myself fortunate indeed that in 1941 at the age of fifteen I was accepted to begin my first job as apprentice in the drawing office at 'The Vulcan'.

Thanks to John and his superb painting for the awakening of countless memories – moments in the signal box, hours on the footplate and endless visits to the station, unique in many ways including its accepted public right-of-way. Earlestown station is really very special.

Roy Wilson

(PHOTO: DR BRIAN WILSON)

Earlestown was the main wagon manufacture and repair works for the London & North Western Railway. By the early 1900s the works employed two thousand men. It closed in 1964 after the Beeching Report changed the way freight was carried by rail and the need for wagons was severely reduced. Here we see the 1830s original waiting room on Platform 2 – now a listed building – as well as a Pacer and an EWS class 66.

Earlestown
JOHN HARRISON
37 x 33 CM, WATERCOLOUR, 2002

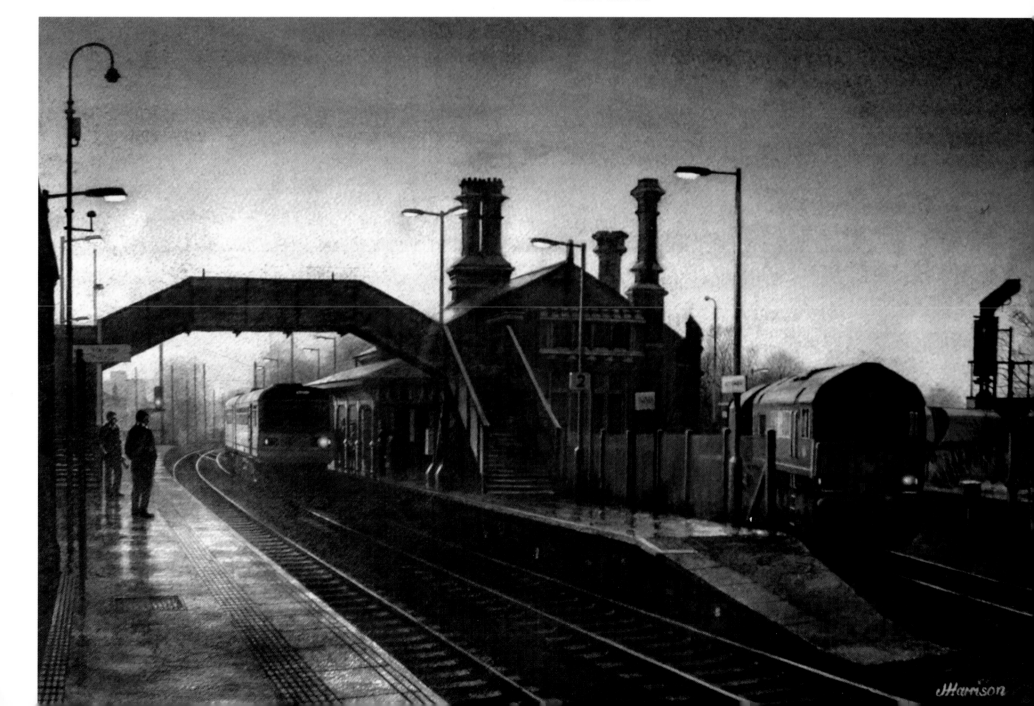

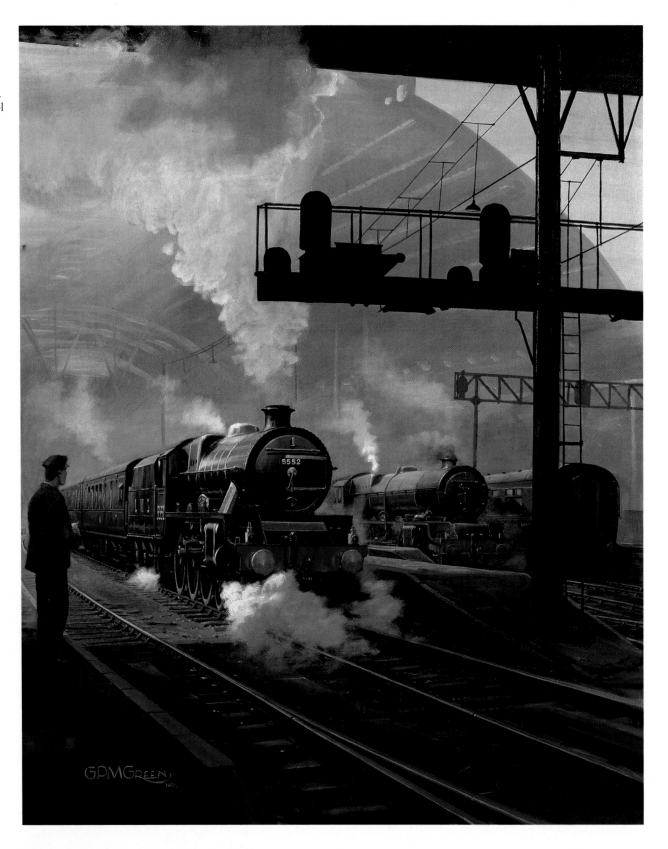

Liverpool Lime Street Station
PETER GREEN
61 x 76 CM, OIL, 1993

A post-war scene showing No. 5552 *Silver Jubilee* at Liverpool Lime Street. This locomotive was built at Crewe in 1934 by the LMS. The station opened to the public in 1836 to serve the first passenger railway between Liverpool and Manchester.

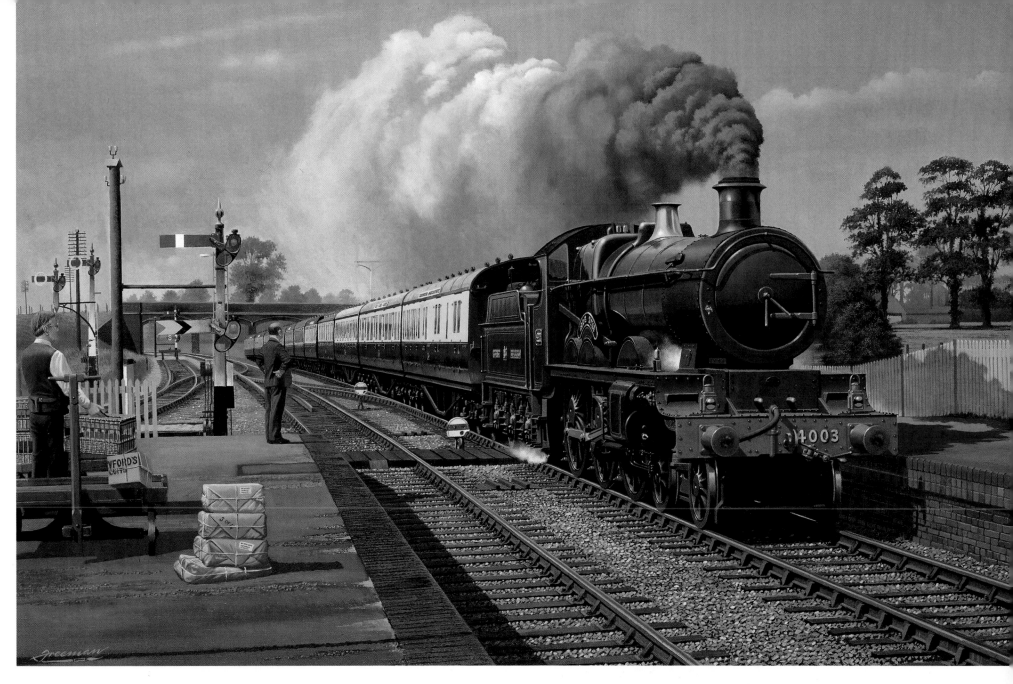

Great Western Railway No. 4003 *Lode Star* at Patchway, north-west of Bristol. It is at the end of its climb from the Severn Tunnel with an express from South Wales to London, set in the 1930s.

The 'Star' class were designed and built by G J Churchward in the early twentieth century to commemorate the earlier GWR broad-gauge locomotives built between 1839 and1841. *Lode Star* is in the National Railway Museum warehouse.

Star Quality
BARRY FREEMAN
92 x 61 cm, oil on linen, 2002

Set in 1958, this painting shows the Irish Mail, which first ran between Euston and Holyhead in 1848 to connect with the steamer crossing to Dun Laoghaire, south of Dublin. A Royal Scot class 4-6-0 No. 46141 *The North Staffordshire Regiment* hauls the train.

On an adjacent track an ex LNWR 0-8-0 pulls a heavy goods train going south on to the Coventry and Birmingham line.

Here the artist has captured the hustle and bustle of a noisy city station with its modern trains and electric overhead cables. Painted in a morning in autumn, it also captures the light reflected from the roof and platforms. The train on the left is a Great North Eastern Railway 125 on its way to Scotland and the one at the right is a class 158 DMU operating the Transpennine Express service. Whilst painting this, the artist overheard a railway worker say to his mate, 'When you've finished with Van Gogh, come across to platform 5 where we have a problem.'

York Railway Station 2002
IAN CRYER
50 x 40 CM, OIL ON CANVAS, 2002

Liverpool Street Station –
Information
MIKE BOOTH
49 x 59 CM, OIL ON CANVAS BOARD,
2002

Liverpool Street has inspired many artists over the years. Edward Bawden did several sketches and lithographs of the station he passed through every day; there are also works by Marjorie Sherlock and Chris Brace. Helen McKie's wartime sketches of Waterloo station influenced Mike Booth after a visit to Liverpool Street in 2001. He used Roy Wilson's photographic studies for detail, and the figures are influenced by the work of L S Lowry.

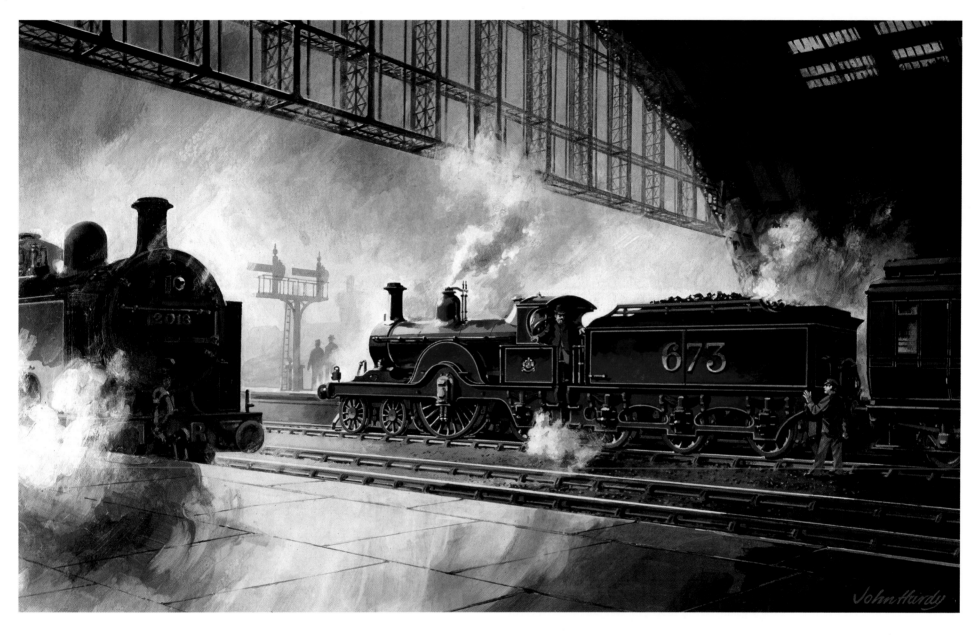

These Midland Railway locomotives, designed
by Samuel Johnson and built between 1887
and 1890, were affectionately known as 'spin-
ners'. This one, No. 673, was built in 1897 and
saved for preservation in 1928. The scene is
c.1910 at St Pancras station in London.

Johnson's Artistry at St Pancras
JOHN HARDY
51 x 31 CM, ACRYLIC, 2000

Great Western Railway 'King' class No. 6000 *King George V*, an express passenger locomotive designed by C B Collett who was the Chief Mechanical Engineer from 1922 to 1941. It was the first locomotive to return to mainline service after the final withdrawal of steam by BR and is now preserved at the GWR Museum in Swindon, although it is part of the National Railway Museum collection.

The painting shows the locomotive about to leave Birmingham Snow Hill on 25 May 1960. The driver was Joe Smith and the man on the right is the fireman and artist. The train left Snow Hill one minute late and arrived at High Wycombe eight minutes early.

The first locomotive named *Novelty* took part in the Rainhill Trails of 1829. However, seen here at Birmingham's New Street station is a later London & North Western Railway Precedent 2-4-0 No. 1682, one of a class introduced in 1874. They were nicknamed "Jumbos" – an English pet name for elephants – because they were powerful and reliable. However, they were also very fast and were used in the 'Races to the North'.

Hardwicke, another member of this class, is on display at the National Railway Museum.

Stirling Single at York Station
BRIAN LANCASTER
64 x 48 CM, WATERCOLOUR, 1997

This painting shows Stirling Single No. 5 at York station c.1890. It was designed by Patrick Stirling, locomotive superintendent of the Great Northern Railway between 1868 and 1895, and built in Doncaster works. The class had a single pair of 8 ft 1 in diameter driving wheels. The design meant Stirling had to use outside cylinders to keep the centre line of the boiler at a reasonable height.

Stirling Single No. 1, the first one built in 1870, is on display in the Great Hall of the National Railway Museum. Fifty-two more were constructed and worked on the East Coast main line passenger expresses between London and York. They could reach speeds of up to 75 mph.

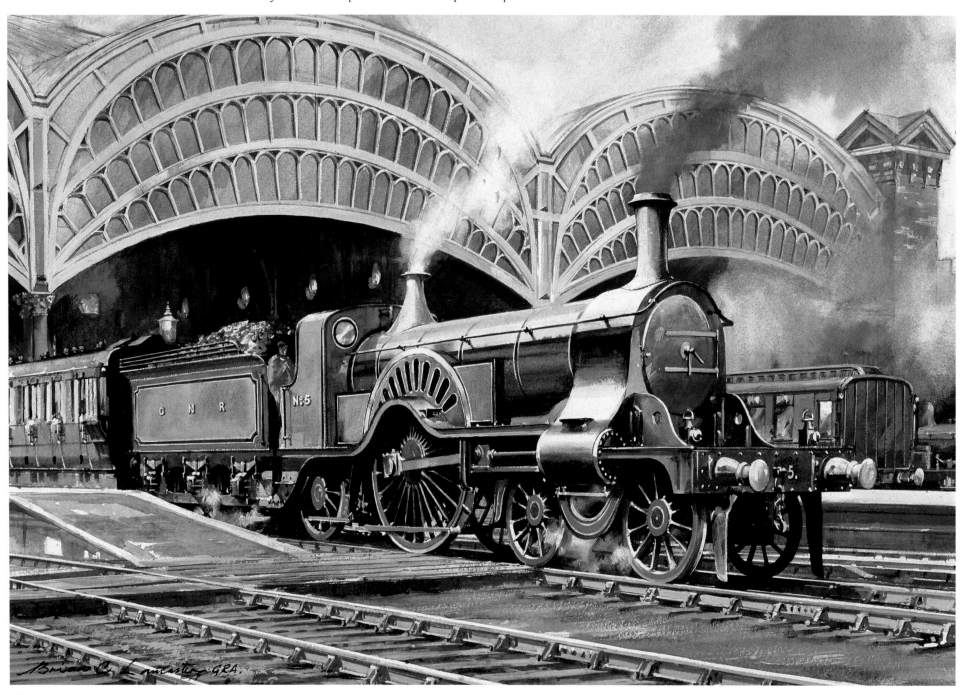

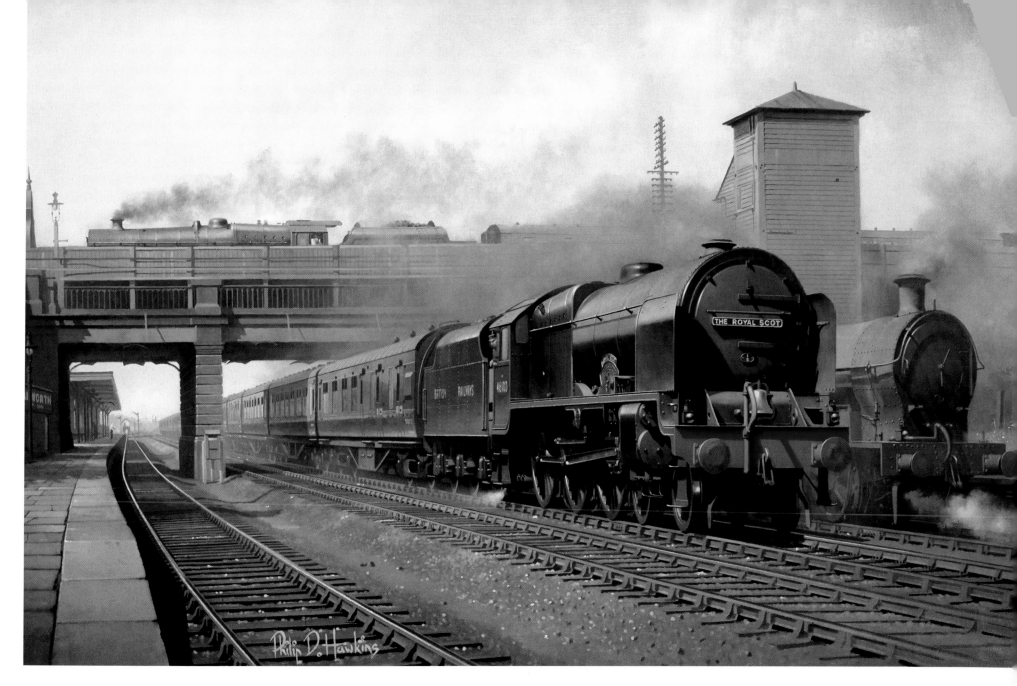

The Royal Scot class No. 46100, named *Royal Scot*, is seen pulling the Royal Scot train that ran between Euston and Glasgow. Set in 1947, it still has the LMS passenger livery but has 'British Railways' on its tender. This scene is at Tamworth. A Jubilee 4-6-0 can be seen travelling south on the bridge and a freight locomotive is waiting in the platform.

The North British Locomotive Company built the *Royal Scot* locomotive in 1927. It was bought by Bressingham Steam Museum in 1989 where it is on display.

Royal Scot at Tamworth
PHILIP D HAWKINS
76 x 51 CM, OIL, 2002

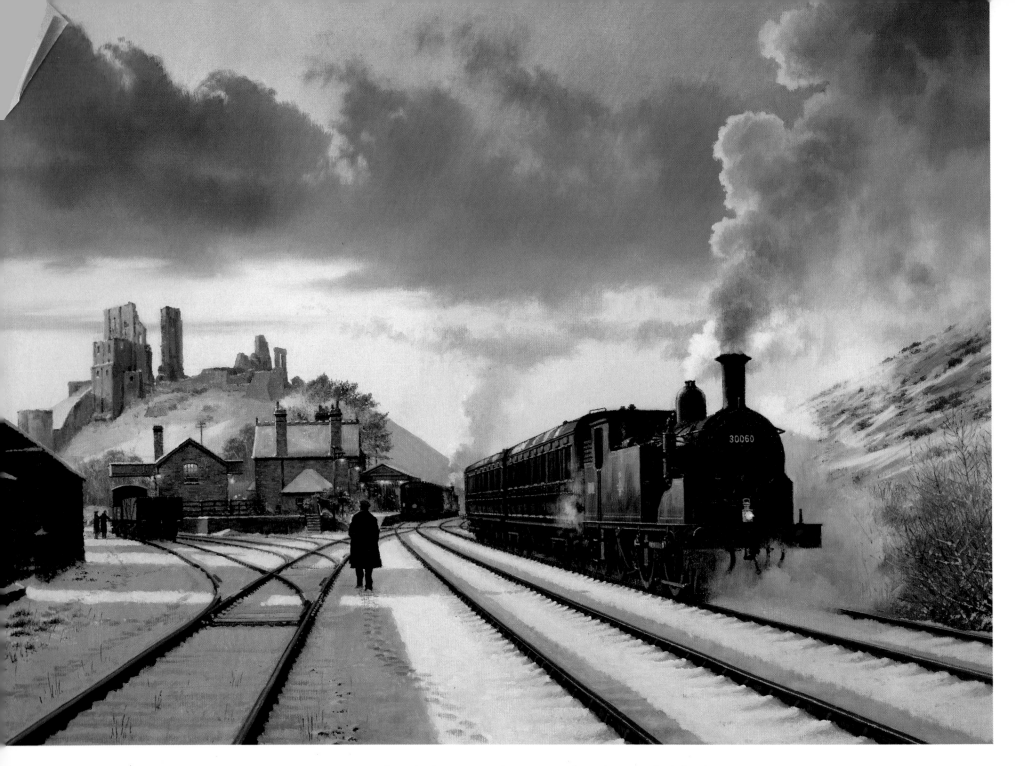

Corfe Castle
MALCOLM ROOT
50 x 40 CM, OIL, 2001

A British Railways M7 0-4-4 tank engine in Corfe station in winter c.1950. The ruins of Corfe Castle, on the Isle of Purbeck in Dorset, make an impressive backdrop to this railway scene. The Swanage Railway is now on this site.

The Drummond M7 class were built for the London & South Western Railway and survived up to 1964. No. 245 is now part of the NRM collection.

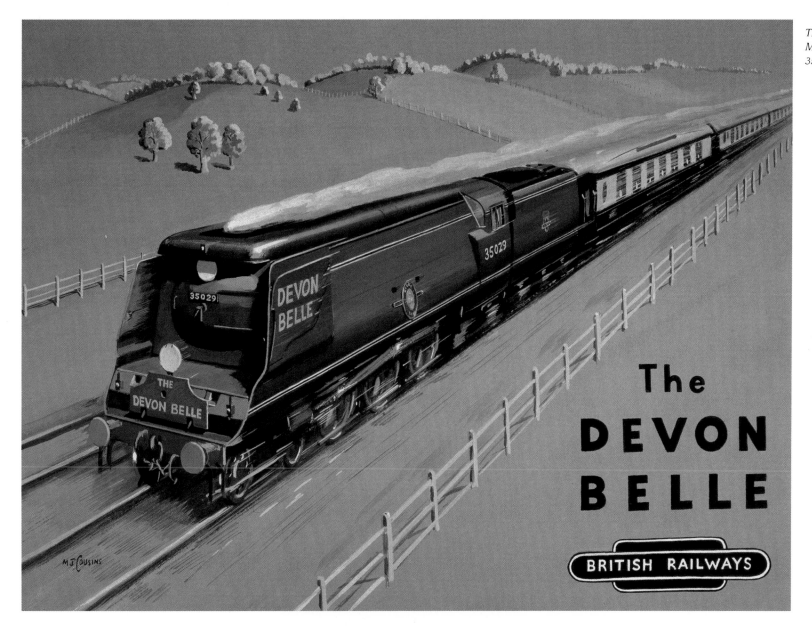

The Devon Belle
MATTHEW COUSINS
35 x 25 CM, GOUACHE, 2002

A British Railways (Southern Region) poster design c. 1951 shows the Devon Belle being hauled by rebuilt Merchant Navy No. 35029 *Ellerman Lines*. One of a class designed by Oliver Bulleid and named after shipping lines using the port of Southampton, it is now on display in the National Railway Museum's Great Hall. The locomotive has been cleverly sectioned so that museum visitors can see how it was constructed and how it works. It has chain-driven valve gear.

This poster is set in 1951, only two years after the original locomotive was built. The Merchant Navy class worked mainline expresses such as the Golden Arrow, the Atlantic Coast Express and the Devon Belle.

The Old York Railway Museum
Matthew Cousins
25 x 35 cm, gouache, 2002

This poster was designed to encourage people to visit the old museum, which was in Queen Street, York, near the railway station. The LNER opened the museum in the 1930s and the government ran it after nationalisation in 1948. In 1975 the relics were transferred to the National Railway Museum.

The poster shows Stirling Single No. 1, built by the Great Northern Railway at Doncaster in 1870, which became famous in the 'Races to the North' of 1895. It now significantly sits alongside its rival, the London & North Western Railway *Hardwicke*, in the National Railway Museum's Great Hall.

This London & South Western Railway poster design of c.1910 advertised the Atlantic Coast Express. It was not actually named as such until the Southern Railway had a competition for its improved service from Waterloo via Exeter to the north Cornish coast. The winner was a guard called F Rowland from Great Torrington. The name Atlantic Coast Express was used in the summer timetable of 1926 for the first time and it soon became known as the 'ACE'.

The locomotive pulling the train is the L & SWR Drummond 4-4-0 No. 120, which is now in the National Railway Museum collection. It was built at Nine Elms in 1899 and withdrawn in 1963.

The Atlantic Coast
MATTHEW COUSINS
35 x 25 CM, GOUACHE, 2002

A poster for Anglia Railways inspired by the collection at the National Railway Museum. The LNER often produced a series of six posters with themes such as 'Lighthouses' or 'Landmarks'. This is one of a hypothetical 'Views of East Anglia' with the River Orwell as its focus. The Thames barge is sailing up river to Ipswich, with the Orwell Bridge in the distance. The print is based on modern Anglia promotional literature and the Website address brings it up to date.

OPPOSITE, RIGHT
Sutton Hoo
MIKE GUNNELL
25 x 41 CM, CHROMACOLOUR, 2002

A poster design jointly for Anglia Railways and the National Trust, which has been collaborating with the railway companies' poster designs since the early 1920s. The artist was inspired by the simple yet effective block design of the LNER and uses the same Gill sans-serif lettering it adopted. Vikings are an ever-popular subject in advertising. With the cycle promotion the artist also emphasises the 'green' travel angle now used by the railway companies.

The Blue Riband Route via Southampton
MATTHEW COUSINS
25 x 35 CM, GOUACHE, 2002

A Southern Railway poster design set in about 1938 advertised the *Queen Mary* liner that was launched in May 1936. In 1938 the ship gained the Blue Riband award for the fastest ocean liner crossing of the Atlantic and set new records both eastbound and westbound. The award, held until 1952, came with a trophy, but Cunard refused to accept it for the *Queen Mary*, claiming that safety was paramount over speed.

The Southern Railway built the Lord Nelson Class to haul the Continental expresses from the Channel ports. No. 850 is being restored by the Eastleigh Railway Preservation Society.

CHINA AND JAPAN
BRITAIN'S HISTORIC RAILWAY CONNECTIONS

Home Again after 45 Years

On 21st June 1981 the cargo ship *Renee Rickmers* berthed at London's Tower Wharf concluding a five-month voyage begun in Shanghai on 22nd January. On deck – and returning to Britain as a generous gesture of friendship by the Chinese Ministry of Railways – was one of twenty-four 4-8-4s built in 1935/36 by the Vulcan Foundry, Newton-le-Willows. They were the largest non-articulated rigid frame steam locomotive ever to be constructed in this country.

Off-loading this 100-ton giant by the Port of London Authority's massive floating crane *London Samson* commenced five days later when it was ferried across the Thames to No. 30 Berth, Tilbury Docks. There it was gently lowered onto an 80-wheeled, ten-axle Sunters trailer and on 28th June commenced its four day journey by road to the British Rail Carriage Works at Poppleton Road, York. After almost half a century it was settled down on British track again to be re-united with its massive double bogie twelve-wheeled tender.

Five months as deck cargo, lashed by sea spray, called for some cosmetic restoration. The locomotive was then moved to its final resting-place as the largest single exhibit within the National Railway Museum.

The initial order for these steam giants originated in the 1930s when Britain, France and America received substantial compensation from the Chinese Government as a result of the severe destruction of property and assets suffered during the Boxer uprisings of 1900-1906. Subsequently these countries jointly agreed to re-invest these funds in China's repair and reconstruction of its standard gauge railway network. It was with the completion of the Canton-Hankow Railway in sight that these locomotives were designed and ordered.

Colonel Kenneth Cantlie and Roderick Morrison, two Scottish-born locomotive engineers based in Nanking, were closely involved in the specification and design. Cantlie had been a premium apprentice at Crewe immediately after World War 1. His father, an eminent doctor, had had close links with China around the turn of the century, so it was appropriate that his son should be appointed as Technical Adviser to the Chinese Minstry of Railways in 1929. Morrison on the other hand served his time at Swindon, prior to going out to China as a technical representative of the Vulcan Foundry in 1931.

Five leading British locomotive builders were invited to submit tenders – Vulcan Foundry, Beyer Peacock, North British Locomotive Company, Armstrong Whitworth and Robert Stephenson & Co. The order was awarded to Vulcan in November 1934, initially for sixteen engines, but even before the first rolled out of the erecting shop a further eight had been ordered in August 1935.

Since the pioneering days of railways, British manufacturers had enjoyed a lucrative export trade in the production of steam locomotives for service around the world. However, by the turn of the century, manufacturers in Europe, America and Japan had joined the competition.

The shipment of small numbers of engines as deck cargo was no longer practicable or acceptable. To meet the demands the Norwegian shipping line Christen Smith introduced in 1927 the first of the specially designed 'Bel' ships incorporating all the facilities necessary for the transportation of fully erected engines and their tenders. Locomotives could now be stacked within the hold and also occupy extensive deck space. Armstrong Whitworth built these specialist vessels, which incorporated heavy lift crane facilities to off-load in ports without the necessary dockside facilities. Prior to the introduction of the 'Bel' ships it had been necessary to export locomotives dismantled – a time consuming and costly system involving fully supervised re-erection upon delivery.

The second batch of seven locomotives left the Vulcan Works complete and each one was conveyed the fifteen miles to Liverpool Docks by road aboard the Edward Box multi-wheeled heavy transporters. I vividly recall my pleasure and excitement as a ten-year old to hear in the distance the powerful roar of the prime mover as it negotiated the severe gradient adjacent to the Vulcan Works. This was my signal to make a dash to the nearby route and to watch in awe the approach of the powerful transporter and its magnificent cargo – what a splendid sight and what a privilege to enjoy such an experience!

Little did I know that in another five years I would be employed in my first job at fifteen as apprentice within the drawing office at the Vulcan Foundry. Nor had I any idea that I should be further privileged to experience at first-hand a journey aboard such a transporter carrying a 90-ton steam locomotive to Liverpool Docks en-route for Turkey.

I often wonder if one of the locomotives I had witnessed at the start of its long journey to Shanghai could be the majestic machine now residing within the National Railway Museum? Or how many miles of service has she achieved? Through what type of countryside? – and so on. These and many more thoughts occupied me as I painted the 4-8-4. At least I could boast that both began our working lives at the Vulcan Foundry.

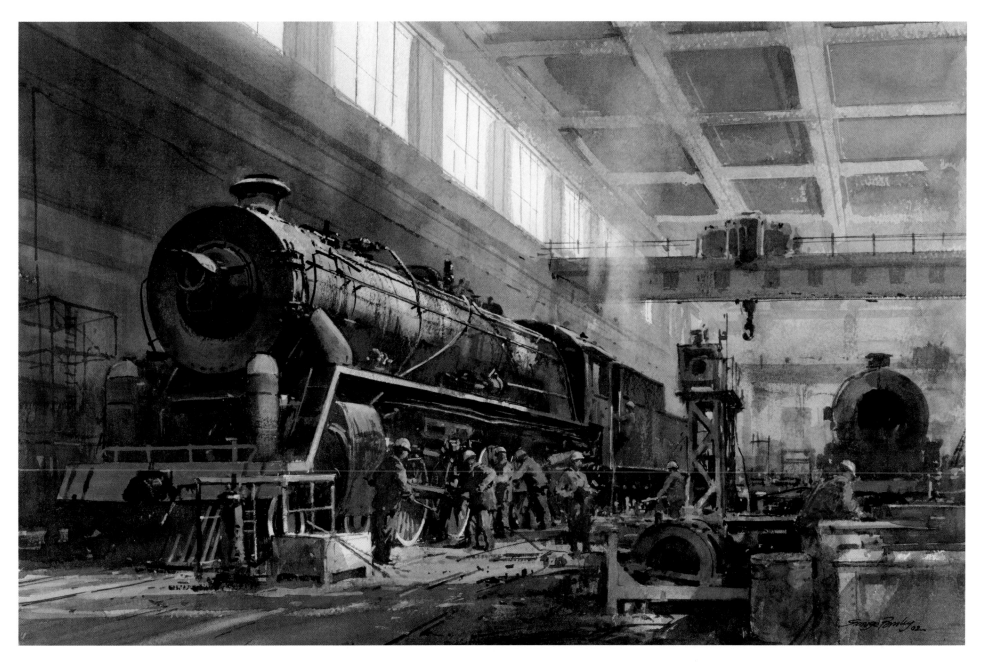

On the other hand, what stroke of genius brought us together again? To whom are we indebted for this splendid exhibit? It seems that the idea originated at this very location, over lunch, shortly after the opening of the National Railway Museum when Colonel Kenneth Cantlie was among those present. Once the agreement of the Director of the Science Museum, Dame Margaret Weston, had been obtained it was then mainly as a result of Col Cantlie's personal friendship with the Chinese Minister of Railways that the formal offer of gift was made. Shipment aboard the MV *Renee Rickmers* was generously provided free of charge thanks to the enthusiastic co-operation of shipping agent Peter Trinder. Col Cantlie was one of the trustees of the Boxer indemnity fund and the Chinese nation had clearly not forgotten the constructive role he played in the development of their great country.

The 4-8-4 has been proudly displayed within the National Railway Museum since 1993. Col Kenneth Cantlie died in 1986 but he did pay one last visit to the NRM before his sad departure.

Overhauling a 'KF7' Class (Chinese locomotive)
GEORGE BUSBY
45 x 30 CM, MIXED MEDIUMS, 2002

These giant 4-8-4 locomotives were built at the Vulcan Foundry Limited in 1935 for the Chinese National Railways.

Roy Wilson

NATIONAL RAILWAY MUSEUM REVIEW

The Journal of the Friends of the National Railway Museum

No 99 Spring 2002

Vulcan Foundry 4-8-4 No. 610 is unloaded at Shanghai from the Belpamela, specially built by Armstrong Whitworth in 1927 to convey complete locomotives. In 1939 the same ship took LMS 4-6-2 Duchess of Hamilton *(masquerading as No. 46220* Coronation*) from Southampton to Baltimore. (NRM 531/83)*

The Biggest in the Museum –
Chinese KF7
ROY WILSON
PASTEL, 2002

This painting was selected from Roy Wilson's exhibition at the Museum in 2002 for use on the cover of the Spring edition of the *NRM Review*. The locomotive is the largest exhibit in the NRM.

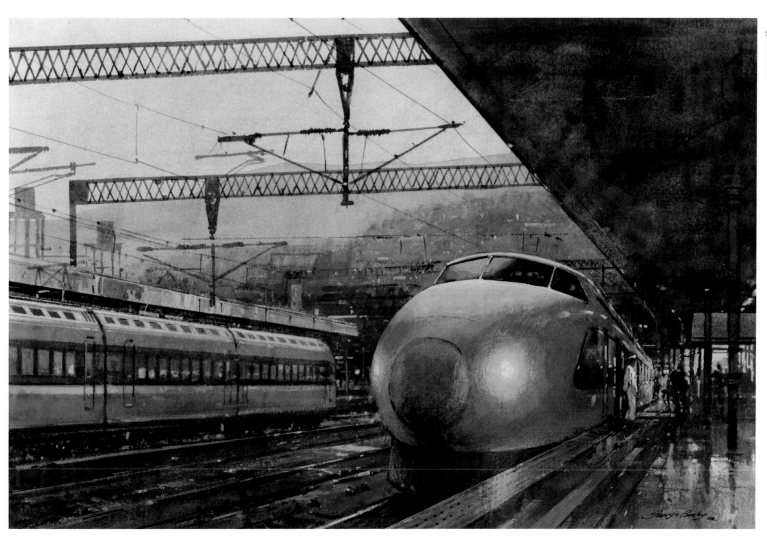

Shinkansen
GEORGE BUSBY
45 x 30 cm, mixed mediums, 2002

'Shinkansen' or 'bullet train' is Japanese for the new super express developed to provide a high-speed passenger service between the main cities of Japan. This is one of the original 'O' series, which now run the stopping services on the Tokaido and San-yo lines. The train is the same as the one displayed in the National Railway Museum. The NRM has a unique working relationship with the Japanese Transportation Museum in Tokyo.

Banner symbolising the close working relationship between the National Railway Museum and the Japanese Transportation Museum

In contrast to the painting on the previous page, here is the first steam locomotive used on Japan's railways. Constructed at the Vulcan Foundry, Newton-le-Willows, in 1871, it was one of ten locomotives built for service between Tokyo, Shimbashi and Yokohama. Restored almost to original condition, Japan's pioneer locomotive No.1 is now proudly displayed at Tokyo's Transportation Museum.

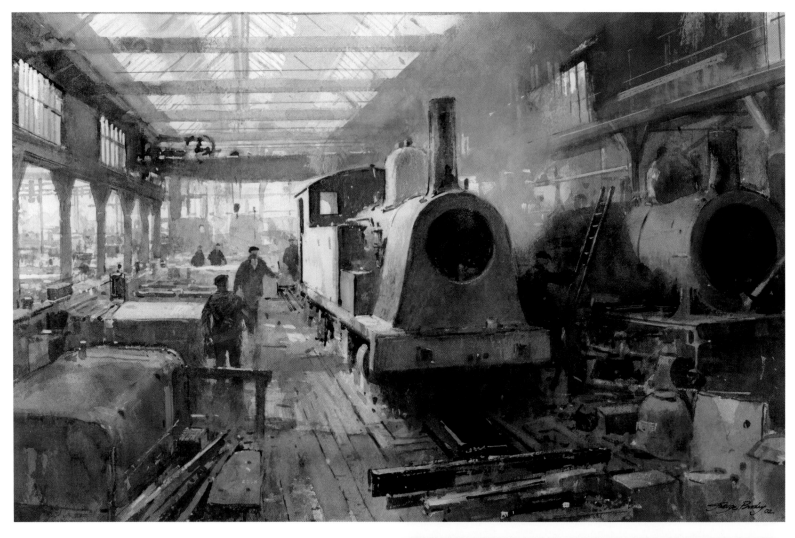

British Practice in Japan

The inauguration of the railway from Tokyo (Shimbashi) to Yokahama on 12th September 1872 was celebrated in the presence of the Emperor Meiji. The scale of the stately ceremony was reported in detail in the *Illustrated London News* of 7th December 1872, which contained a picture of the Imperial procession. It is now considered an important historical drawing depicting the life of upper class Japanese in those days.

Towards the end of the Shogunate regime both American and Russian envoys demonstrated scale model railways to persuade officials and the general public of their advantages to communication. Finally it was Britain's proposals for the building of railways that were accepted by the officials of the Meiji regime.

The initial ten locomotives – all 2-4-0 tanks – were built by five major British companies: Vulcan Foundry (No. 1), Sharp Stewart (Nos. 2 to 5), Avonside Engine Works (Nos. 6 and 7), Dubbs & Co (Nos. 8 and 9) and Yorkshire Engine Works (No. 10). Metropolitan Vickers & Co supplied most of the 58 two-axle passenger coaches. One 1st Class, two 2nd Class and five 3rd Class made up the standard train of eight coaches, although the Imperial train was recorded to have consisted of nine on the inauguration day.

Public services on the first 18 miles of 3ft 6in gauge line comprised nine trains per day, departing each terminal every hour on the hour from 8am to 6pm, the journey taking 53 minutes. Thirty covered and forty low-sided wagons were provided for goods traffic, a standard freight train consisting of fifteen vehicles.

Locomotives and rolling stock were all imported from Britain as were the bull-headed rails and chairs. Instruments and semaphore signals were of British pattern and all passenger stations were built with high platforms to give easy access in a style typical of our stations. Of the initial railway staff, 107 of the 114 Western engineers were from Britain. It is fair to say, 'In the early days of Japan's railways the JNR followed British practice.'

There is also a connection between Richard Trevithick and the railways of Japan in that two of his grandsons worked there on the early locomotives. They travelled out in the 1870s under contract to the Railway Department of the Japanese Government.

After working in India, Richard Francis Trevithick (1845–1913) arrived in 1874 as a mechanical engineer and joined 93 other British railway employees. All the steam locomotives at this time were still being imported from Britain and assembled in various workshops with few modifications. Trevithick was assigned to the Kobe Workshop, where some drastic alterations were made to the locomotives to make them more compatible with local conditions, as Japanese engineers acquired the necessary skills and confidence.

By 1888 the suggestions of British engineers enabled the Japanese desire that locomotives be designed and built in Japan to be fulfilled. In that year Trevithick became the Locomotive Superintendent at Kobe. He designed and organised the construction of the first all-Japanese locomotive – a compound that was also the first of its kind in Japan. Of completely new design, its trial run in 1893 from Kobe to Kyoto proved it to be excellent in performance. This was the first of 33 locomotives built under Trevithick's supervision at Kobe before his return to England in 1904.

Roy Wilson

Images of No. 1 at the Transportation Museum in Tokyo, photographed by Roy Wilson in 1982.

OPPOSITE PAGE
Display panel

THIS PAGE, TOP
Leaflet cover
LOWER, LEFT
Model of locomotive and carriages from UK on inaugural run
RIGHT
No. 1 preserved within the museum

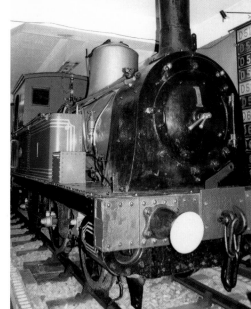

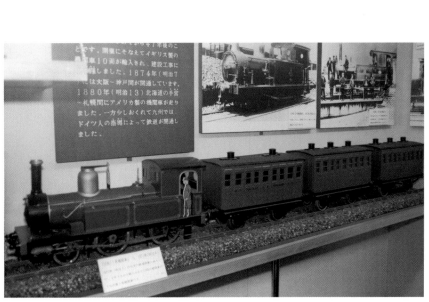

65567 on Norwich Shed, 1962
NICK HARDCASTLE
40 x 29 CM, PEN AND INK WITH WATER-
COLOUR, 2003

Designed by J Holden in 1901 the class J17
0-6-0s were ubiquitous on ex Great Eastern
Railway lines. This particular locomotive was
the last survivor and is now part of the
National Collection. It was the last steam loco-
motive to be shedded at Norwich in 1962.

Introduced by Samuel Johnson in 1902 and improved by Richard Deeley and Henry Fowler, some of these locomotives were still active in the late 1950s. A Compound uses steam in more than one set of cylinders. The painting is set at Ais Gill summit on the Settle to Carlisle railway.

No. 1000 is preserved in its Midland livery of crimson lake at the National Railway Museum.

Turning at Mildenhall
NICK HARDCASTLE
39 x 27 CM, PEN, INK AND WATER-COLOUR, 2002

E4 2-4-0 No. 62785, the last survivor of its class, is turned at Mildenhall, Suffolk, in the late 1950s. This was the end of the now closed branch line from Cambridge.

Built at Stratford in 1894, the locomotive has now been restored to its Great Eastern Railway livery as No. 490. It is on display at Bressingham Steam Museum and is part of the National Railway Museum collection.

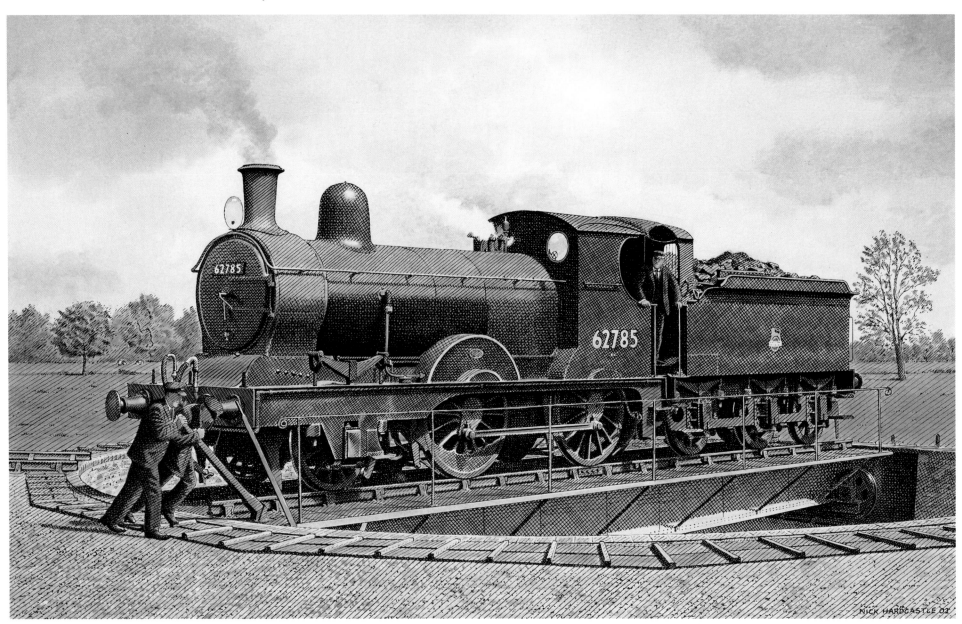

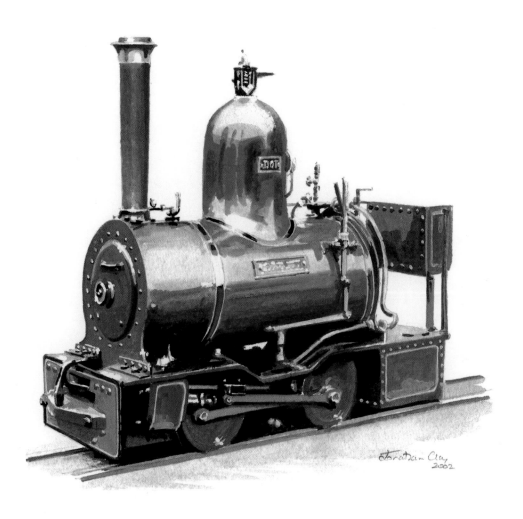

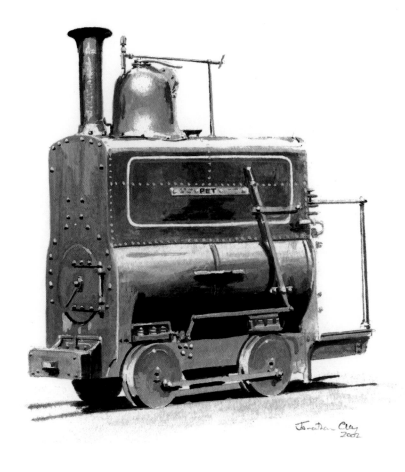

Dot
JONATHAN CLAY
28 x 35 cm, gouache, 2002

Built by Beyer Peacock of Manchester in 1887, *Dot* was used in the builder's Gorton works for shunting and moving materials. It is now on display at the Narrow Gauge Museum in Tywyn, North Wales

Pet
JONATHAN CLAY
28 x 35 cm, gouache, 2002

The narrow-gauge *Pet* was built in 1865 at Crewe works, where its spent 64 years as a shunter. It was donated to the National Railway Museum in 1965 and restored at the Narrow Gauge Museum at Tywyn.

Crab Valve Gear
ERIC BOTTOMLEY
21 x 29 CM, PENCIL, 2002

E. BOTTOMLEY

'CRAB' VALVE GEAR

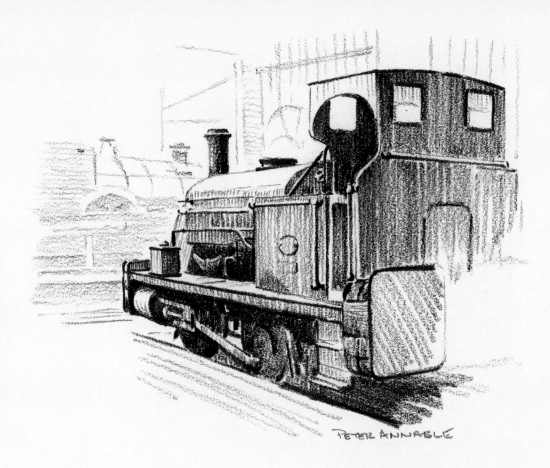

PETER ANNABLE

The Bauxite No. 2
PETER ANNABLE
18 x 13 CM, PENCIL, 2002

Black, Hawthorn & Company of Gateshead built 0-4-0ST No. 305 in 1874. Withdrawn from service in 1947, this industrial locomotive worked at the international Aluminium Company works at Hebburn in County Durham. Bauxite is the ore from which aluminium is extracted.

The valve gear from an LMS class 5MT 2-6-0 designed by Hughes and built at Horwich in 1926. The class is distinctive in having a high running plate over the cylinders and valve gear, resulting in the nickname 'Land Crabs' later shortened to 'Crabs'. This design was adopted because a low boiler pressure meant that large cylinders, which had to be set higher than normal to get within the loading gauge, were necessary to achieve the required tractive effort.

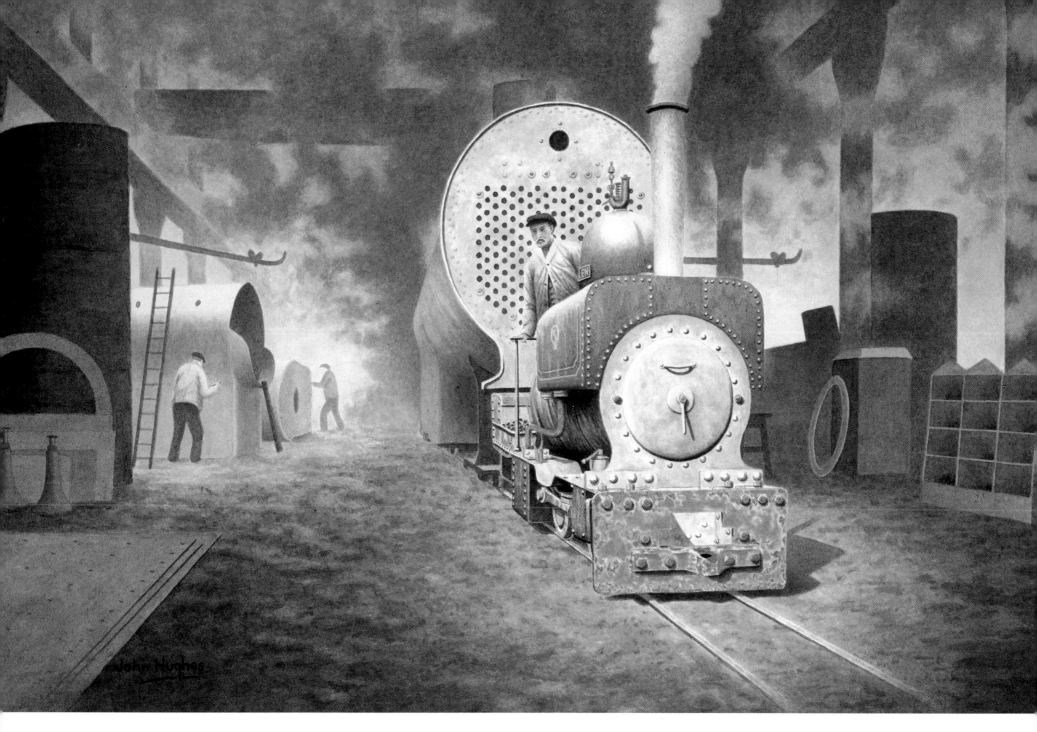

The tiny 0-4-0ST *Wren* pulling a boiler in a workshop in Horwich c. 1910. *Wren* is a 0-4-0 saddle tank locomotive. Built for the 18in gauge internal line at the Lancashire & Yorkshire Railway's locomotive works, Wren is the last survivor of eight similar engines. It is also one of the first three Horwich narrow-gauge locomotives built by Beyer Peacock in Manchester. It was used until 1957 and then kept as a replacement for the diesel engine.

The design is unusual in having a cylindrical firebox housed within the larger boiler barrel. The firebox is divided horizontally by the fire grate.

'Troglodytes' is a particularly appropriate title as it is the scientific name for the wren and for cave dwellers. The locomotive was small and adaptable; it spent all of its life at Horwich Works.

Troglodytes
JOHN HUGHES
45 x 30 CM, ACRYLIC, 2002

London & North Western Railway
0-4-0ST No. 1439

Weight: 22¾ tons
Cylinders: 14in diameter x 20in stroke
Working pressure: 120lbs
Driving wheels: 4ft 0in

Designed by John Ramsbottom and built at Crewe in 1865, this unique locomotive was placed on the duplicate list in 1885. Withdrawn from LNWR service in 1919, it was sold to Kynochs Ltd of Birmingham, later to become part of ICI, who in 1954 presented the engine to the British Transport Commission for preservation.

Subsequently renumbered 1985 and 3042 during periods in store at Crewe paint shop, it was transferred to Staffordshire County Council in the early 1960s and stored out of sight for twenty years at Shugborough Hall, near Stafford. The locomotive was never shown to the general public while at Shugborough, but was repainted in its old LNWR livery with its original number of 1439 reinstated.

It was moved to the Severn Valley Railway in April 1983 to participate in a BBC drama documentary. Since the engine had not worked for many years, steam effects were simulated for BBC Cardiff's filming of 'The Fasting Girl', the story of a Welsh lass of the 1860s who claimed she could survive without eating! Arley assumed the identity of Pencader station on the former Carmarthen to Lampeter line. The locomotive, listed as being part of the National Collection, is at present located within the main building at the East Lancashire Railway's Castlecroft Transport Museum, Bury (photo, left).

The East Lancashire Railway Museum
WYNNE JONES
61 x 51 CM, OIL, 2002

The Ramsbottom tank engine outside the Museum in Bury. In 1987, four miles of the old East Lancashire Railway between Bury and Ramsbottom were restored and reopened, with services later being extended to Rawtenstall. Volunteers run the railway and the museum – one of them can be seen in overalls in the bottom right-hand corner of the painting. Preservation societies are dependent on enthusiastic volunteers to fundraise and to work on the railway.

An insight into the artist's studio, showing the tools of the trade. The photograph of David Shepherd on the wall also gives away the artist's influence. Here we see blank canvases, half-finished canvases, easel, paint box, thin-ners, various brushes, palette, palette knife, paints, fixative and rags – just in case anyone thought it was just a matter of a brush and canvas!

A Brush with Railway Heritage
WYNNE B JONES
61 x 51 cm, oil, 2002

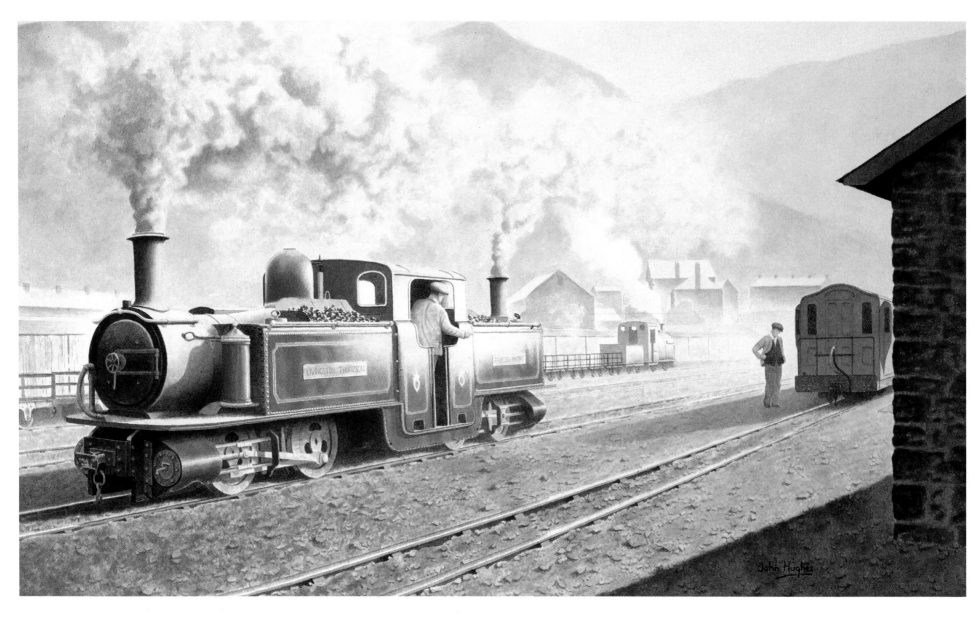

Duffws
JOHN HUGHES
47 X 29 CM, ACRYLIC, 2002

The narrow-gauge Festiniog Railway is one of the oldest in the world. The mountainside line climbs 700 feet in 13 miles through the Snowdonia National Park from Porthmadog to Blaenau Ffestiniog.

The locomotive is *Livingston Thompson*, built in 1886 and designed by Robert Francis Fairlie with a wagon-top double-engine boiler. It was named after one of the directors. It is on loan from the Festiniog Railway and can be seen in the Great Hall of the National Railway Museum.

A fictitious composition inspired by the Great Western Railway and the Severn Valley line, set in about 1920. The freight locomotives are Dean goods 0-6-0 No. 2516 and Churchward 2-8-0 No. 2818, built at Swindon in 1905. This class set the standard for years to come and proved to be the most economical of all freight locomotives. It could carry over five tons of coal and 3,500 gallons of water. Both locomotives are in the National Railway Museum.

Freight, Snow and Steam
PHILIP SHEPHERD
51 x 39 CM, OIL, 2002

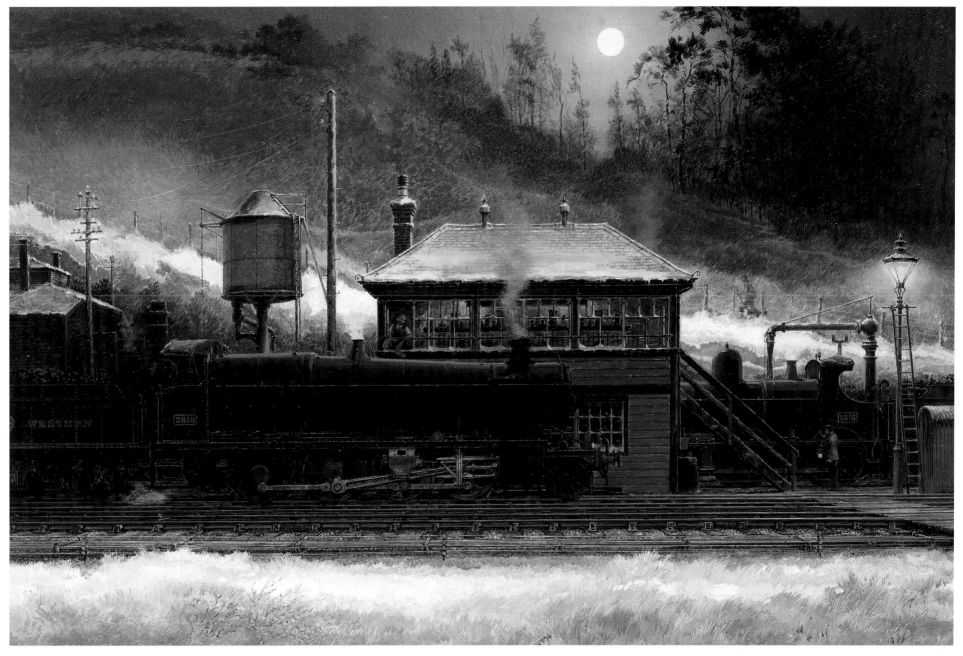

Owain Glyndwr
JIM TEAGUE
40 x 30 CM, OIL ON CANVAS, 1990

Vale of Rheidol 2-6-2T tank No. 7, built at Swindon in 1923. It still works on the narrow gauge Vale of Rheidol line, which runs from Aberystwyth to Devil's Bridge. The artist was the last BR driver to be passed out on this locomotive.

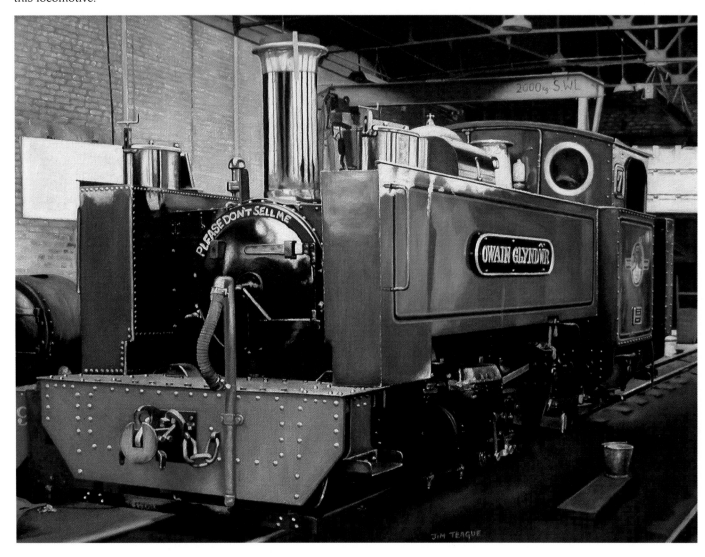

OPPOSITE
Big Piece of Brick Arch
WILLIAM ROBERTS
75 x 62 CM, OIL, 2003

A painting influenced by the poster designed by Terence Cuneo for British Railways in 1949 titled 'Clear Road Ahead'. It shows the driver and fireman working on the footplate of Monmouth Castle. The title refers to a dilemma that could be experienced by the crew while firing a locomotive. Occasionally, a piece of the firebox brick arch would fall into the fire and make it difficult to raise steam. Such a scene is captured in this painting, with the fireman trying to pull the piece of arch under the door and out of the way. Both Cuneo and Roberts capture the heat, smoke, speed and concentration of the scene.

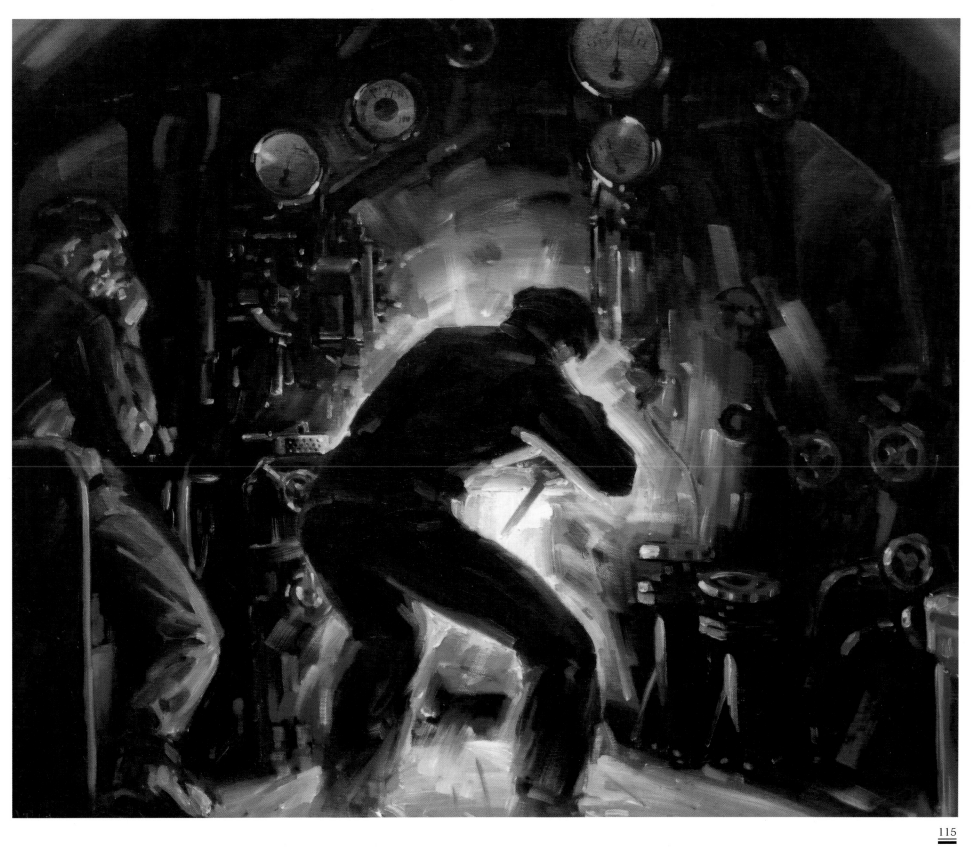

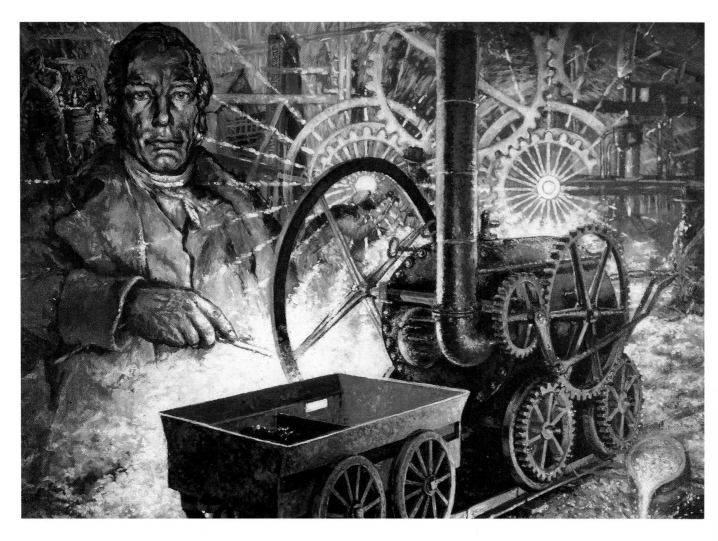

Trevithick 200
STEPHEN WARNES
61 x 51 CM, ACRYLIC, 2003

The dynamic character of Trevithick and his revolutionary inventions are captured in this explosive design. The artist was inspired by the Cornish tin and copper mines, Trevithick's character and genius, the pumping engine house at Dolcoath copper mine, the rural poverty in Cornwall, the Newcomen engine, the spirit of the Industrial Revolution, mining technology and, of course, the *Penydarren* locomotive.

Aegenoria
JOHN WIGSTON
38 x 55 CM, WATERCOLOUR, 1996

This locomotive was built in 1829 by Rastrick & Foster in Stourbridge, West Midlands, and is named after the goddess of courage and industry. It ran for over 35 years at Shutt End Colliery, hauling wagons of coal from the pit to the nearby canal. It is now on display in the National Railway Museum. Like most early locomotives, *Aegenoria* had two pivoted beams high over the boiler with an assortment of rods connected to the coupling rods on the wheels. These made the locomotive shake, and people living along the line nicknamed it the 'Grasshopper'.

A streamlined A4 is seen travelling in an idyllic snow-dusted setting on the LNER. The birds remind us that many of the A4 locomotives were named after them, for example *Mallard*, *Wild Swan*, *Sparrow Hawk*, *Bittern*, *Guillemot*, *Golden Eagle*, *Kingfisher*, *Falcon*, *Merlin*, *Golden Plover*, *Gannet* and *Seagull*.

Cold Streak
JOHN HUGHES
42 x 23 CM, ACRYLIC, 1998

Icons
JOHN HUGHES
37 x 15 CM, ACRYLIC, 2002

The chimney of the replica
locomotive *Rocket* and the
roof structure of the National
Railway Museum are the focus
of this composition. The title
of the painting refers to the
iconic status of both the
locomotive and the NRM.

Drawing Gear
JOHN WIGSTON
26 x 33 CM, WATERCOLOUR, 1996

A detail of the right-hand side
coupling and front buffer beam
of *Evening Star*. It was the last
locomotive built for British
Railways at Swindon works in
1960 – the 'evening star' is the
planet Venus.

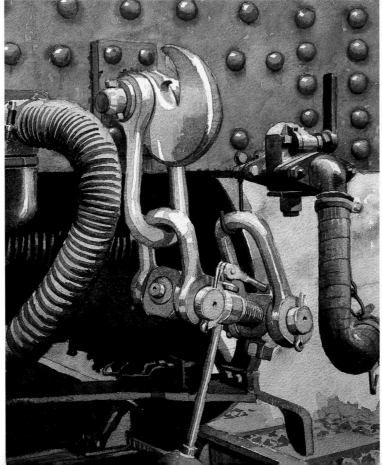

steve wyse www.artwyse.com

OPPOSITE

The Curvaceous Duchess of Hamilton
JOHN COWLEY
20 x 20 CM, COMPUTER SKETCH, 2003

Having completed the painting 'Lady In Red' (page 63), John decided to produce a sketch or illustration of *Duchess of Hamilton* in her original streamlining, choosing to use his computer as the medium on this occasion. An initial line drawing was scanned into the computer and he then completed the artwork using a graphics programme in much the same way that movie cartoonists first worked. Multiple layers with transparency and various masks and blends provided the basis for the artwork. Finally, many hours were spent using the digital brush combined with the obligatory stylus and graphics tablet.

John has found that computer generated artwork is a very different medium when compared with the tactile experience of hands-on painting, but a certain touch is still required. Artistic stimulus is enjoyed in this creative process in much the same way that other media provide.

Rocket to the Moon
STEVE WYSE
COMPUTER GRAPHIC, 2002

This was created on a Macintosh G4 computer using cinema 4D software and took approximately thirty-five hours to produce. The inspiration is the symbolism of travel, the adventure and the future. The science fiction of railway travel is a popular and historic notion. In 1839 the French magazine *La Mode* printed a lithograph titled 'Predictions – the Railway from Paris to the Moon' showing a locomotive and carriages heading for the moon.

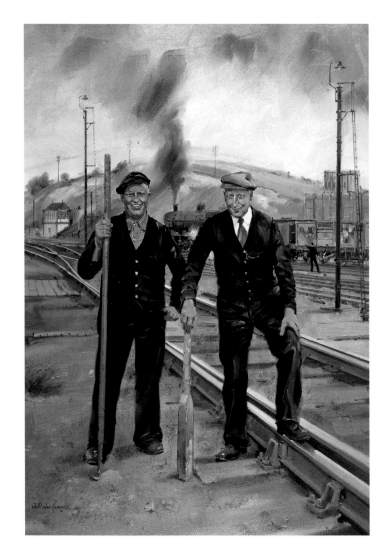

Unsung Heroes 1 – The Shunters
DAVID CHARLESWORTH
51 x 61 CM, OIL, 2003

The title 'Unsung Heroes' was originally created some twenty years ago for a series of pictures depicting the work of railway personnel not usually in the limelight. It was inspired by a set of negatives given to the artist showing what, in the 1950s, were ordinary, everyday scenes of friends at work. These, and countless images like them all over the world, are now part of our social history.

These men, even in later life, could run across points, crossings and sleepers to keep up with the freewheeling wagons – and nimbly pin down the brakes. This was not a job for the faint-hearted. The long hook was essentially for uncoupling but, contrary to regulations, was often used to pin down the brakes too.

This painting shows Barrow Hill 'down' sidings, near Chesterfield, and was inspired by the Museum's collection of miscellaneous railway equipment and tools.

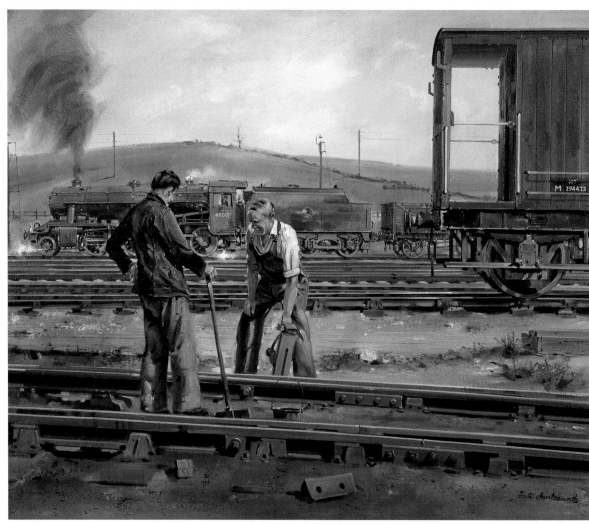

Unsung Heroes 2 – The Gangers
DAVID CHARLESWORTH
61 x 51 CM, OIL, 2003

The 'permanent way' is anything but permanent, requiring a great deal of maintenance to keep it safe and operational. Out in all weathers, often in the middle of the night, the 'gangers' worked with their bare hands, moving heavy equipment and rail.

The painting shows Barrow Hill 'up' sidings. It was inspired by the National Railway Museum's educational display of track and equipment.

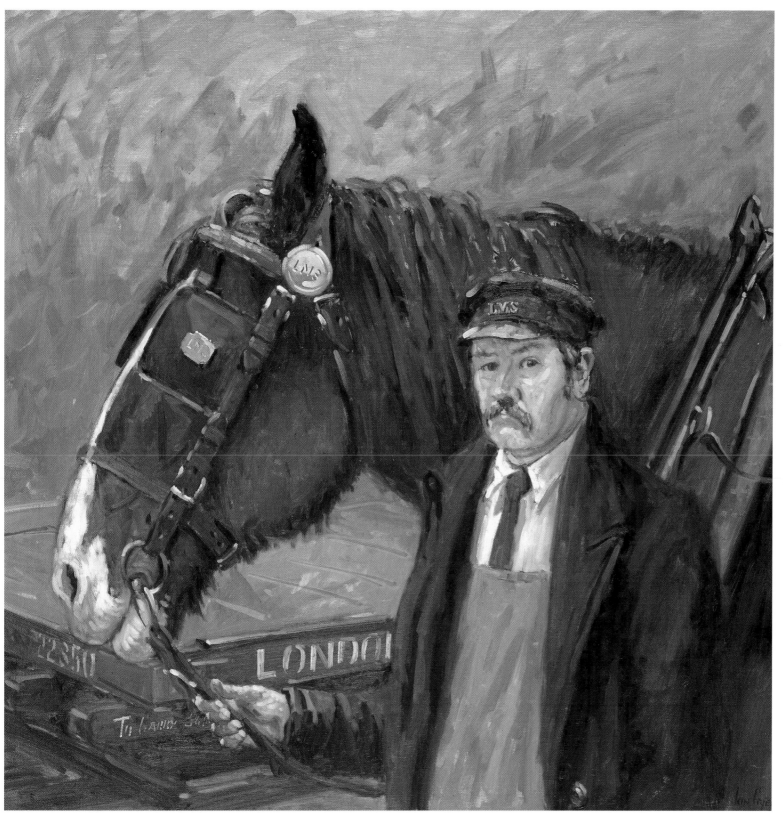

The Railway Horse (self-portrait with Truman)
IAN CRYER
76 x 28 CM, OIL ON CANVAS, 2002

This painting shows the artist and his horse, Truman. Before the First World War, the constituent LMS companies owned around 15,000 horses and 20,000 vehicles. During the war, many horses were sent to the front never to return. The last railway horse, used for shunting at Newmarket Station, retired in 1967.

Truman is a 14-year-old Shire gelding and is typical of the heavy horses used for the collection and delivery of goods. The LMS trolley was built at Wolverton Works in 1934, and the harness Truman is wearing is part of the National Railway Museum collection.

The faces of the artist and horse show the hard-working, down-to-earth attitude of railway employees. They were sometimes cynical but also had an obvious pride in their work and loyalty to the railway company.

Stretching the Imagination
JOHN HARDY
26 x 34 CM, ACRYLIC, 2002

A Hornby Gauge 0 clockwork train set and its box, on which is the London & North Eastern Railway *Flying Scotsman*. The National Railway Museum has a huge collection of models.

Hornby is now a household name and brand leader in model railways. The name originates from Frank Hornby (1863–1936) who invented Meccano. The first Hornby train was produced in 1920 and was powered by clockwork.

TSS Duke of Rothesay
JOHN WIGSTON
55 x 38 CM, WATERCOLOUR, 2002

This was a British Railways passenger ferry that travelled between Heysham and Belfast, Northern Ireland. It was built by W Denny & Bros of Dumbarton and broken up in 1957 at Milford Haven. There is a scale model of it in the NRM warehouse.

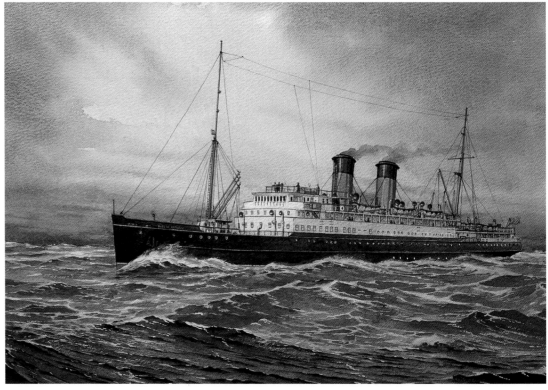

Crab Motion
JOHN WIGSTON
55 x 38 CM, WATERCOLOUR, 1996

Although part of the National Railway Museum collection, this 'Crab' locomotive is kept at Barrow Hill near Chesterfield, the last surviving operational roundhouse in Britain. No. 2700 is one of a class introduced in 1926 and built under Fowler's direction to the design of George Hughes.

The painting was done in the National Railway Museum in 1996 while Wigston was Artist in Residence.

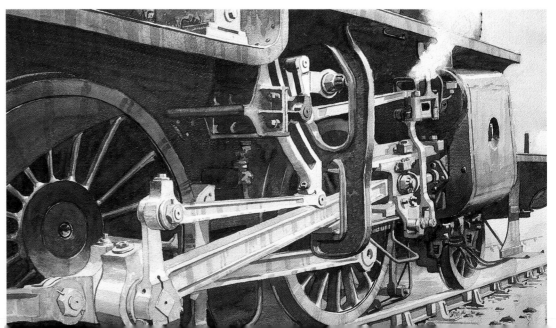

Biographies

Peter Annable, GRA, b1949
Born in Nottingham, Peter studied at Mansfield Art College and has since worked in graphic design, both in illustration and painting. Regularly exhibits and teaches art at Ranby prison in Nottinghamshire.

John Austin, GRA, b1949
John was born in Birmingham and studied art at Gosta Green Art College in Moseley and Aston University. After college he worked in creative light design until 1985 when he took up the opportunity to become a professional artist. Lives in Bridgnorth and Dawlish and draws inspiration for his paintings from both places. Much of his work is commissioned and a number of his works are available as fine art prints. His popularity has gained him the accolade of winner of the Guild's annual 'Picture of the Year' award no fewer than nine times. He is currently Deputy President of the Guild.

Paul Bate, b1947
Born and still residing in Stoke-on-Trent his first specialized art training was in 1960-62 at Portland House School of Art in Burslem. Became an apprentice lithographic artist in ceramics, an industry in which he was employed for much of his working life. Latterly he began to carry out artwork for collectors' plates, mainly of sailing ships, and for the first time took up acrylics as a medium. On retirement in 1998 he took voluntary redundancy, which gave him the opportunity to rekindle some of the pleasure derived in his youth from train spotting and 'going up the sheds' as a basis for his artistic depictions.

Mike Booth, NDD, ATD, DA (Manc), GRA, b1940
Born in Eccles, Mike studied at Manchester College of Art and began his career as a teacher. In 1992 he took early retirement to concentrate on painting. Draws inspiration from the combination of oil, grease and fatigued metal, which he finds in derelict railways. His work is characterized by the use of light and shade and reflection. He also paints the railway as it is now. He is passionate about textures. Uses a variety of media but usually finds that railway subjects need oil on canvas. He is currently President of the Guild.

Eric Bottomley, GRA, b1948
Born in Oldham, he studied for three years at Oldham School of Art, leaving in 1964 to enter the world of advertising in Manchester. Disillusioned by the lack of illustration work, he started to paint in his spare time. In 1974 he moved to Dorset continuing as a freelance artist/illustrator, which enabled him to devote more time to oil painting. In 1976 he took up painting full time from his studio in Wimborne Minster. In 1988 Eric and his wife moved to the village of Much Marcle in Herefordshire, where along with much commissioned work he now publishes his wide range of fine art prints and cards.

Glenys Burrows, b1949
The artist studied at Nottingham College of Art in 1966 and has been a member of various art groups during her career. In 1986 she moved to Malvern, Worcestershire, and took up studying again at Malvern Hills College. Influenced by her 'train spotting' brothers in her youth, she was later to open a shop on Great Malvern station where the local art and craft co-operative sell their work.

George Busby, MCSD, RBSA, FRSA, GRA, b1926
Born in Birmingham and still lives in the West Midlands. Worked as a graphic designer and illustrator until 1978 when he became a full time artist. Uses watercolour, gouache and acrylic and covers a wide variety of subjects but particularly likes industrial scenes. He has exhibited at the Royal Birmingham Society of Artists, Solihull Art Gallery and others. So far he has been commissioned to illustrate calendars for Amoco Oil Company, Abbey National Building Society, Courage Breweries, British Gas and British Waterways. He also designs Christmas cards and is represented in various books.

David Charlesworth, GRA, b1954
David began drawing at an early age. He started painting with oils when eight years old and completed his first commission when only twelve. He is one of the few professional artists of his generation with well over 30 years of continuous experience in producing and selling paintings and illustrations for customers at home and abroad. His work is not confined to railway subjects. As an industry-trained, working professional artist and graphic designer, he covers every subject – including portraits – and most mediums. His interest in railways has been life-long. His daughter first visited the National Railway Museum at York when only 12 days old in 1985 and on every visit thereafter Lauren has been photographed alongside the EM1 class 26020.

Jonathan Clay, b1950
Born in Blackpool, he went to grammar school and graduated in history and politics. He worked in the public and private sector for thirty years but has always been interested in art and railways. He specializes in locomotive portraits, works on commissions and exhibits widely.

Matthew Cousins, GRA, b1953
Born in Hitchin, within sight and sound of the East Coast main line, Matthew has had an almost life-long interest in railways. He was inspired by the artworks in the many railway books available in the 1950s including Ian Allan's use of Vic Welch paintings and later works by Heiron. He has developed a particular liking for poster art, and especially admires Cuneo's masterful paintings for British Railways. Taking the lead from poster artwork in the railway heydays of the 1930s and 1950s, Matthew has produced poster art for the Bluebell Railway for the last seven years. A period of ten years on the footplate at the Bluebell gave him a real insight into the working of railways in the age of steam. Having now semi-retired he has more time for painting and has also turned his hand to railway restoration with the rebuilding of a Southern Railway luggage van in which he holds painting exhibitions at the Bluebell Railway.

John Cowley, GRA, b1940
The artist was born in Bedfordshire in 1940 and was apprenticed to Vauxhall Motors, later becoming a car body designer. He retired from this career to become a landscape designer and artist. He undertakes painting commissions and exhibits.

Ian Cryer, GRA, b1959
Born in Bristol, he paints in a robust and versatile manner and delights in taking on challenging subjects. A great believer in 'the integrity of first hand observation', he works directly from life in order to achieve the freshness and spontaneity that have become the hallmarks of his work. A committed artist all his life, he held his first one man show when he was sixteen and has since exhibited widely in both on his own and with the professional societies. These have included the Royal Academy, Royal West of England Academy, Royal Society of British Artists, Royal Institute of Oil Painters, Royal Society of Portrait Painters and the New English Art Club. He has carried out many varied commissions and his work is featured in numerous collections including those of the Bass Museum, Lord Bath,

Longleat House, Price Waterhouse, Wadworths Brewery, Bristol Rovers FC, Scotrail, Railtrack and the English, Welsh & Scottish Railway with whom he has served as Artist in Residence. Ian Cryer is passionate about railways in the broadest terms from architecture to rolling stock, and is the founder of the Railway Horse and Cartage Collection.

Barry John Freeman, BA, FRSA, GRA, b1937

He was born in Northampton and was educated at the town's Grammar School and later, as a mature student, at the City of Leicester College of Education. Served for ten years in the Royal Navy, followed by several years in the electronics and aviation industries before becoming a teacher in 1971. Taught drawing and painting for eighteen years before early retirement provided the opportunity to become a professional artist in 1989. He is a former Deputy President of the Guild of Railway Artists. His paintings have been reproduced in many forms, including collectors' plates, book covers, postcards, greetings cards, jigsaw puzzles and calendars as well as fine art prints, which can now be found in many parts of the world. He was elected a Fellow of the Royal Society of Arts in 1995.

Peter Green, b1933

Peter was born in Nantwich to a railway modelling clergyman and worked in the textile industry before opening an art supplies shop in Wealdstone. He became a professional artist in 1987. He was commissioned by London Underground to design posters for its 'Steam on the Met' events and was also commissioned as illustrator for British Rail (Union Railways Ltd) Channel Tunnel Rail Link project. His work has appeared in several books and magazines and as fine art prints and greetings cards.

Mike Gunnell, b1937

Born in Hull, he studied physics and mathematics at the city's university and after National Service became an electronic technician for the Hawker Siddeley Aircraft Company. He then taught at pri-

mary schools for twenty years before retiring in 1989. His first solo exhibition was in 1991. He works in watercolour, ink and pastel and concentrates on railway and aviation subjects. Teaches art on a freelance basis.

Nick Hardcastle, GRA, b1957

Nick was born in Norfolk and studied illustration at Maidstone and then the Royal College of Art. He spent most of his career as a freelance illustrator in London but now lives in Norwich. He was commissioned to draw the royal train by InterCity. Works in pencil, ink and watercolour, mostly for book illustrations including publications by the Folio Society.

John Hardy, b1936

Born in north-east London in 1936, he was evacuated to Somerset on the Great Western Railway in the war. This was the beginning of his interest in railways which was to cover the whole of the network. He was influenced by the 'naïve painting' of Cuthbert Hamilton Ellis. Another of his interests is tinplate models.

John Harrison, ATD, GRA, b1930

The artist went to Cowley Grammar School in St Helen's and then onto Liverpool Regional College of Art in 1950. In 1955 he gained his art teacher's diploma. His career was interrupted by National Service in the Royal Army Education Corps. From 1957 he was an art teacher and then Head of Art at a comprehensive school. Works in watercolour, pen and ink and sometimes scraperboard.

Philip D Hawkins. FGRA, b1948

A childhood spent in Birmingham during the 1950s surrounded by the sights and sounds of trains is responsible for Philip's enduring passion for railways. After graduating from Birmingham College of Art, he worked in the railway industry as a technical illustrator at Metro-Cammell Ltd and then as a press photographer and freelance illustrator before becoming a freelance artist. He paints both historic and contemporary railway scenes and has

commissions from European Passenger Services (Eurostar), Docklands Light Railway, Railfreight, Freightliner and, most recently, Virgin Trains. His work appears as prints, greeting cards, calendars, on fine porcelain collectors' plates and in books and magazines. Philip was a founder member of the Guild and held the position of President from 1988 to 1998. He was honoured by being elected a Fellow of the Guild in 1998, this being the highest accolade that the GRA grants its members.

Chris D Holland, b1946

A self-taught artist, born in Wigan, who enjoyed photographing steam locomotives. He began painting in watercolour, gouache, oil and acrylics at the age of thirty. Now a professional artist, he has exhibited widely including the 1980 Royal Academy summer exhibition and the Manchester Academy.

John Hughes, GRA, b1935

Born in Birmingham, this artist had no formal training. He began painting railways from frustration in trying to photograph them as a hobby. He left school at fifteen and worked in the motor industry. Now retired he lives in Minehead. He paints with acrylics in a watercolour style for pleasure and commissions.

Peter Insole, GRA, b1957

Peter was born at Hainhault in Essex and began painting at a young age. After leaving school he joined an aircraft company as an illustrator before going freelance. He paints in water-soluble crayons and gouache, which give a unique clarity to his works. He exhibits regularly and is well known for his London Underground work.

Bernard Jones. NDD, ATC, GRA, b1943

Born in Surrey, he studied at Reigate School of Art and Brighton College of Art. He taught Arts & Crafts at Crawley for six years and then became a full-time studio potter until 1986 when he returned to painting – mainly railways – as a professional artist. Using mostly oil, he works on commission and exhibits regularly at

Bridgnorth station on the Severn Valley Railway.

Wynne B Jones, b1950

This artist's work was first exhibited in about 1960 at a children's exhibition at the Royal Cambrian Academy in Conway. It was the beginning of a life interest in railway painting. This he juggled with a career in the oil industry until he retired in 1996 and was able to concentrate on his art. He is also interested in railway restoration and is a member of the Llangollen Railway Preservation Society.

Brian C Lancaster, RSMA, FRSA, GRA, b1931

Born in Atherton near Manchester, he gained a scholarship to Bolton College of Art, followed by a further three years at Southport Art College studying graphic design and illustration. During all of this time he painted mainly in watercolours and exhibited regularly at the Southport annual exhibitions. Worked in Canada from 1957 to 1962 and since then has spent much of his spare time in the steam preservation field, still with brush in hand, painting, lining and lettering. He is a self-employed illustrator. He exhibits widely, particularly in the open London exhibitions, and is a full member of the Royal Society of Marine Artists and an elected member of the Bristol Savages.

Richard Sidney Potts, b1929

Richard was born in Birmingham to a railway family and became a post office telegraph messenger in 1943. Six years later he enrolled as a cleaner at the Great Western Railway works in Tyseley, leaving as a driver in 1993. During his railway career he regularly attended vocational art classes and took railway art commissions. Since his retirement he has been collecting information on the history of Bordesley and Tyseley sheds.

William Roberts, b1928

Born in Pwllheli, he became an engine cleaner for the Great Western Railway in 1944 and worked his way up to become a passenger locomotive driver. In 1955 he spent some time at sea before working for

Butlin's. He went to Chelsea School of Art in 1956-58 and then became a mason's engraver and carver – work he does to this day as well as continuing as an artist.

Malcolm Root, GRA, b1950

Born in Colchester, he lives in Halstead in north Essex. He left school at sixteen and trained as a printing apprentice, leaving the trade in 1981 to become a full-time artist. Publication of his paintings has culminated in two books featuring solely his own work. The first was *The Railway Paintings of Malcolm Root* by Mac Hawkins, and the most recent is *Malcolm Root's Transport Paintings* with text by Tom Tyler. His greatest interest is mid twentieth century transport and its impact on the ordinary person. He regularly has commissions for calendars, collectors' plates, prints and private work.

Philip Shepherd, RWS, GRA, b1927

The son of a relief signalman, Philip was born in Willesden, London. He won a scholarship to Harrow College of Art in 1941 and then Birmingham College of Art in 1950. He worked as a technical and advertising illustrator and an architectural perspective artist. He was elected to the Royal Watercolour Society in 1977 and awarded bronze and gold medals for wood engravings at the Paris Salon. The Fitzwilliam Museum in Cambridge and the Whitworth Gallery in Manchester hold examples of his work. He has also exhibited at the Royal Academy on several occasions. While passionate about the Great Western, he will paint other railway subjects and many of his depictions are in moonlight settings. He is also a keen campanologist.

Jim Teague, b1964

He was born in Hertfordshire in and grew up in Oxfordshire. Went to Southampton Art College in 1983 to study graphic design but left a year later to start as a second man at Old Oak Common. He lives in Machynlleth. Has been painting regularly in a variety of mediums for about twelve years.

Mike Turner. GRA, b1950

Born in Hampstead, London, he went to High Wycombe College of Arts & Technology and the London College of Printing. Worked as a graphic designer before becoming an illustrator and designer for the *Sunday Times*. He was made redundant and became a freelance illustrator. Specializes in continental and southern railway scenes. He lives in Sussex and is influenced by the sea, sky and landscape.

Stephen Warnes, BA(Hons), PGCE, GRA, b1951

Stephen was born in north-east Lancashire and graduated from Essex University in 1972 with a BA Honours degree in the Theory & History of Art. Has been a full member of the Guild of Railway Artists since 1985. He received his first public commission in 1997 when he produced 'A Painting to Celebrate the Centenary of the Glasgow Underground' for Strathclyde Passenger Transport Authority. Later that same year his work was featured alongside paintings by Terence Cuneo and photographs by Eric Treacy in the 'Making Tracks' exhibition. Held at Tullie House Museum & Art Gallery in Carlisle, it celebrated the 150th anniversary at Carlisle Citadel station.

Roger Watt, b1947

Roger has inherited his father's passion for drawing and railways. Having studied graphic art and design at Watford School of Art in the late 1960s, he became an art director in the field of international magazine publishing before being appointed Group Publishing Director of Athena, the art print and poster company, in 1987. He has remained in this sector ever since and is currently European Creative Director for one of the leading American fine art print publishing companies. During his career he has been a judge for the Association of Illustrators and worked with the Arts Council on projects to promote new creative talent. Having also been a professional car photographer, Roger's drawing has always struggled to

find a place within the hectic schedule of his 'day jobs' but there is no doubt that it is the most fulfilling of his creative activities. He says that it doesn't get any easier to find the time, however, as he also teaches art in Cambridge, where he lives with his wife and their two children.

Julie West, GRA, b1959

Born in Hartlepool, the artist studied at Middlesbrough College of Art. She went on to work in film animation where she won awards. Specialized in railway art after a commission to depict a steam special on the Settle and Carlisle line. She also works as Artist in Residence at vintage vehicle and steam rallies.

John E Wigston, GRA, b1939

John was born at Redhill, Surrey, but spent most of his early life in Chingford, Essex. After initial training in horticulture, three years in the RAF and two years with Ilford Films at Brentwood, he joined ICI on Teesside and remained with the company for 27 years. Transport – and especially railways – has fascinated him all his life. It was natural therefore for transport to be the earliest subject for his other hobby of painting. His art began to take on more importance when he attended evening classes at Hartlepool College of Art. Receiving encouragement from his family, the college and colleagues at ICI, he had his first one-man exhibition at the Gray Art Gallery, Hartlepool in 1970. More exhibitions followed, including those at the Museum of British Transport at Clapham and Doncaster Art Galleries. The150th anniversary celebrations of the Stockton and Darlington Railway in 1975 brought commissions from Northumbria Tourist Board for a painting of *Locomotion*, which in turn led to commissions from Barclays Bank, the North of England Development Council and one from Canada. He was Artist in Residence on the *QE2* in 1995 and at the National Railway Museum in 1996.

Lawrence Roy Wilson, NDD, GRA, b1926

Born in Wolverton, Buckinghamshire, he

began work at fifteen as an apprentice in the Vulcan Foundry's drawing office at Newton-le-Willows. Thanks to an appreciative chief his artistic abilities were encouraged and recognized. A scholarship to Manchester School of Art was achieved and following graduation he worked as a studio artist with a Manchester advertising agency. Within two years he was invited to join one of the agency's major clients as Assistant Publicity Manager and four years later at the age of 28 was appointed Publicity Manager. A new career in promoting and organizing international exhibitions began with a two-month project in Moscow in 1961. Extensive world travel was essential over the next three decades involving visits to no fewer than 70 countries, leading eventually to the establishment (with his wife) of their London office.

Retirement heralded a serious return to painting. Throughout his travels every opportunity had been taken to pursue a life-long love for railways, resulting in a vast archive of sketches and photographic references. In 2002, at the age of 75, he was invited by the National Railway Museum to stage his first solo exhibition, held over three months and involving several days as Artist in Residence. Roy specializes in pastel paintings, which he claims give him the immediacy he desires. His work is represented in collections within the United Kingdom and overseas. He is also an active member of the Friends of the National Railway Museum.

Steve Wyse, b1953

Born in London, he originally painted in oils but began using computer graphics in 1994. He was the first person to exhibit computer artwork for the GRA in 1996 and Kidderminster Railway Museum. He runs his own commercial computer graphics company.

Artists' Index

Further Information

BEVERLEY COLE, Curator of Pictorial Collections
NATIONAL RAILWAY MUSEUM
Leeman Road, York, YO2 4XJ
Phone: 01904 686209
Fax: 01904 611112
E-mail: b.cole@nmsi.ac.uk

FRANK HODGES, Chief Executive officer
GUILD OF RAILWAY ARTISTS
45 Dickins Road, Warwick, CV34 5NS
Phone: 01926 499246
E-mail: frank.hodges@tinyworld.co.uk

MICHAEL WALLACE, Hon Secretary and Editor NRM Review
FRIENDS OF THE NATIONAL RAILWAY MUSEUM
Leeman Road, York, YO2 4XJ
Phone and Fax: 01904 636874